My
Digital Photography
for Seniors

Jason R. Rich

que

800 East 96th Street,
Indianapolis, Indiana 46240 USA

AARP®
Real Possibilities

My Digital Photography for Seniors

ISBN-13: 978-0-7897-5560-5

ISBN-10: 0-7897-5560-2

Library of Congress Control Number: 2015941377

Printed in the United States of America

First Printing: July 2015

Trademarks

Warning and Disclaimer

Special Sales

For information about buying this title in bulk quantities, or for special sales opportunities (which may include electronic versions; custom cover designs; and content particular to your business, training goals, marketing focus, or branding interests), please contact our corporate sales department at corpsales@pearsoned.com or (800) 382-3419.

For government sales inquiries, please contact governmentsales@pearsoned.com.

For questions about sales outside the U.S., please contact international@pearsoned.com.

Editor-in-Chief
Greg Wiegand

Senior Acquisitions Editor
Laura Norman

Development Editor
Todd Brakke

Marketing
Dan Powell

Director, AARP Books
Jodi Lipson

Managing Editor
Sandra Schroeder

Senior Project Editor
Tonya Simpson

Copy Editor
Geneil Breeze

Indexer
Lisa Stumpf

Proofreader
Laura Hernandez

Technical Editor
John Rizzo

Editorial Assistant
Kristen Watterson

Cover Designer
Mark Shirar

Compositor
Bronkella Publishing

Contents at a Glance

Chapter 1 Getting Started with Digital Photography Using Your Mobile Device .. **3**

Chapter 2 Taking Amazing Pictures with Your Smartphone or Tablet **23**

Chapter 3 Improving Your Photography Skills **67**

Chapter 4 Transferring Photos to Your Computer **101**

Chapter 5 Viewing, Editing, and Enhancing Photos On Your Mobile Device ... **143**

Chapter 6 Viewing, Editing, and Enhancing Photos Using Your Computer ... **171**

Chapter 7 Organizing and Managing Photos On Your Computer **197**

Chapter 8 Organizing and Managing Photos On Your Mobile Device **219**

Chapter 9 Share Photos via Email with Family and Friends **253**

Chapter 10 Sharing Photos Online ... **277**

Chapter 11 Creating a Digital Diary That Tells a Story **311**

Chapter 12 Ordering Prints from Your Digital Images **325**

Chapter 13 Printing Digital Photos from Your Own Printer **355**

Chapter 14 Creating Compelling Photo Albums, Scrapbooks, and Photo Books ... **371**

 Index ... **397**

Bonus Material! Two additional chapters, a Glossary, and two articles are available to you at www.quepublishing.com/title/9780789755605. Click the Downloads tab to access the links to download the PDF files.

Chapter 15 Creating and Sharing Animated Digital Slide Shows **Online**

Chapter 16 Backing Up and Archiving Your Digital Photo Library **Online**

 Glossary

 Using Optional Photo Editing and Enhancement Apps

 Optional Photo Editing Software Options for PCs and Macs

Table of Contents

1 **Getting Started with Digital Photography Using Your Mobile Device** 3

Digital Photography Is Both a Skill and an Art Form 8

Some Digital Photography Basics .. 10

Making Photos More Useful with Metadata ... 10

Not All Digital Cameras Are Alike .. 13

The Main Steps Involved with Digital Photography 15

An Overview of Picture-Taking .. 15

Start Taking Photos .. 20

2 **Taking Amazing Pictures with Your Smartphone or Tablet** 23

Launching the Camera App on Your Mobile Device 24

Launch the Camera App on iOS ... 25

Launch the Camera App on Android ... 27

Understanding Popular Camera Features and Functions 29

Use the Shutter Button to Snap a Photo .. 30

Working with Autofocus Sensors ... 31

Zoom In on Your Subject .. 33

Burst Mode Is Perfect for Capturing Action ... 35

Shed Light on Your Subject Using a Flash .. 37

Discover How HDR Mode Can Improve Your Shots 38

Portrait Versus Landscape Mode ... 39

The Timer and Time Lapse Options Can Be Useful 40

Panoramic Shots Are Ideal for Shooting Landscapes 41

An Image Filter Can Dramatically Alter the Appearance of an Image .. 42

Adjusting the Camera App's Settings Before Taking Pictures 44

Take Pictures with Your iPhone or iPad .. 45

Turn On/Off the iPhone or iPad's Grid Feature 49

Using the Camera App with an Android-Based Device 51

Take Pictures with Your Android Device ... 52

Understanding the Settings Menu Options .. 55

Understanding the Mode Options ... 59

You Have the Skill, Now Perfect the Art Form Aspect of Digital Photography .. 63

3 Improving Your Photography Skills 67

Breaking Your Current Picture-Taking Habits 69

Knowing Your Objectives 70

Finding Visually Interesting Subjects 73

Photograph an Inanimate Object 74

Using the Rule of Thirds as You Frame Your Shots 76

Use the Rule of Thirds When Framing Your Shots 78

Paying Attention to Lighting 79

Choosing a Shooting Angle or Perspective 82

Taking Advantage of Your Surroundings 84

Taking More Interesting Portraits and Candid Shots of People 85

Strategies for Taking Candid Shots of People 85

Strategies for Taking Posed Portraits 86

Capturing Action Shots with Ease 89

Making Your Travel Photos as Memorable as Your Adventures 90

Keep Taking Photos Throughout Your Travels 90

Take Photos of Signs Wherever You Go 91

Mix and Match Different Types of Shots 92

Shoot Through Glass 93

Overcoming Common Shooting Challenges and Mistakes 96

4 Transferring Photos to Your Computer 101

Determining Your Available Storage 103

Manage Your iOS Mobile Device's Internal Storage 104

Manage Your Android Smartphone or Tablet's Internal Storage 107

Syncing Your Digital Photo Library Between Your Mobile Device and Computer Via the Internet 111

What You Need to Know About Cloud-Based Services 112

Using Microsoft OneDrive to Sync Your Photos 114

Using iCloud Photo Library to Sync Your Photos 122

Using Dropbox to Sync Your Photos 129

Finding Other Cloud-Based Photo Storage Options 129

Transferring Digital Photos from Your Mobile Device to Your
Windows PC or Mac Via a USB Cable ... 130

Transfer Content from Your Mobile Device to a Windows PC 131

Transfer Content from Your Mobile Device to a Mac 133

Transferring Images Wirelessly ... 134

Using AirDrop to Transfer Photos from iOS to Your Mac 135

Use Bluetooth to Transfer Images from an Android Mobile
Device to Your Computer .. 135

Manually Deleting Photos from Your Mobile Device 138

Delete Photos from Your iPhone/iPad .. 138

Delete Photos from Your Android-Based Mobile Device 140

Working with Images Stored on Your Computer 141

5 Viewing, Editing, and Enhancing Photos On Your Mobile Device 143

Enhancing and Editing Photos ... 144

Using Common Photo Editing Tools Built in to Smartphone
and Tablet Apps .. 146

Straightening Shots ... 146

Rotating Images ... 147

Cropping Images .. 148

Additional Editing Tools .. 149

Using the Photo Editing and Enhancement Apps On Your Device 156

Edit with the iOS Photos App .. 156

Using the Photos App on an Android Smartphone or Tablet 163

6 Viewing, Editing, and Enhancing Photos Using Your Computer 171

Editing and Enhancing Images on Your PC Using the Photos App 172

Get Started Using the Photos App ... 173

Understanding the Photos App's Main Tools 174

Using the Editing and Enhancement Tools .. 175

Editing and Enhancing Images on Your Mac Using the Photos App 183

Edit Images Using the Photos App on a Mac 185

Getting Acquainted with the Photo App's Editing Tools 189

7 **Organizing and Managing Photos On Your Computer** **197**

Using Custom-Named Folders ... 198

 Create Custom Folders on a PC .. 200

 Copy or Move Images into a PC Folder 203

 Rename Images on a PC ... 206

 Create Custom Folders on a Mac ... 207

 Copy or Move Images into a Mac Folder 210

 Rename Image Files on a Mac ... 212

Altering Image Metadata ... 213

 Adjusting Image File Metadata from a PC 214

 Adjusting Image File Metadata from a Mac 215

8 **Organizing and Managing Photos On Your Mobile Device** **219**

Organizing Your Photos On an iPhone or iPad 220

 Open an Album ... 220

 Browse Collections ... 222

 Create New Albums ... 224

 Delete or Move an Album ... 226

 Copy Photos Between Albums ... 229

 Delete Images from Albums .. 231

 Add Images to Your Favorites Album .. 232

Organizing Your Photos On an Android-Based Smartphone or Tablet 233

 Access and View Your Albums .. 234

 Create New Albums ... 236

 Hide Albums ... 240

 Delete or Rename Albums ... 242

 Delete Images from Albums .. 243

 Sorting Images ... 244

9 Share Pictures via Email with Family and Friends **253**

 Understanding the Pros and Cons of Using Email to Share Photos 254

 Sending Emails That Contain Photos from Your Smartphone or Tablet 255

 Send Images via Your Device's Mail App 256

 Send Photos from Your iPhone or iPad's Photos App 261

 Send Photos from Your Android Device's Gallery App 264

 Emailing from Your Computer 267

 Add Photos to an Email 267

 Sending Images Between Devices 269

 Send Photos with AirDrop 270

 Sharing Photos with Bluetooth (Android Devices) 273

 Sending Photos in Messages 274

10 Sharing Photos Online **277**

 Using Cloud Storage Services 278

 Using Online Photo Sharing Services 279

 Use Flickr.com to Showcase and Share Your Photos 284

 Social Media Services 290

 Getting Started with Facebook 291

 Publish Photos on Your Facebook Wall 292

 Create a Facebook Photo Album 294

 Getting Started with Twitter 296

 Compose a Tweet Featuring Your Photo 296

 Getting Started with Instagram 302

 Publishing Photos on Instagram 304

11 Creating a Digital Diary That Tells a Story **311**

 Understanding the Difference Between a Written and Digital Diary 312

 Getting Acquainted with Digital Diary Software 313

 Create an Entry in Day One 314

 Work with Day One Entries 317

 Using Journal for Windows 319

 Setting Up an Online Digital Diary 321

12 Ordering Prints from Your Digital Images **325**

Finding an App .. 327
Ordering Prints from Your Mobile Device 329
 Order Prints with Kicksend ... 331
Ordering from an Online-Only Photo Lab 338
 Order Prints with the FreePrints App 341
Creating Prints from Your Computer 347
 Ordering from a One-Hour Photo Lab 348
 Ordering from an Online-Only Photo Lab 349
 Order from Apple ... 351

13 Printing Digital Photos from Your Own Printer **355**

Shopping for a Photo Printer ... 356
Understanding Printer Ink and Photo Paper 358
Creating Prints from Your Computer or Mobile Device 359
 Create Prints on Windows PCs 361
 Create Prints on Macs .. 363
 Create Prints Using AirPrint ... 366

**14 Creating Compelling Photo Albums, Scrapbooks,
and Photo Books** **371**

Setting a Strategy for Your Photo Album, Scrapbook, or Photo Book ... 373
Finding the Best Supplies ... 376
Creating a Photo Book Using Your Computer 378
 Getting Acquainted with Blurb 379
 Download the Blurb Photo Book Software 380
 Use the Blurb BookSmart Software 382
Taking the Next Step ... 396

Index **397**

Bonus Material! Two additional chapters, a Glossary, and two articles are available to you at www.quepublishing.com/title/9780789755605. Click the Downloads tab to access the links to download the PDF files.

15 **Creating and Sharing Animated Digital Slide Shows** **3**

 Animated Slide Show Options ..4

 Make Your Slide Show Look Amazing ..4

 Creating Slide Shows from Your Windows PC5

 Start a Slide Show with the Photos App6

 Producing and Sharing Slide Shows from Your Mac7

 Create a Slide Show Using the Photos App8

 Producing Slide Shows on Your Mobile Device13

 Finding Slide Show Tools Online ..13

16 **Backing Up and Archiving Your Digital Photo Library** **17**

 Backing Up Images Using an External Hard Drive18

 Set Up Your PC to Back Up Automatically20

 Set Up Your Mac to Back Up Automatically24

 Backing Up Your Smartphone or Tablet26

 Finding Online Backup Solutions for PC or Mac27

 Set It Up, But Don't Forget It ...31

Glossary **32**

Bonus Articles **Using Optional Photo Editing and Enhancement Apps**

 Optional Photo Editing Software Options for PCs and Macs

About the Author

Jason R. Rich (www.jasonrich.com) is an accomplished author, journalist, and photographer, as well as an avid traveler. Some of his recently published digital photography-related books include *iPad and iPhone Digital Photography Tips and Tricks* (Que), *How to Do Everything Digital Photography* (McGraw-Hill), *My GoPro Camera* (Que), and now *My Digital Photography for Seniors* (Que).

For publication in late 2015, Jason R. Rich is writing *iPhone and Apple Watch Fitness Tips and Tricks* (Que). He recently created and produced the *Managing Your Information Using Evernote* and *Using Your GoPro Hero3+: Learn To Shoot Better Photos and Videos* video courses, and has written numerous other books about the iPhone, iPad, interactive entertainment, and the Internet.

Jason's photography work continues to appear with his articles published in major daily newspapers, national magazines, and online, as well as in his various books. He also works with professional actors, models, and recording artists developing their portfolios and taking their headshots, and continues to pursue travel and animal photography.

Through his work as an enrichment lecturer, he often offers digital photography workshops and classes aboard cruise ships operated by Royal Caribbean, Princess Cruises Lines, and Celebrity Cruise Lines, as well as through Adult Education programs in the New England area. Please follow Jason R. Rich on Twitter (@JasonRich7) and Instagram (@JasonRich7).

About AARP and AARP TEK

AARP is a nonprofit, nonpartisan organization, with a membership of nearly 38 million, that helps people turn their goals and dreams into *real possibilities*™, strengthens communities, and fights for the issues that matter most to families such as healthcare, employment and income security, retirement planning, affordable utilities, and protection from financial abuse. Learn more at aarp.org.

The AARP TEK (Technology Education & Knowledge) program aims to accelerate AARP's mission of turning dreams into *real possibilities*™ by providing step-by-step lessons in a variety of formats to accommodate different learning styles, levels of

experience, and interests. Expertly guided hands-on workshops delivered in communities nationwide help instill confidence and enrich lives of the 50+ by equipping them with skills for staying connected to the people and passions in their lives. Lessons are taught on touchscreen tablets and smartphones—common tools for connection, education, entertainment, and productivity. For self-paced lessons, videos, articles, and other resources, visit aarptek.org.

Dedication

This book is dedicated to my family and friends, including my niece, Natalie, and my Yorkshire Terrier, named Rusty, who is always by my side as I'm writing.

Acknowledgments

Thanks once again to Laura Norman and Greg Wiegand at Que for inviting me to work on this project and for their ongoing support. I would also like to thank Todd Brakke, Kristen Watterson, and Tonya Simpson for their ongoing assistance, and offer my gratitude to everyone else at Que whose talents helped to make this book a reality.

We Want to Hear from You!

As the reader of this book, *you* are our most important critic and commentator. We value your opinion and want to know what we're doing right, what we could do better, what areas you'd like to see us publish in, and any other words of wisdom you're willing to pass our way.

We welcome your comments. You can email or write to let us know what you did or didn't like about this book—as well as what we can do to make our books better.

Please note that we cannot help you with technical problems related to the topic of this book.

When you write, please be sure to include this book's title and author as well as your name and email address. We will carefully review your comments and share them with the author and editors who worked on the book.

Email: feedback@quepublishing.com

Mail: Que Publishing
 ATTN: Reader Feedback
 800 East 96th Street
 Indianapolis, IN 46240 USA

Reader Services

Visit our website and register this book at quepublishing.com/register for convenient access to any updates, downloads, or errata that might be available for this book.

Take, view, edit, and share
photos using your mobile
device (viewfinder).

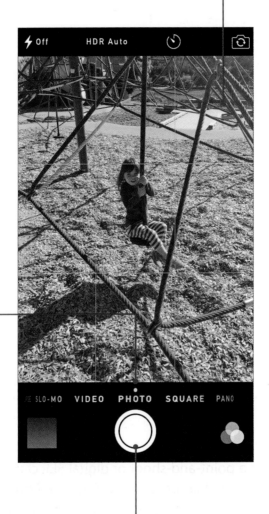

⚡ Off HDR Auto ⏱ ◎

Photo mode —

SLO-MO **VIDEO** **PHOTO** **SQUARE** PANO

iPhone camera app shutter button

In this chapter, you'll learn some of the basic information needed to ultimately take awesome photos using your mobile device, including

→ What equipment and apps you need
→ When and where you can snap digital photos
→ What you can do with the images after you take them

Getting Started with Digital Photography Using Your Mobile Device

You probably know that the smartphone or tablet you carry around with you to make and receive calls is capable of handling many additional tasks. Chances are you already use it for some of these purposes, up to and including taking photos. In many ways, the technology built in to these small devices is similar to the technology built in to a notebook or desktop computer.

If you'll be using a point-and-shoot or digital SLR camera to take pictures, skip over to Chapter 3, "Improving Your Photography Skills," to learn some digital photography shooting techniques that will help you take better photos.

Refer to the owner's manual for your camera to learn how to operate it, because every camera make and model is different. Alternatively, to watch free videos that can teach you how to use your particular camera, visit YouTube (www.youtube.com), and in the Search field, enter the exact make and model of your camera.

Whether you use an Apple iPhone or iPad, have invested in a smartphone or tablet that operates using the Android operating system, or own a mobile device that operates using the Windows Mobile operating system, all these devices can handle a wide range of tasks from virtually anywhere.

Of all the features and functions your device likely has, its digital camera is by far one of its most useful and fun pieces of technology. In fact, some smartphones and tablets actually have two separate cameras built in to them—one in the front and one in the back. Depending on which app you use to operate these cameras, they can be used to make and receive video calls, shoot video, or take digital photos.

Shown here is the front of an iPhone 6, which has a tiny camera located in the top-center of the device.

The back of the iPhone 6 also has a camera, along with a flash, which is shown here.

Front-facing camera

Rear-facing camera and flash

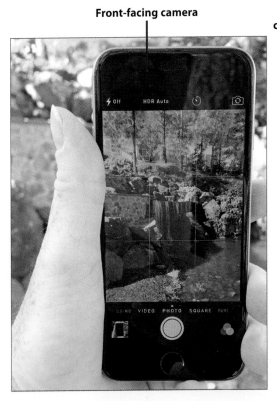
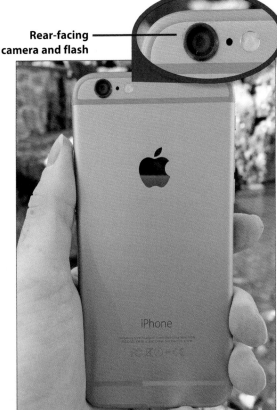

The location of the cameras is similar on most smartphones and tablets. Shown here are the front and back of the popular Samsung Galaxy Note 4 (an Android-based smartphone), for example, with the location of the device's two built-in cameras pointed out.

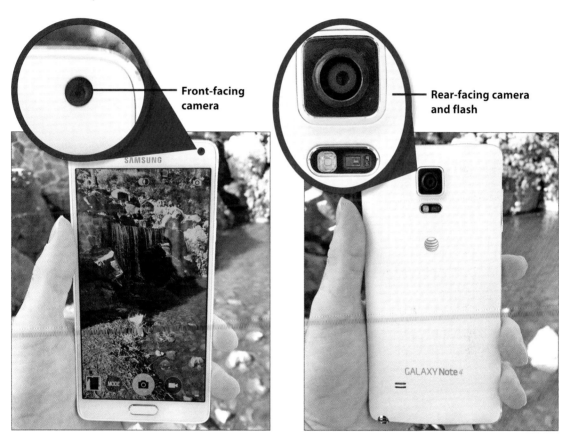

To use your mobile device as a digital camera, you need to utilize a camera app. Although you can download different camera apps, your phone comes with one out of the box, too. This app controls the camera and provides most of the same features and functions built in to a standalone point-and-shoot digital camera. Thus, you can take digital photos using your smartphone or tablet, and those photos are automatically saved within the internal storage of your mobile device.

Use the Camera App to Snap Photos

On the iPhone, iPad, or Android device the camera app is aptly called Camera.

The Camera app icon is displayed here on the device's Home screen.

iPhone's Camera app icon

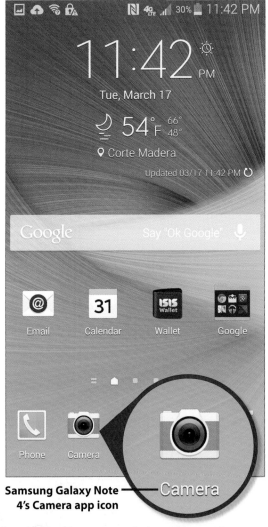

Samsung Galaxy Note 4's Camera app icon

The Camera app icon is shown on the right on the Samsung Galaxy Note 4's screen.

Once digital images (your photos) are stored within your mobile device, you can use a different app to view, edit, enhance, print, share, or archive them, or transfer your images to your computer to handle some or all of these tasks. On an iPhone or iPad, for example, the Photos app is used for these digital photography-related tasks.

The camera and photo management apps required to transform your mobile device into a feature-packed digital camera come preinstalled on your smartphone or tablet and are ready to use.

Shown here is the iPhone's Photos app with an image pulled up and ready to edit.

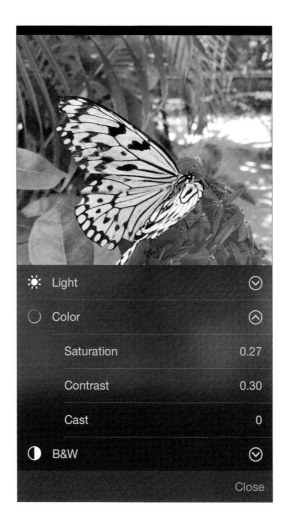

From the app store that supports your particular mobile device, you'll discover dozens, possibly hundreds, of additional third-party apps that provide many additional features and functions for taking, viewing, editing, enhancing, printing, sharing, and storing digital images.

>>>Go Further

APPS TO ENHANCE YOUR DEVICE'S PHOTOGRAPHY CAPABILITIES

Your Internet-enabled iPhone or iPad can easily connect to the online-based App Store, operated by Apple. Here, you'll discover more than 1.5 million third-party apps that can be used to expand the features and functions offered by your mobile device.

The App Store app contains a Photo & Video category, which offers thousands of third-party apps that either can be used instead of the Camera and Photos apps that come preinstalled within your iPhone or iPad, or can be used with these two powerful apps to greatly expand the digital photography capabilities of your smartphone or tablet.

Likewise, if your mobile device operates using the Android operating system, Google Play's Android Market app store offers many third-party digital photography-related apps, as does the Windows Store, which supports Windows Phone devices. You learn more about how to find, download, and install these optional digital photography apps in Chapter 5, "Viewing, Editing, and Enhancing Photos on Your Mobile Device."

Digital Photography Is Both a Skill and an Art Form

Digital photography, which is the process of taking pictures using any type of digital camera, is both a skill and an art form. Taking digital photos using the camera built in to your mobile device and then managing them from your smartphone or tablet requires skill.

These aren't difficult skills to obtain. You must understand how to operate your mobile device, which is like a computer. It's important to know exactly which buttons to press, which onscreen icons to tap, and which app-specific features and functions to use to take the best possible pictures in each shooting situation you encounter.

You then need to know how to access the images stored within your mobile device to view, edit, enhance, print, share, transfer, and/or archive them, for example.

The art form aspect of digital photography relates to the creative decisions you ultimately make during the picture-taking process. For example, it's up to you to choose your subject (the focal point of your photo), plus decide where, when, and how to take each photo.

It's necessary to frame each of your shots to best utilize lighting, and take advantage of other appropriate camera-related features and functions so that your photos turn out clear, in focus, and ultimately visually interesting.

My Digital Photography for Seniors covers both the skill and the art form aspects of digital photography. So, by the time you're finished reading this book, you'll understand exactly how to use your mobile device to take eye-catching digital photos, edit and enhance them, and then share or manage them, either directly from your smartphone or tablet or after transferring the digital images (your photos) to your computer.

To make this whole process easier to understand, we focus on the skill aspect of digital photography first. So, starting in Chapter 2, "Taking Amazing Pictures with Your Smartphone or Tablet," you learn how to operate the one or more cameras built in to your mobile device to take photos. Separate step-by-step directions are offered for iOS and Android-based mobile devices, so it's important to first determine what kind of mobile device you'll be using to take pictures.

Some Digital Photography Basics

Before acquiring your first digital camera, you were probably accustomed to taking photographs using a film-based camera. After you shot a roll of film, which allowed for 12, 24, or 36 exposures, it was necessary to have that film developed into prints by a photo lab. Times have changed. Digital cameras do not require film, and instead of being limited to 12, 24, or 36 exposures, you're limited by the storage capacity of your smartphone or tablet, which can be anywhere from a few dozen to several thousand digital images (if you're using a newer and higher-end smartphone or tablet).

Be Less Frugal When Taking Digital Pictures

Unlike when using a film-based camera, as soon as you snap a photo, you can preview it on your mobile device's screen. If you don't like it, delete the image and retake the same (or a similar) shot. Plus, because your mobile device can potentially store thousands of photos, you can be much less frugal in deciding when to take pictures, or what to take pictures of. Ultimately, you can delete the images you don't like later.

Some of the same photography principles you used when taking pictures with a film-based camera, however, still apply when it comes to taking digital photographs, but there are some major differences as well.

For example, because digital photography requires no film, when you take a photo using the camera built in to your smartphone or tablet, each image gets saved as a digital file within the internal storage of your mobile device. Because the image is stored digitally, like a word processing document or a spreadsheet file, for example, the digital camera can add information to that digital file as it gets saved. This additional information is called *metadata*.

Making Photos More Useful with Metadata

Each time you take a digital photo, that file automatically receives its own unique filename. Initially, your smartphone or tablet assigns a sequential filename that can include letters and numbers, such as IMG_1234. Later, you can edit this

filename to be something more recognizable, such as "Rusty's 10th Birthday." How to rename images is covered later in this book. For now, just understand that each image has its own unique filename and is stored as a separate file within your mobile device.

The digital camera also automatically records the time and date each photo is taken. Plus, depending on how you set up the camera app you're using to take photos, additional information can be stored with each digital image file, including exactly where the photo was taken.

Your mobile device has built-in GPS or Location Services capabilities. Thus, when you take a photo, the camera can determine exactly where you are and store this information with your image. This feature is called *geo-tagging.*

Then, during the photo viewing, editing, and sharing process, as the digital photographer, you can later add additional information to the image, including a caption, keywords that describe the image, and the names of the people who appear within the image (if applicable). When you add names to a photo, this is referred to as *tagging* the image.

All this metadata makes it much easier to later organize and locate your images, because each piece of metadata becomes searchable. After you amass a personal image library that contains hundreds or thousands of images, you can quickly find specific photos by performing a search based on filename, time/date, location, keyword, the contents within a caption, or by the names of people who appear in your photos, for example.

And, just like with other types of digital files, like word processing documents or spreadsheet files, for example, you can sort and organize your digital images into separate folders or albums. Plus, you can share individual photos, groups of photos, or entire albums with others in a variety of ways, either directly from your mobile device or after transferring your images to your computer.

As you can see on the next page on the iPhone that's running the Photos app, it's possible to sort your images into various albums. You can give each album its own custom name for easy identification.

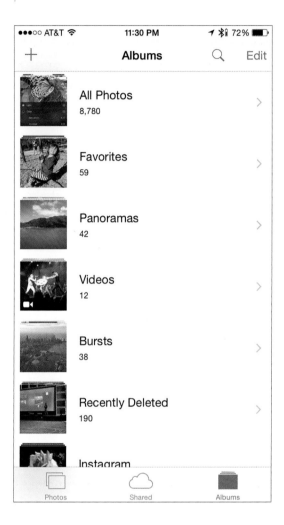

The digital image, along with its metadata, becomes a single digital file, which is initially saved within the internal storage of your mobile device. How much storage space each image requires depends on several factors, including the photo's resolution.

Thus, if you have a mobile device with 8GB, 32GB, 64GB, or even 128GB of internal storage, each time you snap a photo, the image's digital file takes up a portion of that space. The image remains there until you move or delete it.

Some Mobile Devices Use Memory Cards for Content Storage

Some smartphones and tablets enable you to store content on removable memory cards in addition to (or instead of) utilizing the device's internal storage. Depending on the capacity of a memory card, it can add additional space to hold thousands of digital image files.

It's important to remember that it's not just your photos competing for your phone's available storage. If you opt to also store apps, HD videos, TV shows, movies, many email or text messages, music, document files, and other content that has large file sizes associated with it, the remaining storage space available for your digital photos will be greatly diminished.

If you wind up filling up your mobile device's internal storage with digital photos and/or other content, you simply need to transfer or copy images stored within your mobile device to a computer or online service, and then delete the images from your smartphone or tablet to free up space.

Contrary to what some people believe, it is *not* necessary to go out and buy a new smartphone or tablet when your existing device's internal storage gets filled up.

Creating Space

In addition to removing images when storage space runs low, consider deleting other content from your device, such as apps that you don't use or content you no longer need. How to do this is explained in Chapter 4, "Transferring Photos To Your Computer."

Not All Digital Cameras Are Alike

The image quality you wind up with when taking a photo using a digital camera depends on a number of factors, including the camera's resolution. When it comes to digital photography, resolution is measured in megapixels.

A *pixel* is one tiny, colored dot. A *megapixel* is comprised of one million pixels. Thus, when the camera built in to your mobile device boasts a five-megapixel

resolution, this means that each individual photo is comprised of five million separate colored pixels.

The higher a digital camera's resolution, the more pixels it utilizes and showcases within each image, and the more detailed and vibrant your photos will be. It's important to understand that the front- and rear-facing cameras built in to your smartphone or tablet, in most cases, do not offer the same resolution.

The rear-racing camera almost always offers a significantly higher resolution, so this is the camera you'll want to utilize most of the time when taking digital photos. The lower-resolution, front-facing camera can be used for taking "selfies," but it's primarily designed to be used when taking part in video calls, for example, where resolution is less important than when taking digital pictures.

>>>*Go Further*

A "SELFIE" IS A PHOTO YOU TAKE OF YOURSELF

When you use the front-facing camera built in to your smartphone or tablet, you can hold up the camera and point it toward yourself to take a picture of yourself and whatever is behind you. As you take the photo, you can frame your shot using the viewfinder displayed on your smartphone or tablet's screen. Anytime you use this front-facing camera to snap a photo of yourself (and the people you're with), this is called a *selfie*.

It's common for people to share selfies online using social media services, such as Facebook, Twitter, or Instagram, which you learn more about in Chapter 10, "Sharing Photos Online."

An alternative method for taking a selfie is to stand in front of a mirror, and then use the rear-facing camera built in to your smartphone or tablet to snap a photo of your reflection. This results in a higher resolution image, but it's much harder to take a well-composed, visually interesting image this way.

Because taking selfies has become a popular pastime, people have discovered all sorts of creative ways to capture themselves in digital images, using funny poses or unusual camera angles, for example.

To make framing your selfie shots easier, many people attach an optional "selfie stick" to their smartphones. This is a pole-like accessory that can be purchased for less than $30.

The Main Steps Involved with Digital Photography

Because most people carry around their smartphone just about everywhere, digital photography using your mobile device is a convenient and popular activity, and it's a relatively simple task.

What gets a little more confusing is all the things you can do with your digital images once they've been shot and are stored within your mobile device.

An Overview of Picture-Taking

The following are the basic steps involved with digital photography using your mobile device. These procedures are covered in greater detail throughout this book.

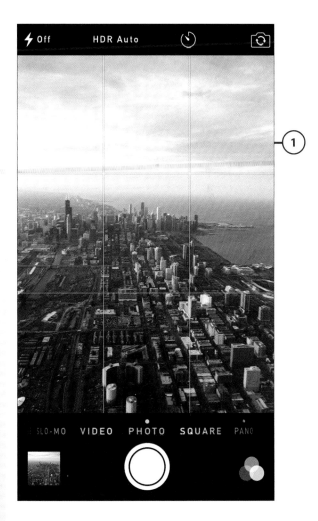

1. **Take some photos**—To take pictures using the camera built in to your smartphone or tablet, launch the camera app. Use the camera app built in to your mobile device (or a third-party app) to control the camera and snap photos. Chapter 2 covers how to take pictures using your smartphone or tablet.

Start with a Fully Charged Battery

Battery power on a smartphone is a precious resource because everything you do with it, especially operating the camera, draws power from it. It's always a good idea to begin your day with a fully charged battery, so when you want to take pictures, you have the power to do so. If you're traveling and plan to spend the day sightseeing, you do not want your smartphone or tablet's battery to die halfway through your day, or you might miss out on awesome photo opportunities.

(2) **View and manage your photos on your mobile device**—Using a separate app, it's possible to view, edit, enhance, print, and share your photos, as well as organize them, and/or group them together into albums. This can all be done from your mobile device.

(3) **Edit and enhance your
photos**—As you're viewing your
photos on your mobile device's
screen, it's possible to edit and
enhance them before sharing
them or creating prints from
them. There are several approach-
es you can take when it comes
to editing or enhancing your
photos. For example, use a one-
tap image filter to add a special
effect to the image, or use spe-
cific image editing tools to alter
one aspect of an image, such as
its contrast, color saturation, or
brightness.

**This is the Image
Straightening tool offered by
the iPhone/iPad's Photos app.**

>>>*Go Further*

ALTERING THE APPEARANCE OF IMAGES

Using the editing and image enhancement tools of the photo editing app you use on your smartphone or tablet, it's possible to dramatically improve or alter the appearance of a digital photo, often within less than one minute and with just a few onscreen taps.

Chapter 5 discusses how to edit and enhance your digital images while they're stored in your mobile device. You can also edit and enhance your photos using photo editing software on your computer or using software included in an online-based photo sharing service. You learn about these options in Chapter 6, "Viewing, Editing, and Enhancing Photos Using Your Computer," and Chapter 10.

(4) **Share your photos**—Because your smartphone or tablet is capable of connecting to the Internet, you can use email, text messaging, or a social media service (like Facebook, Twitter, or Instagram) to share your photos with others. You can also upload your images from your mobile device to an online-based photo sharing service, such as Flickr.com or Shutterfly.com. Some of your options for sharing your photos via the Internet are covered in Chapter 10. The Share menu of the Photos app running on an iPhone is shown here.

What It Means To Upload and Download Content

If you send a file, such as a digital image, from a smartphone, tablet, or computer to the Internet, this is referred to as *uploading*. When you use your mobile device or computer to access the Internet to retrieve content, such as a digital image, this is referred to as *downloading* the content. Downloaded content then gets stored in the computer or device's internal storage, for example.

(5) **Transfer your photos—** Ultimately, you want to transfer your digital images from your mobile device and store them elsewhere—either on your computer or on an online service, for example. Chapter 4 and Chapter 10 cover these options (not pictured here).

(6) **Create prints from your photos—**In addition to viewing and sharing your digital photos in their digital form, by looking at them on a mobile device or computer screen, you can do much more with those digital image files. For example, you can have traditional prints created in a wide range of sizes. Chapter 12, "Ordering Prints from Your Digital Images," explains exactly how to do this. One option is to use the Kicksend app (shown on an iPhone) to upload images to a local one-hour photo lab. By the time you drive to the lab, your ordered prints will be ready for pickup.

>>>Go Further

CREATE PRINTS, PHOTO BOOKS, OR ANIMATED SLIDE SHOWS

Using a home photo printer, a local one-hour photo lab, or an online-based professional photo lab, you can easily create prints from your digital images. Beyond that, it's possible to create one-of-a-kind, professionally printed and bound photo books, or showcase a group of your images in the form of an animated digital slide show, which can be viewed on a computer, via the Internet, or on a television screen. How to do all this and more is covered later in this book.

Start Taking Photos

People love taking pictures to chronicle memorable moments in their life and potentially share their experiences with others. In fact, on Facebook alone, more than six billion new images are uploaded every month. Thanks to the fact that the smartphone or tablet you already carry with you has a camera built in, you no longer need to remember to take your separate point-and-shoot or digital SLR camera out and about with you to take great-looking pictures.

The digital photography technology built in to most smartphones and tablets is now as good as many consumer-oriented point-and-shoot digital cameras. So, once you learn how to use this technology, you can take photos as you go about your everyday life, travel, or spend time with family and friends.

Plus, from this book, you'll develop an understanding of how to receive digital photos from friends and family using the Internet and your smartphone, tablet, or computer, so that you can easily obtain or access photos of your children and grandchildren, for example.

It's Not All Good

Don't Toss Out Your Point-and-Shoot Camera Just Yet

Although the camera built in to your mobile device is powerful, a higher-end, standalone, point-and-shoot camera might still offer a higher shooting resolution, a better-quality lens, and more powerful zoom capabilities. For travelers especially, there are benefits to leaving your phone safely in your bag (or stateroom) and using a less-expensive point-and-shoot camera that you don't mind risking by exposing it to the elements. This is to say nothing of theft. Should someone steal your point-and-shoot camera you may lose some treasured photos, yes, but that likely pales in comparison to the volume of personal information you would lose if someone stole your phone!

You can still use your point-and-shoot digital camera to take pictures, and then transfer those images from the camera's memory card to your mobile device or computer to view, edit, enhance, print, share, and/or store them.

What you're about to discover is that digital photography is fun, and it enables you to express yourself creatively. Just because you might feel a bit apprehensive about using modern technology (which is understandable), this should not stop you from learning to use your smartphone or tablet to take, view, edit, enhance, print, and share digital photos. This book walks you through all these digital photography-related tasks, using easy-to-understand, nontechnical language.

It's Not All Good

Adjust Privacy Settings Before Sharing Photos Online

Don't worry, there are few mistakes you can make when learning to take pictures with your smartphone or tablet that have any meaningful consequences, so don't be afraid to experiment.

When it comes to sharing photos via the Internet and using social media, however, one thing you should be mindful of is that some of these services automatically make your digital images public and viewable by anyone. To prevent this, you'll want to adjust the privacy settings associated with each social media account and online service you use. These settings enable you to determine exactly who will have access to your photos.

Chapter 10 talks more about these privacy issues. Right now, understand that it's important to adjust these privacy settings before you start uploading (sending) photos to the Internet and tagging people in those images.

Every mobile device that has a built-in camera uses a specialized Camera app to take pictures.

In this chapter, you'll learn how to use the Camera app to take pictures with the camera built in to your smartphone or tablet. This includes

→ Ways to launch the Camera app from your smartphone or tablet
→ Using the Camera app to take photos
→ Picture taking features and functions offered by the Camera app

2

Taking Amazing Pictures with Your Smartphone or Tablet

The front- and rear-facing cameras built in to your smartphone or tablet can be used for a variety of purposes, based on which app you use to control them. When you use the Camera app, for example, you're able to take pictures and use a handful of picture-taking features and functions that enable you to control the camera's operation.

Getting back to the concept that digital photography is both a skill and an art form, the skill aspect requires you to understand how to launch and then operate the Camera app that comes preinstalled on your mobile device.

This chapter explains how to use the Camera app that comes preinstalled on the iPhone and iPad and on Android-based mobile devices.

Attention Point-and-Shoot or Digital SLR Camera Users

If you'll be using a point-and-shoot or digital SLR camera to take pictures, skip over to Chapter 3, "Improving Your Photography Skills," to learn some digital photography shooting techniques that will help you take better photos.

Refer to the owner's manual for your camera to learn how to operate it, because every camera make and model is different. Alternatively, to watch free videos that can teach you how to use your particular camera, visit YouTube (www.youtube.com), and in the Search field, enter the exact make and model of your camera.

Launching the Camera App on Your Mobile Device

Regardless of what model smartphone or tablet you're using, if the device has one or more built-in cameras, it also comes with a specialized app that enables you to control the camera(s) to take pictures. So, when you're ready to snap some photos, the first step is always to launch the Camera app. To make this really convenient, each type of mobile device offers several ways to launch this particular app. The primary way of doing so is from its Home screen.

You Need to Unlock Your Device...Eventually

One method for launching the Camera app on your smartphone or tablet is to do so from the device's Lock screen. This option can save you a few seconds because you won't need to first unlock the device, access the Home screen, and then launch the Camera app to snap a photo. You can simply launch the Camera app from the Lock screen.

Without first unlocking the device, you can take pictures and preview the last image you shot. However, to do just about anything else with your smartphone or tablet, you must first unlock it.

Launch the Camera App on iOS

To launch the Camera app from the iPhone or iPad's Home screen, follow these steps:

(1) From the Lock screen, swipe your finger from left to right across the screen when the Slide To Unlock message appears.

Passcodes
You might need to enter your passcode or allow the TouchID sensor to scan your fingerprint to continue.

Another Way to Launch the Camera App
From the Lock screen, place your finger on the Camera icon and swipe up. This will quickly launch the Camera app.

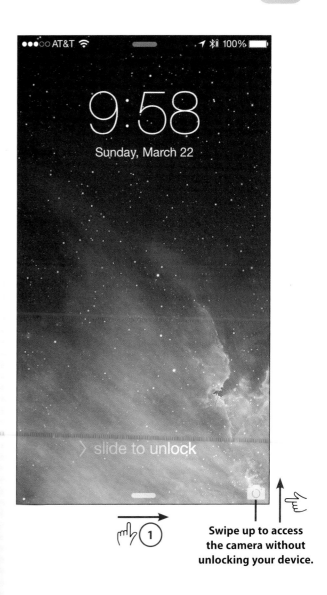

Swipe up to access the camera without unlocking your device.

(2) Upon unlocking the device, the Home screen is displayed. However, if you're currently using another app on your iPhone or iPad, to return to the Home screen, simply press the Home button at the bottom of your device.

(3) From the Home screen, tap on the Camera app icon to launch the Camera app and begin taking pictures.

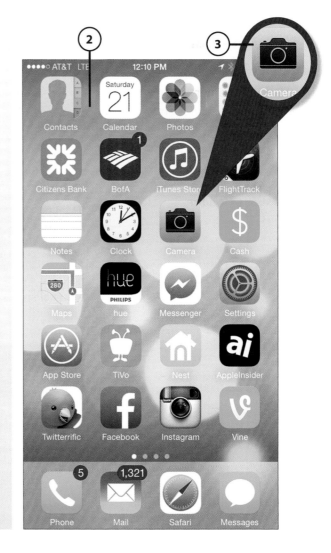

>>>Go Further
USING THE CONTROL CENTER

If you swipe up from the bottom of your phone's display you can access the iPhone or iPad's Control Center. This set of controls gives you fast access, even from the Lock screen, to some often-used features of your device, including the Camera app. Just tap the Camera icon that appears on the screen.

Launch the Camera App on Android

To launch the Camera app from your Android-based smartphone or tablet's Home screen, follow these steps (shown here on a Samsung Galaxy Note 4):

(1) Swipe left on the phone's Lock screen, where it says Swipe Screen to Unlock.

Another Way to Launch the Camera App

From the Lock screen, tap your finger on the Camera icon that appears in the lower-right corner. This will quickly launch the Camera app.

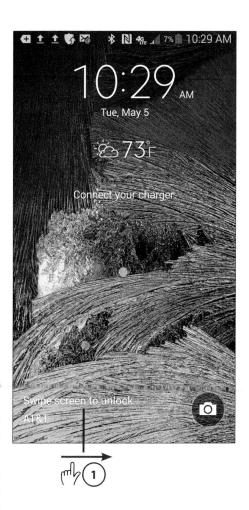

(**2**) Make sure you are located at your device's Home screen. If not, press the Home button on the device.

(**3**) Tap on the Camera icon displayed on the Home screen or the Apps screen.

Launch the Camera App from the Apps Screen

From the Apps screen on your Android mobile device, you can also swipe horizontally right-to-left or left-to-right until you see the Camera app icon, and then tap on it.

Understanding Popular Camera Features and Functions

Regardless of whether you're using an iOS- or Android-based smartphone or tablet, once you launch the camera app that comes preinstalled on your device, the app works pretty much the same way to control the camera, although the appearance of command icons and their locations on the screen vary.

Displayed in the main area of the screen is your viewfinder. If the default rear-facing camera is active, what you see in the viewfinder is what the camera's lens will capture.

What You See Is What You Get

Whatever you see in the viewfinder is what ultimately appears in your photo. By moving around your mobile device and using the camera app's zoom feature (explained shortly), it's your job as the photographer to frame each of your shots to best showcase your intended subject.

Framing your shot includes positioning your subject within the viewfinder (frame), choosing the best shooting angle and perspective, and then making sure your subject is well lit and in focus. In addition to creative decisions, it's important that you have the camera's settings adjusted properly for the shooting situation at hand.

Along the top, bottom, or sides of the viewfinder, based on which type of device you're using, are a handful of command icons for controlling the camera's operation.

This section explains some of the most popular features and functions built in to the Camera app that comes preinstalled on most smartphones and tablets. Later in this chapter, you learn exactly how to use each of these features and functions on your smartphone or tablet.

Ultimately, as the photographer, you must decide which camera features and functions will work best to capture the ideal shots in each shooting situation you encounter. These decisions are based on shooting challenges you might encounter, as well as the creative shooting approach you adopt for each shot.

Use the Shutter Button to Snap a Photo

The large round icon that appears in the bottom-center of the screen on most smartphones is your Shutter button. On some tablets, the Shutter button is displayed along the right side of the screen.

Once you've adjusted all your camera's settings, when you're ready to take a picture, simply tap on this Shutter button to snap a single photo. In this example, the Camera app is running in an iPhone 6.

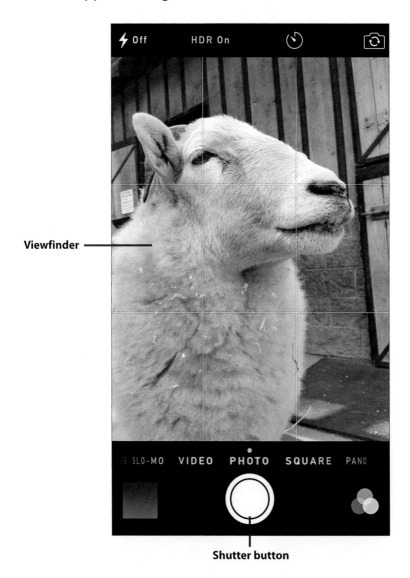

Viewfinder

Shutter button

As you press the Shutter button to snap a photo using your smartphone or tablet, it's essential that you hold the mobile device steady. This is particularly important when shooting in low light situations or when using the zoom feature. Any shaking or sudden movement on your part (as the photographer) typically results in a blurry image.

If necessary, consider using a stand or tripod to position your mobile device, and then hold it firmly in place when snapping photos. If you opt to hold the device in your hand(s), try locking your elbows in place, and/or leaning against a solid object, such as a wall or fence, to help steady your hands.

Steadying Breaths

Some people find it beneficial to briefly hold their breath for the second or two that it takes to press the Shutter button. This helps to steady shaky hands and prevent fuzzy photos.

Working with Autofocus Sensors

The Camera app that comes preinstalled on iOS and Android devices all have face detection technology built in. So, anytime your camera identifies one or more people in your photos, an autofocus frame appears around each face. This means that the camera is focusing on the face(s), and that's what will be in focus.

However, when people are not the main subject of your photo, it's your responsibility to control the autofocus sensor(s). To do this, as you're looking through the viewfinder, tap on your intended subject. An autofocus sensor will be displayed, typically in the center of the screen as in this image from an Android phone.

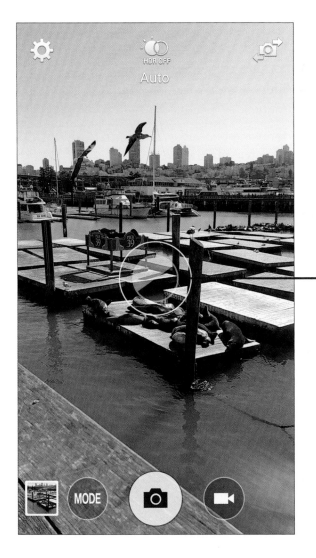

Autofocus sensor

You can tell the camera exactly where to focus by tapping on a subject within the viewfinder (on the device's screen). Otherwise, the camera app will guess and could easily make the wrong decision. Activating the autofocus sensor is particularly important when your intended subject is surrounded by other objects. Whatever the autofocus sensor focuses on is what will appear the most in focus in each of your shots.

Zoom In on Your Subject

There are three ways to zoom in on your subject. The first involves physically moving closer to your subject as you're framing your shots and taking pictures. An easier method, however, is to use the zoom feature built in to the Camera app.

As you're looking at the viewfinder, perform a finger pinch gesture on the screen of your mobile device to activate and control the zoom. In some cases, like on the iPhone (shown on the next page) or iPad, a zoom slider appears. You can either adjust the intensity of the zoom using a pinch or reverse-pinch finger gesture, or place a finger on the dot that's displayed along the zoom slider and move it to the right to zoom in or to the left to zoom out as you're framing your shots.

Another Zoom Control Option for Android Mobile Devices

If you're using an Android-based mobile device, from the Camera app's Settings menu, it's possible to set the Volume Up and Volume Down buttons so that they control the camera's virtual zoom feature. You learn how to do this later in this chapter.

Each of these photos shows the same subject, with the camera (in this case, an iPhone) physically positioned in exactly the same place relative to the subject but a different zoom intensity used when taking each shot.

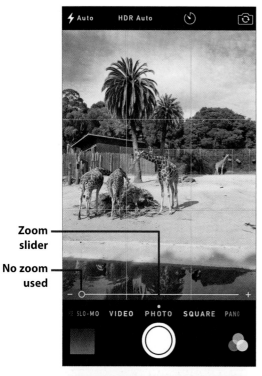

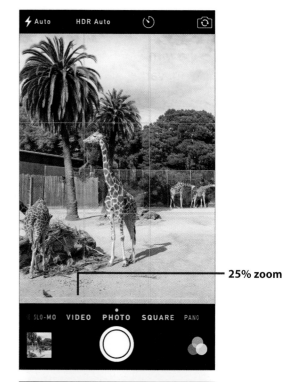

Zoom slider

No zoom used

25% zoom

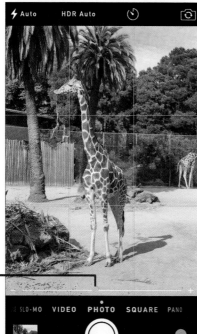

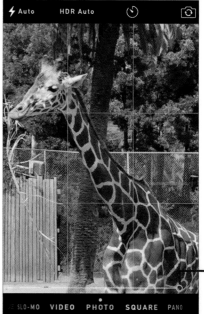

Approximately 50% zoom

100% zoom

In many shooting situations, you cannot physically get as close to your intended subject as you would like. In these situations, use the zoom. The strength of the zoom, or how much closer you can virtually get to your subject without physically moving, varies between smartphone and tablet models.

A third way to zoom in on a subject is after the picture is taken. While you're editing the photo, use the Crop tool offered by your photo editing app or software to reframe your image and zoom in on your subject.

Zoom In on Your Subject After the Photo Is Shot

How and when to use the Crop tool to edit a photo is covered in Chapter 5, "Viewing, Editing, and Enhancing Photos on Your Mobile Device," and Chapter 6, "Viewing, Editing, and Enhancing Photos Using Your Computer."

Burst Mode Is Perfect for Capturing Action

Instead of taking a single photo each time you press the Shutter button, by holding down the Shutter button your camera can capture multiple shots per second in quick succession. If your smartphone or tablet supports this feature (which the iPhone and the newer iPad models do, for example), how many shots per second can be taken varies based on the model of your smartphone or tablet, but it's typically between 3 and 12 images per second.

The following 4 shots were among the collection of 67 shots taken of a moving subject by pressing and holding down the Shutter button for about 6 seconds.

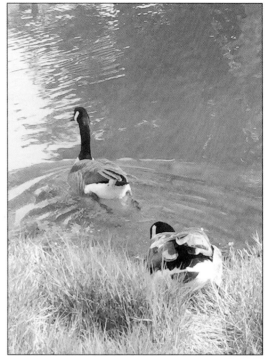

Using the Burst mode is ideal for taking pictures of a fast-moving subject, when perfect timing is essential. Instead of trying to tap the Shutter button at exactly the right moment, press and hold down the Shutter button for several seconds before and after the subject's motion that you want to capture happens.

You'll wind up with many shots, but you can then pick the one taken at exactly the right moment and discard the rest. Images taken even a fraction of a second apart often look very different.

Burst and Continuous Mode Are the Same

Although the iPhone and iPad refer to this feature as Burst mode, on an Android smartphone or tablet, it's called Continuous mode. Depending on the device you are using, you might need to turn on this setting in your camera settings.

Shed Light on Your Subject Using a Flash

Virtually all smartphones and some tablet models have a built-in flash that enables you to shine additional light on your subject as you're taking a photo in a low-light situation. (The iPad tablet does not have a built-in flash, but the Samsung Galaxy Tab S, for example, does.)

The tiny flash built in to your mobile device has a limited range. If you're too close to your subject (within about 2 feet), as you take a photo using the flash, the subject will turn out overexposed, because too much light is captured. As a result, your subject will look washed out, there will be little color detail, and the red-eye effect will most likely appear in a subject's eyes.

If you're too far away from your subject (more than 8 to 10 feet), too little light from the flash will reach your subject, and the subject will be underexposed or appear too dark in your photos.

Thus, you need to determine the best distance to be from your subject, based on the flash within your particular mobile device, and use the flash to add additional light only when it's needed.

When taking pictures with your mobile device, the flash typically has three settings—On, Off, and Auto. By tapping on the Flash command icon displayed in the Camera app, you can adjust its setting.

When turned on, the flash always activates when you take a photo, regardless of the lighting situation. When turned off, the flash is never used. When the Auto option is selected, the camera measures the available light each time you're about to take a photo, and the camera automatically determines when and if the flash is needed.

It's Not All Good

The Flash Won't Always Improve Your Photos

In more shooting situations than not, the tiny flash built in to your mobile device will not improve your photos. Even in low-light situations, you'll wind up with better shots if you instead use the HDR (High Dynamic Range) or Rich Capture feature built in to the camera app and forego using the flash altogether. If you have Windows Mobile, this mode is called Rich Capture.

In Chapter 3, you learn more about situations where the flash can be beneficial, but if you want to maintain the authenticity of ambient colors within your shots, particularly in low-light situations, such as when taking a photo during a romantic candlelight dinner or in front of a fireplace, consider using HDR mode instead of the flash.

If used incorrectly, the flash's burst of light that emanates from the camera directly onto your subject will cause unwanted shadows and red-eye, and will often wash out the ambient colors in the scene.

Discover How HDR Mode Can Improve Your Shots

Most smartphones and tablets now offer an HDR (High Dynamic Range) shooting mode that you can turn on as you're shooting from within the camera app you're using.

When turned on, HDR mode takes full advantage of the ambient light where you're shooting. Each time you press the Shutter button to snap a photo, your camera actually takes multiple shots at once, each capturing the available light in a slightly different way. Then, within a fraction of a second, those shots are merged together automatically, into one image.

Particularly when shooting in low light situations, HDR mode enables you to capture more authentic colors in your shots. Often, your images wind up appearing clearer, are more vibrant and contain more detail, with the colors more accurately

depicted, compared to taking the same shot with a flash or without using HDR mode.

In general, if given the option, turn on the HDR Auto option and allow the camera to determine when and if this shooting mode will be beneficial, based on the lighting conditions where you're shooting.

Portrait Versus Landscape Mode

When you hold the smartphone or tablet upright or vertically, this is called Portrait mode, which is shown here.

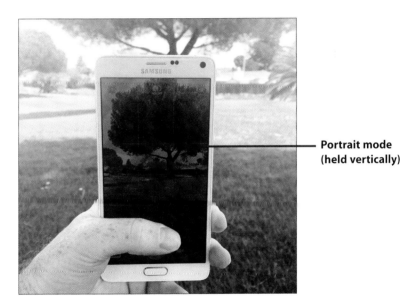

Portrait mode (held vertically)

In terms of digital photography, when your mobile device is held in Portrait mode, you can focus on your intended subject in the viewfinder but little background will be displayed on either side of your subject. Thus, this option is great for taking portraits of people, for example.

When you rotate your smartphone or tablet sideways, so it's held horizontally while you're taking pictures using the Camera app, this is called Landscape mode. As you rotate your device, most or all of the onscreen command icons that relate to the app reposition themselves. For example, your Shutter button is now displayed on the right side of the screen.

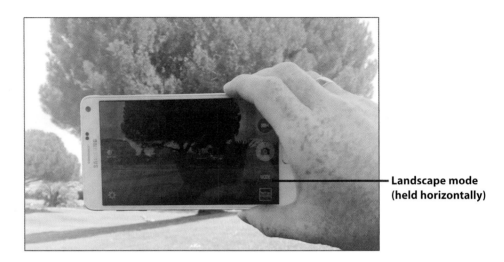

Landscape mode (held horizontally)

Landscape mode is useful for shooting landscapes, cityscapes, or large groups of people, for example, because you're given a wider field of view. Thus, more of what's seen to the sides of and behind your subject is visible.

At any time as you're taking pictures, to switch between Portrait and Landscape mode, simply rotate the camera as you're holding or mounting it.

The Timer and Time Lapse Options Can Be Useful

Typically, when you tap the Shutter button to snap a photo, the picture you want to take is captured almost instantly and then saved. However, when you turn on the Timer feature you delay the picture taking process for a predetermined amount of time.

Thus, you can press the Shutter button, but the camera will wait 3, 5, 10, or 30 seconds, for example, before snapping the photo. If you're using a tripod or stand with your mobile device, this enables you to frame your shot, tap the Shutter button (as the photographer behind the camera), and then move in front of the camera to be included in your photo.

Meanwhile, the Time Lapse feature enables you to press the Shutter button once to make the camera start and continue taking photos at a preset time interval until you tap the Shutter button again to stop the process.

If you set the Time Lapse option to 10 seconds, for example, the camera snaps one photo every 10 seconds until you stop it. Assuming you've mounted the camera in a stable position and don't move it, what you wind up with is a

collection of images that depict the slow movement of your subject over time. Time Lapse images are great for capturing sunrises or sunsets, for example.

Panoramic Shots Are Ideal for Shooting Landscapes

There may be times when you want to capture a vast landscape, city skyline, or a large group of people, where simply rotating the camera to Landscape mode still does not provide an ample field of view to capture the complete scene within a single image.

In these situations, switch your camera to Panoramic mode, if it's available on your smartphone or tablet. You can then pan the camera slowly from left to right (or vertically) as you're taking a photo to capture a very wide scene. What you wind up with is an extra-long panoramic photo, like the one shown on the next page.

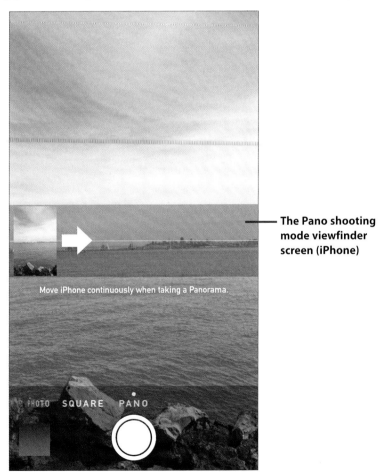

The Pano shooting mode viewfinder screen (iPhone)

Move iPhone continuously when taking a Panorama.

PHOTO SQUARE PANO

As you can see compared to the Landscape shot shown earlier in the chapter, a panoramic image offers a much wider field of view.

Prints Are Possible

Most photo labs or home photo printers can create extra long and narrow prints from panoramic digital images.

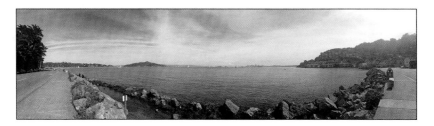

Panoramic shot

An Image Filter Can Dramatically Alter the Appearance of an Image

An image filter is a special effect that can be added to a photo in some cases while you're taking a photo or after the photo has been shot and you're in the process of editing it. An image filter can typically be added with a single tap on the screen, and it impacts the appearance of an entire image.

For example, you can boost the colors of an image, transform a full-color image into black-and-white, or use an effect like Sepia to make a photo look antiquated.

iPhone's Noir
filter selected

The Camera app built in to the iPhone and iPad, for example, has eight filters preinstalled, but you can download additional filters to use with the app. Most photo editing apps offer more than a dozen filter options, as do Facebook, Twitter, and Instagram when you use these apps to edit a photo before uploading it to the service.

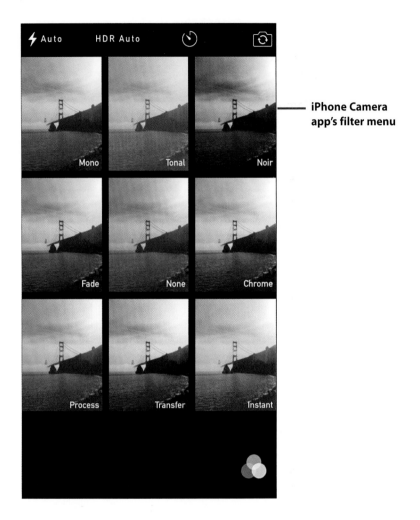

iPhone Camera
app's filter menu

Adjusting the Camera App's Settings Before Taking Pictures

Once the Camera app you're using is launched, and you see the viewfinder and Shutter button on the screen, consider using the app's default settings to quickly begin taking pictures. However, based on your needs for a particular shooting situation, it's possible to easily adjust the app's shooting options by tapping on the various onscreen command icons to use the camera-related features and functions you read about in the previous section.

This section explains how to fully use the Camera app that comes preinstalled on your mobile device.

Take Pictures with Your iPhone or iPad

After launching the Camera app on your iPhone using one of the methods described in the "Launching the Camera App on Your Mobile Device" section found earlier in this chapter, follow these steps to adjust the camera's settings prior to taking photos:

(1) Select a shooting mode by placing your finger on the shooting mode menu displayed above the Shutter button and swiping your finger horizontally. The option displayed in yellow, directly above the Shutter button, is the one that's selected and active. (Note that the Slow-Mo and Video shooting modes are used for shooting HD video with your iPhone or iPad.)

(2) Switch between the front- and rear-facing camera by tapping on the Camera Selection icon displayed in the top-right corner of the screen. The default camera is the rear-facing camera.

(3) To adjust the flash setting, tap on the Flash icon displayed in the top-left corner of the screen. Choose between On, Off, or Auto.

(4) To alter the HDR shooting mode setting, tap on the HDR option displayed at the top of the screen, to the right of the Flash icon. On more recently released iPhone models, choose between On, Off, or Auto. The Auto option is not available on older iPhone models.

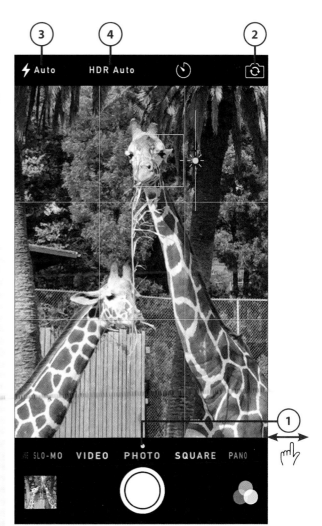

The Difference Between Shooting Modes

Photo shooting mode enables you to capture rectangular-shaped shots and is the shooting mode you'll most likely use 99% of the time.

Square shooting mode automatically crops your images into a square shape. Use this shooting mode if you know you'll be uploading your photos to Instagram. Choose the Pano shooting mode to shoot panoramic shots, or the Time-Lapse mode to shoot a sequence of time-lapse images.

(5) Turn on/off the Timer option, as needed, if you want to delay the camera's response after tapping the Shutter button. Tap on the Timer icon displayed near the top center of the screen, and then choose between the displayed Off, 3 Second, or 10 Second options by tapping on your selection. When you turn on this feature, it is displayed in yellow on the Camera app's main viewfinder screen.

(6) To add an optional Filter to an image, tap on the Filter icon and then select from the available filters. (If you want to remove a selected filter choose the None option in the middle of the display.) Keep in mind that you can always add a filter to the image during the editing process.

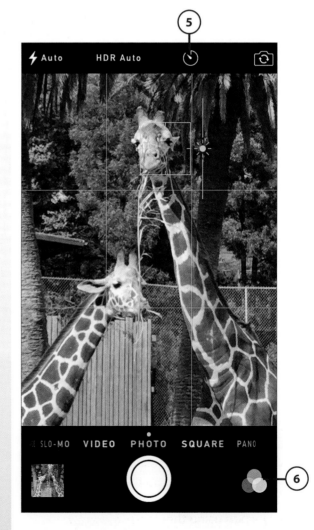

Zooming

To adjust the Zoom feature to get in closer to your subject without physically moving, use a reverse-pinch motion on the screen to activate the zoom feature, and then adjust the zoom's intensity using a pinch finger gesture or the displayed zoom slider.

(7) Tap your subject within the frame to tell the autofocus sensor what subject you want to focus on in the image. (The autofocus sensor automatically detects the faces of people.)

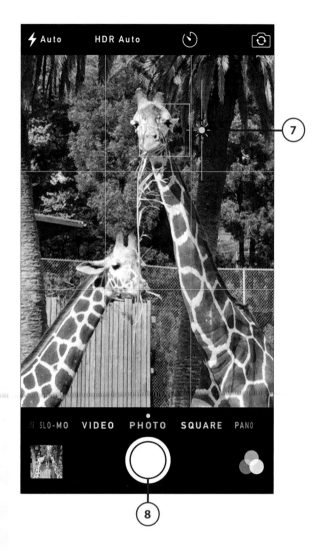

Adjust the Contrast/ Brightness

Displayed to the immediate right of the autofocus sensor is a sun-shaped icon used for adjusting the brightness of the shot prior to taking it. Move this icon (using your finger) upward or downward to manually control the brightness and contrast. Keep in mind that you can also adjust this setting after the fact, using the Photos app, for example, during the editing process.

Fixing Autofocus

If the autofocus sensor is not reacting appropriately to your needs, tap on a different location within the viewfinder to readjust the autofocus sensor. Sometimes, tapping near your intended subject, as opposed to directly on your intended subject, causes the autofocus sensor to react slightly more favorably.

(8) Tap the Shutter button to take a single photo. Press and hold down the Shutter button to activate Burst shooting mode, if it's needed. (Burst mode is available only when using the Photo or Square shooting mode.)

Alternative Shutter Button Option

Whether you're using the front- or rear-facing camera built in to the iPhone or iPad, an alternative to pressing the onscreen Shutter button is to press the Volume Up or Volume Down button located on the side of your device.

(**9**) To quickly preview an image you've just shot, tap on the Image Preview thumbnail displayed in the bottom-left corner of the viewfinder screen. You can continue taking additional photos as needed.

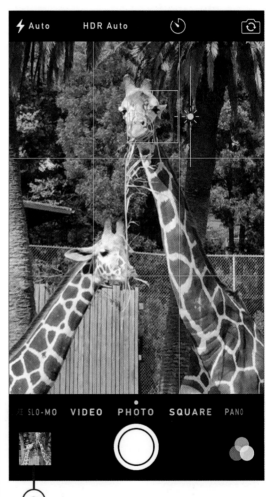

Make Sure iOS Is Up to Date

This section covers the Camera app that comes preinstalled with iOS 8.3 running on an iPhone or iPad. In late 2015, Apple is expected to release iOS 9, which might impact the features and functions offered by the Camera app, as well as the appearance and/or location of various command icons.

Make sure you're using the most current version of iOS. To update your mobile device, launch Settings, tap on the General option, tap on the Software Update option, and if an update is available, follow the onscreen prompts while your iPhone or iPad has Wi-Fi Internet access.

Using the Camera App on the iPad

Depending on which model iPad you're using, the Camera app that comes prein-stalled works much like the iPhone version of the app. However, the features and functions available when using the iPad's Camera app are more limited.

For example, some iPad models do not offer HDR Auto mode, Burst mode, or filters when shooting. Also, although they look the same as their iPhone coun-terparts, the various camera-related options are located in different areas on the screen. As of mid-2015, no iPad models have a built in flash.

Turn On/Off the iPhone or iPad's Grid Feature

Built in to the Camera app for the iPhone or iPad is a Grid feature. Although this grid is displayed in your viewfinder, it does not appear in your photos, but you can turn it off if you want by following these steps:

1. Launch the Settings app from the Home screen.

(2) From the Settings menu, swipe up on the screen to reach the Photos & Camera option.

(3) Tap on Photos & Camera.

(4) Swipe up on the screen to locate the Camera section.

(5) Toggle the Grid setting on or off.

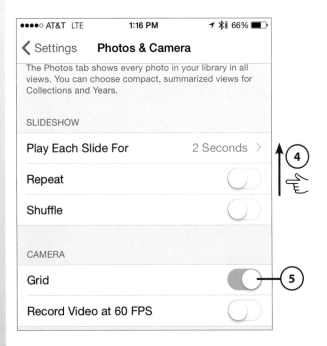

Using the Camera App with an Android-Based Device

The Camera app that comes bundled with Android-based smartphones and tablets is also chock-full of useful digital photography-related features. The layout of the Camera app on the Samsung Galaxy Note 4 smartphone and Samsung Galaxy Tab S, for example, looks pretty much the same.

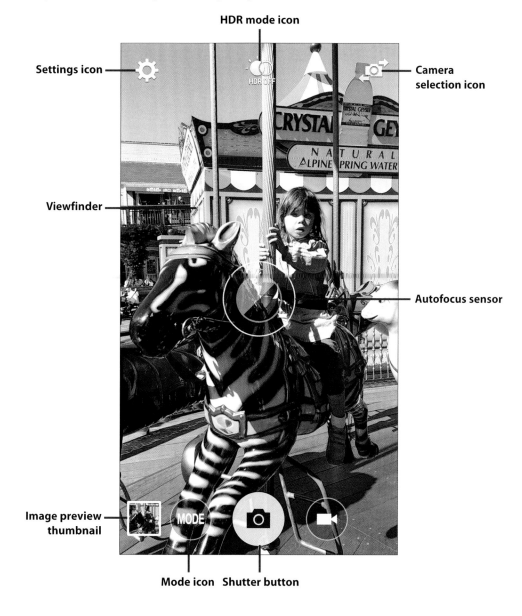

HDR mode icon

Settings icon

Camera selection icon

Viewfinder

Autofocus sensor

Image preview thumbnail

Mode icon Shutter button

Make Sure Your Android Operating System Is Up to Date

This section covers the Camera app that comes preinstalled with version 4.4.4 of the Android operating system. If you're using a different version of the Android OS, the appearance and/or location of camera-related features, functions, and icons might vary.

Take Pictures with Your Android Device

To take photos using the Camera app, follow these steps:

1 Launch the Camera app from the Lock screen, Home screen, or Apps screen.

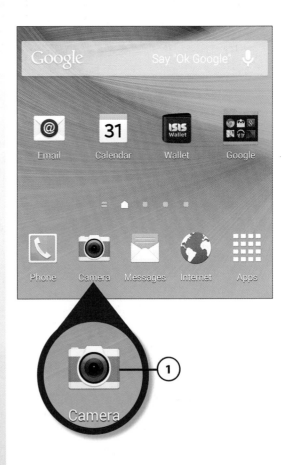

(2) Tap on the Camera selection icon
to select between the front- and
rear-facing camera.

(3) Tap on the HDR mode icon to
turn on or off the camera's HDR
mode.

(4) Tap on the Settings icon to see
the menu where you can turn on
the flash and/or Timer, adjust the
Picture Size, and/or adjust other
Camera app-related settings.

Learning Settings

See the next section, "Understanding
the Settings Menu Options," to learn
about all the features available upon
tapping on the Settings icon.

(5) Tap on the Mode icon to switch
between several additional
shooting modes, including
Auto, Rear-Cam Selfie, Selective
Focus, Beauty Face, Shot & More,
Virtual Tour, Duel Camera, and
Panorama. From this menu, the
Manage Modes and Download
options are also available.

Mode Settings

See the section "Understanding the
Mode Options" later in this chapter to
learn about each of the features found
in the Mode settings.

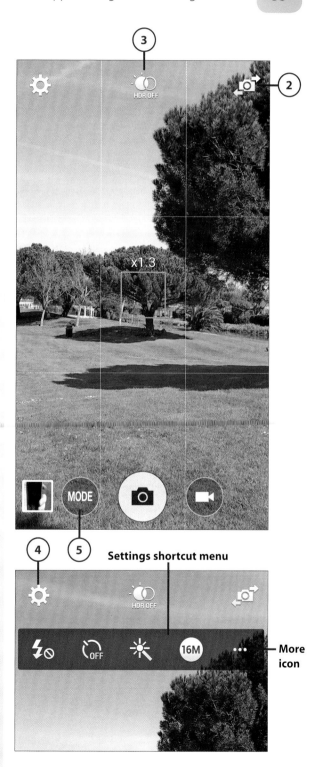

6 Tap on your subject in the view-finder so that the autofocus sensor kicks in and focuses on your intended subject. (The autofocus sensor automatically detects the faces of people.)

7 Tap the Shutter button when you're ready to snap your photo. The photo is saved on your device.

8 Tap on the Last Image Shot Image Preview thumbnail to see the last image you captured. Immediately after taking a photo, you can repeat these steps to take additional photos, as needed.

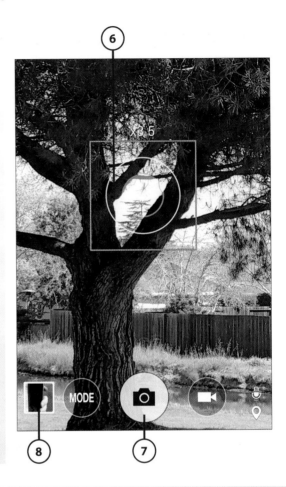

>>>Go Further
ALTERNATIVE SHUTTER BUTTON OPTIONS

If you select the front-facing camera to take a selfie, instead of tapping on the Shutter button to snap a photo, on the Samsung Galaxy Note smartphones, you can place your finger on the heart rate sensor on the back of the smartphone (next to the flash) to snap a photo. This enables you to hold the phone steadier during the picture-taking process.

Whether you're using the front- or rear-facing camera, an alternative to pressing the onscreen Shutter button is to press the Volume Up or Volume Down button. Using the Volume Up or Volume Down button as a Shutter button also works on the iPhone and iPad.

Understanding the Settings Menu Options

Conveniently located in the top-left corner of the Camera app screen on your Android-based mobile device is the gear-shaped Setting icon. Tap on this to reveal an additional menu of icon-based options you can adjust before taking a picture.

From this menu you see several Settings options along the Settings Shortcuts menu bar (including Flash, Timer, Effect, and Resolution), but to access the complete Settings menu on many Android-based smartphones, it's necessary to first tap on the More icon (which looks like three horizontal dots).

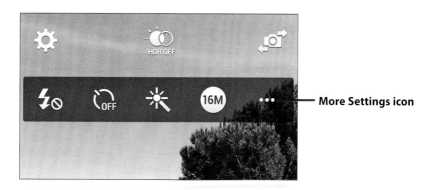

When using an Android-based tablet, upon tapping on the gear-shaped Settings icon, a menu of options is displayed using feature icons showcased in a grid format. This appearance, as well as the settings included here, can vary based on the device and version of the Android OS you're using.

Customize the Settings Shortcut Menu

When looking at the Settings menu grid, it's possible to customize which commonly used Camera options you want to add to the Settings Shortcut menu. To do this, place and hold your finger on the desired option icon for about two seconds, and then drag that icon up to the Settings Shortcuts bar. This gives you slightly faster access to commonly used features along the Settings Shortcut menu bar.

The following options are available from the Camera app's Settings menu when using an Android-based mobile device to take digital photos. Many of these Settings have simple on or off switches you can toggle by tapping on the command icon:

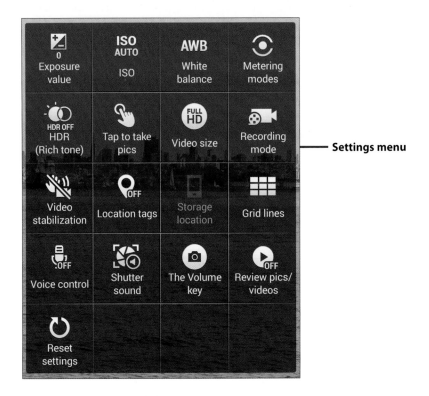

Settings menu

- **Flash On/Off/Auto**—Tap on the lightning bolt-shaped icon to toggle between turning the camera's flash on, off, or to Auto mode. Select the Auto option to allow the camera to determine when and if the flash should be used, based on current lighting conditions.

- **Timer**—Tap on this option to reveal a submenu that enables you to preset the camera's timer to 2, 5, or 10 seconds, or turn off this Timer feature.

- **Picture Size/Image Quality**—Earlier you learned that every camera has a maximum resolution for taking pictures, which is measured in megapixels. The cameras built in to most Android-based devices enable you to use the camera's maximum resolution or change the resolution. The Galaxy Note 4 smartphone, for example, has a 16MP (megapixel) rear-facing camera, while the Galaxy Tab S tablet has an 8MP rear-facing camera. Tap on this Resolution (Picture Size) option to change the resolution of the images as you're shooting.

Resolution Matters

In general, take pictures at the highest resolution the camera is capable of shooting. Then during the editing process you can lower the resolution of images as needed.

- **Continuous Shots**—Tap on this shooting mode option to toggle the feature on or off. When turned on, when you press and hold down the Shutter button (instead of tapping it), the camera captures multiple photos in very quick succession.

- **Picture Stabilization**—Turn on this feature if you are unable to hold the camera steady when taking a picture; for example, if you're in a moving car, on a bus, or on a boat and can't control your movement as you're taking pictures. Picture Stabilization compensates for this motion, so you wind up with clear, in focus, and blur-free images.

- **Face Detection**—When turned on, this automatically detects the faces of people in your photos and ensures that they are captured in focus.

- **Exposure Value**—This is a manually adjustable setting that uses a slider to lighten or darken what's in your viewfinder before taking a photo.

- **ISO**—This is a manually adjustable setting that enables you to control the camera's ISO setting, which determines how light is used as you're taking pictures. If you've spent much time working with film cameras, it's analogous to the film speed rating. In general, leave this setting at its default Auto setting, unless you understand how ISO can alter your images.

- **AWB (Auto White Balance)**—White Balance determines how the camera interprets the color white, and then adjusts all the other colors that appear in your image accordingly to keep them looking as they should. The color white is impacted by the type of lighting in your shooting area. Use the Auto White Balance (AWB) feature to let the camera automatically adjust this setting on your behalf. Alternatively, you can select from the menu the type of light source being used in the area where you're shooting. Options include Daylight, Cloudy, Incandescent (traditional light bulbs), or Fluorescent.

- **Metering modes**—When using the autofocus sensors to instruct the camera to focus on your intended subject, you can set this sensor to one of three settings: Center-Weighted (the default option), Matrix, or Spot. The option you choose determines how light is used as the camera focuses on your intended subject.

- **HDR mode**—Instead of using the flash in low-light situations, turn on the HDR shooting mode to enhance the tones and vibrancy of the colors that appear in your images.

- **Tap To Take Picture**—When this feature is turned on, instead of tapping the Shutter button to snap a photo, you can tap anywhere on the smartphone or tablet's screen.

- **Location Tags**—When turned on, this feature automatically attaches location-related metadata to each image you take, so you later can determine exactly where it was taken.

- **Storage Location**—Some Android devices allow content to be saved on a separate memory card that gets installed into the smartphone or tablet you're using. This options enables you to determine where your photos will be stored, if an option other than the device's internal storage is availabe.

- **Grid Lines**—Turn on this option to superimpose a grid over your viewfinder. This grid is a useful tool when framing your shots, particularly when utilizing the Rule of Thirds, which is a photography strategy you learn about in Chapter 3.

- **Voice Control**—Instead of having to press the Shutter button to snap a photo, when the Voice Control feature is turned on, simply say the word "smile," "cheese," "capture," or "shoot" to take a photo.

- **Shutter Sound**—Each time the camera takes a photo, a camera shutter sound effect is heard if this feature is turned on. This serves as an audible indication that a photo has been taken.

- **The Volume Key**—From this menu, it's possible to set up the smartphone or tablet so that the Volume Up or Volume Down button on the side of your device can be used as a Shutter button for taking pictures. To do this, select the Take Pictures option. Alternatively, if you select the Zoom option, you can use the volume buttons to manually control the zoom feature of the camera.

- **Review Pics/Videos**—When turned on, this feature enables you to quickly preview each photo on the screen after it has been taken, without first having to tap on the Image Preview Thumbnail displayed in the lower-left corner of the viewfinder screen.

- **Reset Settings**—Tap on this option to reset all the Camera-related Settings options to their factory default settings.

Understanding the Mode Options

In addition to the Settings menu, which enables you to control various camera-related options as you're taking pictures, you can tap on the Mode icon to access the Camera app's Shooting Mode menu.

Shooting Mode menu

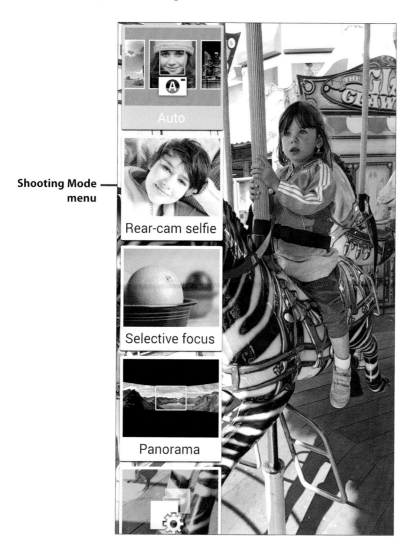

As you can see, the various shooting modes are displayed as icons along the left margin of the viewfinder screen. Tap on the shooting mode you want to use before taking a photo. You can also switch shooting modes in between taking multiple photos.

In general, you should leave the shooting mode on the default Auto option, unless your current shooting situation warrants using one of the specialized shooting modes, which include the following:

- **Rear-Cam Selfie**—As you know, the rear-facing camera is a much higher resolution camera than the front-facing camera (which is typically used to take selfies). When this Rear-Cam Selfie feature is activated, the rear-facing camera automatically detects your face when you take a self portrait. This is useful, because you can't see the viewfinder screen when taking a selfie with the rear-facing camera.

Rear-Cam Helps You Capture Custom Selfies

In addition to just focusing on your face, after turning on the Rear-Cam Selfie feature, you can preframe your shot on the viewfinder screen and instruct the camera where you want your face to appear in the image. Then, when you hold up the camera to take your own photo, the camera beeps when you've positioned it correctly to take the desired shot.

- **Selective Focus**—If your intended subject is within 1.5 feet from the camera, and what's in the background is at least several feet behind your subject, when you turn on this feature, your intended subject appears in focus, but the background is blurred out a bit when you take the photo. This enables your subject to stand out, plus it create a sense of depth in your photos.

Selective Focus is on, and the flower is in focus while the background is blurred.

With Selective Focus turned off, the background is in focus while the flower is blurred.

- **Panorama**—Tap on this option to capture a panoramic shot of a vast landscape, city skyline, or large group of people, for example. You need to slowly pan the camera from left to right or vertically to take this type of shot.

- **Beauty Face**—When taking photos of people, if you turn on this feature, the camera automatically performs a "touch-up" of the subject's face, removing wrinkles, blemishes, and minor skin color variations, for example. This makes the photos look more glamorous, as opposed to crystal clear and sharp. The feature tends to work best on adult females.

- **Shot & More**—When turned on, this feature gives you one-tap access to a variety of special effects that you can incorporate into your photos as they're being taken. Keep in mind, the same effects can also be added after the fact in Studio (the photo editing app that comes preinstalled on Android mobile devices).

- **Dual Camera**—Use this feature to take a photo with the rear-facing camera but superimpose a photo of yourself (a head shot) using the front-facing camera. This feature is useful when traveling, to showcase where you've been and also see your reaction as the photographer. It can also be used to showcase within a photo what's in front of and behind the mobile device when a picture is taken.

Front-facing camera with customizable border Rear-facing camera Rear-facing camera Front-facing camera with customizable border

The Dual Camera Option Is Customizable

When you select the Dual Camera mode, it's possible to choose from a variety of borders for the front-facing camera image, adjust the size of this second image, and switch the two images.

- **Virtual Tour**—This shooting mode enables you to capture a 360-degree image, so you can view the entire layout of a room or area where you're shooting. These images must be viewed on a screen and cannot be transformed into paper-based prints.

Download Additional Shooting Modes

After tapping on the Mode icon from the Camera app's viewfinder screen, tap on the Download option to access the Internet and acquire additional modes that can be used with the Camera app. For example, you can download the free Sports Shot or Sound & Shot modes. Premium shooting modes, available for a fee, are also available.

The best way to discover the impact any of the Camera app's Settings options or Shooting Modes have on photos is simply to experiment with them as you take pictures. Strategies for incorporating some of these features and functions while taking pictures in specific types of shooting situations are covered in Chapter 3.

You Have the Skill, Now Perfect the Art Form Aspect of Digital Photography

This chapter provided the basic knowledge and skill you need to take pictures using your smartphone or tablet. In other words, you now know what buttons to press and which command icons to tap on.

However, as you know, digital photography requires both skill and some creative decision-making. The next chapter focuses more on the art form aspects of digital photography.

Taking visually pleasing photos that are well lit, in focus, and properly depict your intended subject is only the first step. It's then necessary to edit and enhance your photos, organize them, potentially share them with others, and/or transfer them from your mobile device to be archived or managed elsewhere. These are among the other topics covered later in this book.

>>>Go Further
MORE APPS, MORE OPTIONS

In addition to the Camera app that comes preinstalled on your mobile device, many optional third-party apps can be used to control the front- and rear-facing cameras to take photos. Some of these apps offer additional picture-taking features and functions that are not inherently part of the Camera app.

In addition, optional camera accessories can be attached to your mobile device to expand the capabilities of the built-in camera lenses. For example, the 4-In-One OlloClip accessory (www.olloclip.com) clips onto your smartphone or tablet over the rear-facing camera lens and expands the shooting capabilities of this lens.

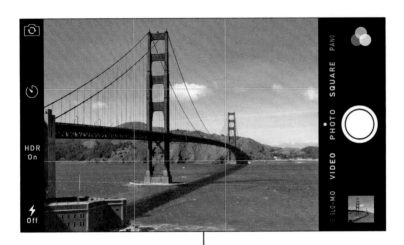

Taking great photos requires some creative
decision making on your part.

In this chapter, you'll learn basic digital photography strategies that you can use with your own creativity to take better photos. Topics covered include

→ Choosing your subject and shooting approach for each shot
→ Using the Rule of Thirds to frame your shots
→ Taking advantage of the available light and what surrounds your subject when framing your shots
→ Selecting the best shooting perspective and camera angle to make your shots more visually interesting

Improving Your Photography Skills

Continuing on the theme that digital photography is both a skill and an art form, this chapter focuses more on the art form aspects related to taking visually interesting photos that are well lit and consistently in focus.

The art form aspect of digital photography involves making some creative decisions, each and every time you prepare to tap the Shutter button to snap a photo.

Some of these creative decisions include

• Choosing your subject

• Utilizing the ambient light so that it shines evenly on your subject

• Positioning your subject in the viewfinder

• Taking advantage of what's in the foreground, background, and to the sides of your intended subject when framing your shots

• Selecting a visually interesting shooting angle or perspective

One of your goals as a photographer is to tell an interesting story with your photos, especially if you'll be showcasing multiple images in the form of an online album, animated slide show, or within a photo book, for example.

At the very least, you want to capture the attention of the people viewing your work, and try to invoke some type of emotional response to your images.

For example, if someone looks at a photo you took of your grandchild or pet, you want them to think, "Aww, how adorable!" If someone views photos of a recent travel adventure, you want them to think, "Wow, it looks like you had an amazing trip." or "How beautiful, I wish I could have been there."

Meanwhile, if it's you looking back at your photos in the months or years to come, you want each image to take you back to the time and place it was taken, so that you can relive those fond memories and reminisce about those moments in your life.

This might sound like a huge challenge or an overly complicated process, when all you want to do is snap some photos, but as you'll discover, once you know how to operate your camera, taking awesome photos from a creative standpoint is a lot easier than you might think, especially if you're willing to practice the strategies covered in this chapter.

>>>Go Further
PICK A CAMERA, ANY CAMERA

The creative aspects of digital photography covered in this chapter apply when using any digital camera—whether it's the camera built in to your smartphone or tablet, a standalone point-and-shoot digital camera, or a higher-end digital SLR camera.

A point-and-shoot digital camera is a digital camera with all the components needed to take pictures bundled in a battery-powered standalone device. The photos you take with a point-and-shoot digital camera get stored on a memory card, and ultimately can be transferred to your computer or mobile device for viewing, editing, sharing, and archiving, or the images can be uploaded to an online-based service.

Virtually all the features and functions built in to most point-and-shoot digital cameras are now available to you when using the cameras built in to your smartphone or tablet.

Meanwhile, a digital SLR camera is more versatile than a point-and-shoot digital camera, because many of the components that work with this type of camera, such as the lens and flash, are interchangeable. These cameras tend to have higher quality lenses, a better image sensor, and can shoot at higher resolutions. Plus, as the photographer, you typically have more manual control over the camera's various features and functions.

If you become more passionate about digital photography, eventually you might want to upgrade to a digital SLR camera. However, as you'll discover, using the cameras built in to your mobile device or using a point-and-shoot digital camera, you can still take amazing photos.

Breaking Your Current Picture-Taking Habits

Most amateur photographers, by default, set up their camera to take photos, center their intended subject in the viewfinder, and then shoot from a head-on perspective. These photographers use this same strategy for every single photo they take, regardless of their subject, the shooting situation, the lighting conditions, or where they're taking pictures.

In the photo on the following page, the subject's face is positioned in the center of the frame and is looking directly into the camera. It's shot from a head-on perspective. The other photo has her positioned in the viewfinder so she's not dead center within the shot, creating a better visual.

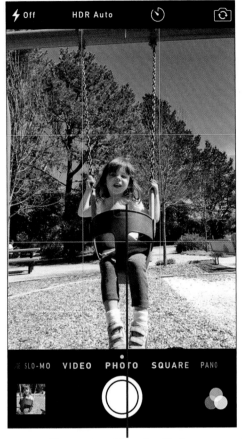 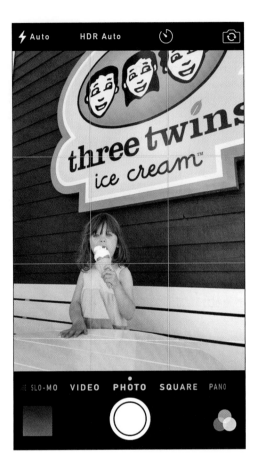

The center of the viewfinder

If this strategy sounds familiar, when you go back and look at all your photos taken to date, you'll probably discover that they all look rather boring, as well as pretty much the same, even though the subject(s) within your various photos might be different.

The first thing you need to do to begin taking more visually interesting photos is to break this habit and adopt a variety of different picture-taking approaches that are customized based on what and where you're shooting. This chapter discusses a handful of easy-to-adopt shooting strategies.

Knowing Your Objectives

Sometimes, simply taking pictures of life as it unfolds before your eyes is the perfect approach to take, especially if you're engaged in something you want to

remember, you're spending time with family or friends, or as you go about your day, you encounter something funny or unusual that you want to remember and/or share with others.

However, if you're attending an organized event, such as a party, your grand-child's soccer game, or you're on vacation and experiencing a once-in-a-lifetime trip, for example, it makes sense to adopt a more organized approach to your picture taking.

>>>Go Further

CANDID VERSUS POSED PHOTOS

When it comes to taking pictures of people, there are two basic types of shots—*candid* and *posed*.

A candid shot is where you capture someone engaged in an activity, and as the photographer, you capture whatever the subject is doing, as well as the subject's real emotion, without you being intrusive. You (the photographer) provide no direction, and your subject is seemingly unaware a photo is being taken.

A posed shot, however, involves you as the photographer directing your subject. You tell the person what to do and where to look.

These two approaches result in vastly different types of shots. Strategies for taking both types of shots are included in the section "Taking More Interesting Portraits and Candid Shots of People" later in this chapter.

An organized approach to picture taking simply means that you think about what you're about to experience and develop a plan for what types of pictures you want to take, so that as you later showcase your photos, you're able to tell a compelling visual story with them.

For example, as you embark on a trip or vacation, start taking pictures of the people you're traveling with as you first board your airplane or cruise ship. Then, throughout each day of the trip, take plenty of photos that showcase where you've been, what you did, the memorable experience you had, and the people you were with.

Because you can often predict what types of experiences you're about to have when attending events, like parties, sporting events, or your grandchild's recital, for example, you can think in advance about the types of shots you want to get, and then plan accordingly.

As you preplan your shots, think about how you'll showcase your images later, and what type of story you want to tell with them. Just knowing what you're trying to accomplish helps you brainstorm ideas for specific shots, as photo opportunities arise.

Take Multiple Shots Using Different Approaches

Just as you want to adopt different strategies for taking photos, you also want to mix and match these strategies for each shooting situation that arises. For example, take some posed photos of the people you're with, but also take plenty of candid shots, as well as shots that showcase where you are and what you're doing.

Don't forget to switch between portrait and landscape mode, as needed, and also make full use of your camera's zoom capabilities.

Shown here are two shots of the Golden Gate Bridge taken from different angles and perspectives. As you can see, the subject is the same but the approach taken to capture each shot is vastly different, and as a result, each shot looks unique.

Finding Visually Interesting Subjects

People always make for interesting subjects in photos, because you can capture them alone, in pairs, or in groups, and they can showcase an unlimited array of poses and facial expressions. Your subjects can be standing or sitting still looking directly into the camera, or engaged in some type of activity as you take photos.

Pets and animals can also be the perfect subject matter for your photos, especially if you capture an animal doing something dramatic or funny, or you're able to capture their cuteness in a visually interesting way, for example.

Whenever possible, photograph animals as they're looking directly into the camera. This often requires patience on your part as the photographer, since animals rarely listen to instructions about how to pose for a photo.

Understand, however, that anything can become the subject matter for a visually interesting, funny, or thought-provoking photo, whether it's a flower, rock formation, piece of architecture, sunrise or sunset, or any inanimate object whatsoever.

Photograph an Inanimate Object

To make photos of inanimate objects more visually interesting, it's your job as the photographer to adopt an approach that works for the situation. More often than not, one or more of these four strategies will work for taking photos of any inanimate object(s):

(1) Use the available light in an unusual way. For example, take advantage of light glares, sunsets, silhouettes, and/or shadows in an interesting or artistic way. Here, the vivid color from the sunset (which is behind London's Big Ben) allows this landmark to be photographed as a silhouette.

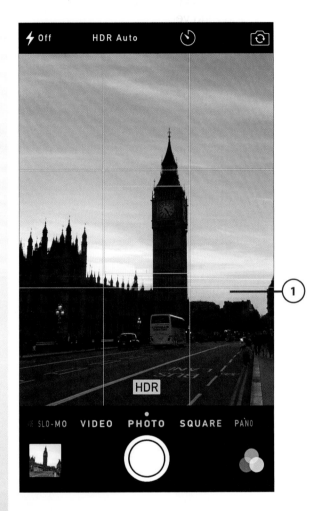

(2) Take the photo from an unusual angle or perspective. Especially when shooting very large objects or buildings, like Westminster Abbey in London, try shooting from a diagonal, as opposed to head-on. Here, the image was shot from a diagonal, with the photographer also crouching down and shooting in an upward direction.

(3) Frame your shot using the intended subject's surroundings. In this example, the lifeguard station (an inanimate object) and the palm trees frame the shot of this Hawaii beach. Without these objects in the photo, the shot would be pretty but rather boring to look at.

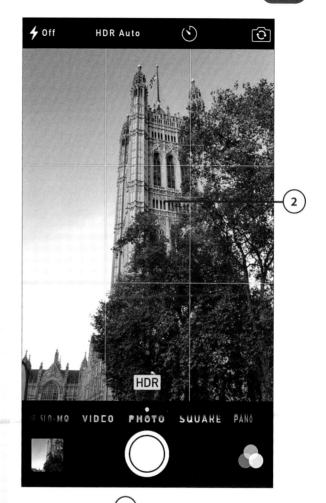

(4) Take advantage of the camera's zoom feature to focus in extremely close on your subject. Sometimes, getting very close to a subject, either physically or using the zoom, enables you to capture a more unusual or attention-getting image.

Close-ups Can Be Very Compelling

An extreme close-up shot, taken from an unusual angle, can often make even the most ordinary object or item look visually interesting in a photo.

Using the Rule of Thirds as You Frame Your Shots

To help encourage you to move your intended subject away from the dead center of the frame as you're framing your shots and taking photos, take advantage of the Rule of Thirds.

The Rule of Thirds is a photography strategy that involves using a tic-tac-toe grid superimposed over your viewfinder when framing your shots. This grid contains nine boxes, with the center box representing the dead center of the frame.

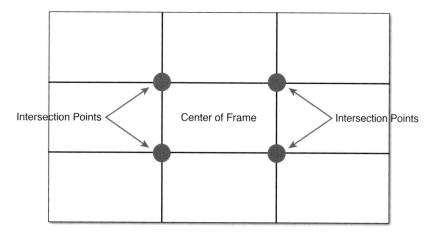

Viewfinder with the Rule of Thirds Grid

Instead of positioning your subject within that center box as you frame your shots, align your intended subject at one of the grid's four intersection points, or along one of the grid's horizontal or vertical lines. The goal is to move your subject away from the center of the frame and change the focal point of your image.

Create a Focal Point Within Each Shot

The focal point of an image is the one area of the shot that someone's eyes gravitate to first. It's typically your subject or a specific aspect of your subject. When using the Rule of Thirds, the focal point of the image is what you want to place at one of the grid's intersection points, or along one of the grid's horizontal or vertical lines.

As you do this, always make sure that, if your subject is pointed in a particular direction (which doesn't involve facing the camera directly), it's facing into the frame, not out of it, and if the subject is in motion, it should be moving into the frame, not out of it.

Each time you use the Rule of Thirds, think about the best area within the frame to position your subject to create a visually interesting shot, keeping in mind that your subject does not always need to be facing the camera as you take the photo.

Use the Rule of Thirds When Framing Your Shots

To incorporate the Rule of Thirds as you take photos, follow these steps:

(1) Turn on the Grid feature of your camera, so a tic-tac-toe-like grid gets superimposed over your viewfinder.

Enabling the Grid
Refer to the section "Adjusting the Camera App's Settings Before Taking Pictures" in Chapter 2, "Taking Amazing Pictures with Your Smartphone or Tablet." If you're using an Android-based device, adding a grid to the viewfinder can be done from the Camera app's Settings menu.

(2) Choose your intended subject.

(3) Position your subject so the focal point of your image is at one of the grid's four intersection points, or along one of the grid's horizontal or vertical lines. Here, the focal point is the statue's eyes, which are positioned along the top horizontal line on the grid.

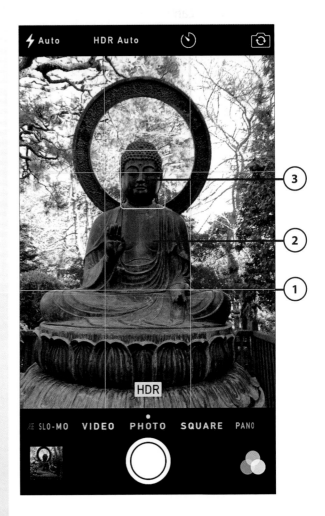

(4) When applicable, have your subject facing the camera directly or facing (moving) into the frame, as opposed to out of it.

(5) Take the picture when you're satisfied with how you have its subject framed.

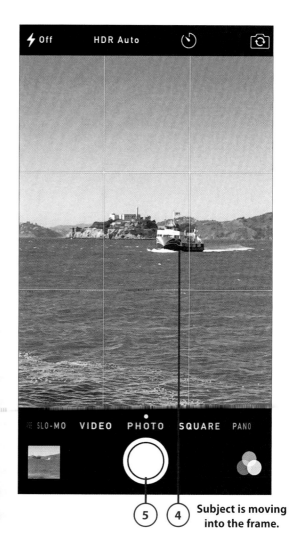

Subject is moving into the frame.

Paying Attention to Lighting

In addition to the position of your intended subject within the frame, one of the first things you must consider as you're planning each shot is your primary light source and where it's emanating from.

If you're shooting outside during the day, your primary light source will most likely be the sun. However, if you're shooting at night, your primary light source might be a streetlight, the moonlight, or your camera's flash.

Meanwhile, when shooting indoors, your primary light source might be overhead lamps, candlelight, flames from a fireplace, your camera's flash, or some other form of artificial light.

In general, you always want your primary light source to be positioned behind you, the photographer who is holding the camera, and it should be shining evenly onto your subject.

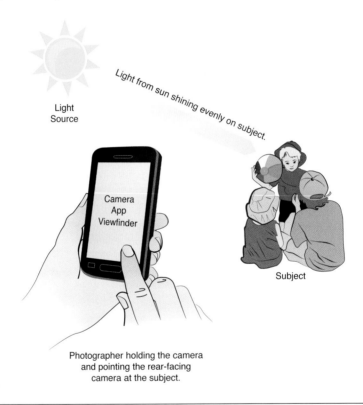

Light Source

Light from sun shining evenly on subject.

Camera App Viewfinder

Subject

Photographer holding the camera and pointing the rear-facing camera at the subject.

Uneven Light Causes Unwanted Shadows

If the primary light source is not shining evenly onto your subject, you'll typically wind up with unwanted shadows in your shots. These shadows can be annoying to look at and visually ruin an otherwise awesome shot.

If the light source is not positioned behind you, the photographer, too much light will be captured by the camera's lens. This could easily result in unwanted glares, an overexposed image, your subject appearing as a silhouette, or the lack of detail and color vibrancy in your photo.

This sample image of a girl eating an ice cream cone shows how an image can be washed out because the camera has caught too much light. Here, the primary light source (the sun) was behind the subject, not the photographer. Thus, the top-right portion of the image is overexposed due to too much light.

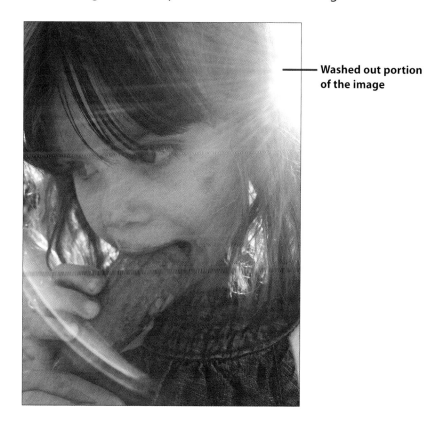

Washed out portion of the image

In the example on the following page, the light source also was positioned behind the subject and not the photographer. As a result, the subject appears as a silhouette within the photo.

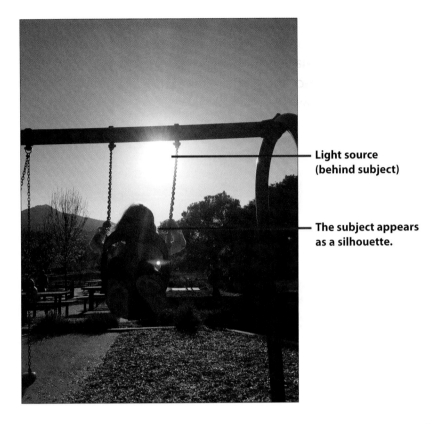

Light source
(behind subject)

The subject appears
as a silhouette.

So, as you begin planning your shots, pay attention to the location or position of your primary light source and adjust your position as the photographer accordingly. Keep in mind that you also often have the option of moving your intended subject into better or more even lighting, or you might be able to adjust the position or intensity of artificial lighting.

Choosing a Shooting Angle or Perspective

As the photographer, you do not always need to position your camera evenly with your subject so you're shooting from a head-on perspective.

Often, positioning your camera above, below, to the side, or at a diagonal in relation to your subject results in a more visually interesting shot. Your shooting angle can be slight, or in some situations, the camera can be positioned at a strong angle.

In the first of these two images, the camera was positioned below the subject and the photographer shot in an upward direction. The result is that the background of the image shows what's above the flowers, which in this case, includes the sky. In the second, the photographer positioned himself above the flowers and shot in a downward direction. As a result, what's in the background is what was below the flowers, which in this case, was a small pool of water.

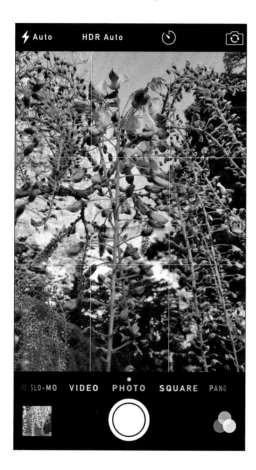 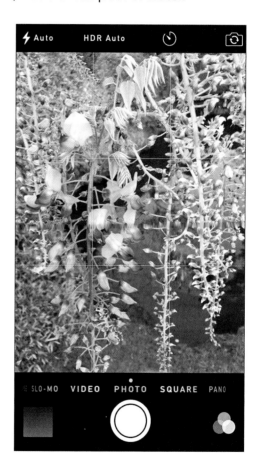

Especially when shooting inanimate objects, selecting an unusual shooting angle often results in a more visually interesting photo, plus it helps to determine what's seen behind your subject, in the background.

Be Creative!

While also incorporating the Rule of Thirds to position your subject within the frame, choosing interesting shooting angles as you frame your shots makes your photos more visually interesting, plus it makes each photo look unique. If you shoot all your photos from a head-on perspective, looking at groups of photos becomes boring because they all start to look the same.

Taking Advantage of Your Surroundings

In addition to these guidelines for framing your shots, also consider what scenery or objects are located in front of, behind, and to the sides of your subject, and use these surroundings creatively to your advantage.

In this example, the subject is the girl at the top of the slide. The curves of the slide were used to frame the shot, with the subject appearing in the center.

Whether you're shooting people, animals, or inanimate objects, when applicable, frame your subject using the natural surroundings, or use what's in front of or behind your intended subject to add a sense of depth to your photos.

Use the Autofocus Sensor

Especially if there's a lot happening within your shots, with objects surrounding your intended subject, it's essential that you point your camera's autofocus sensor on your subject to ensure that what the camera focuses on is your intended subject, and not some other object or item seen in your viewfinder. To do this, tap on the viewfinder, directly over the subject.

Taking More Interesting Portraits and Candid Shots of People

There are different strategies to adopt when taking candid photos of people versus posed portraits. Let's take a look what's involved with effectively capturing each type of shot.

Strategies for Taking Candid Shots of People

Taking a candid shot of one or more people is relatively easy, as long as you (the photographer) are positioned in the right place at the right time and you don't interfere in anyway with the person or people you're photographing.

Remember Your Objective

The goal of a candid shot is to capture someone's genuine emotion and/or an authentic action as it happens. Your intended subject should not be distracted or intimidated by the fact that you're taking the photo.

To improve your candid picture taking skills, consider using these strategies:

- Anticipate what will happen and what you want to capture, and make sure you're in the right place at the right time. Perfect timing is essential for capturing a good candid shot.

- Choose a shooting angle or perspective that enables you to capture the intended subject in the best way possible without you having to give the subject any direction whatsoever.

- Consider moving physically farther away from your intended subject and taking advantage of the zoom feature to get in closer to your subject without being intrusive.

- Prepare your camera in advance to capture the photo you want to get. For example, if you know you want a photo of your granddaughter blowing out the candles on her birthday cake, have all the camera's settings adjusted correctly and be in position before the event takes place. Due to the spontaneous nature of candid shots, you seldom have the opportunity to retake them.

- If your subject will be in action, consider using the Burst shooting mode built in to your camera to capture the shot you want at exactly the right moment.

- In addition to your subject's actions, focus on the subject's facial expression to capture emotion.

Strategies for Taking Posed Portraits

When you take posed photos of people (or well-trained pets), you as the photographer are in control. You have time to plan your shots, position your subject(s), adjust the lighting, and tell your subject(s) where to look, how to pose, and what to be doing as you take the picture. You can also take multiple pictures, either changing the subject's pose or your shooting angle/perspective with each shot.

**The photographer can control
what happens in a posed portrait.**

By following these strategies, you're more apt to capture visually interesting posed portraits:

- Choose a good shooting location, based on lighting and surroundings. Use the lessons detailed in this chapter to frame the most visually interesting setting for your subject.

- Instruct your subject to adopt a pose that's conducive to the photo you're trying to capture. Decide whether you want the subject standing, sitting, or engaged in some type of activity as you're taking the picture.

Direct Your Subject's Eyes

The subject does not have to be looking directly at the camera when taking a portrait. In fact, if the subject is looking at someone else, interacting with a prop, or even staring off into the distance, for example, this often makes for an interesting or thought-provoking image.

- Make sure the subject isn't wearing any flashy jewelry or accessories that might cause a reflection in the photo and ruin the image. Pay particular attention to glares or reflections from eyeglasses, shiny earrings, necklaces, watches, and rings.

- Consider allowing your subject to hold or interact with props to add a theme to your image or make the subject more comfortable posing for the camera.

- In some situations, a portrait can become more dramatic or attention getting if you use a black-and-white filter and remove the color altogether.

Portrait Versus Landscape Mode

If you're shooting a portrait of a person and the background is not important, hold your camera in portrait mode, so the focal point of the image is your subject and little background is visible. Use the zoom, if necessary.

However, if you want to showcase the background, because you're traveling, for example, and your subject is standing in front of a famous landmark or tourist attraction, position your camera in landscape mode and use the Rule of Thirds to help frame your shot.

- Tell the subject exactly what you want them to do as you take the photo. For example, say, "When I count to three, look at the camera, smile, and say 'Cheese'."

Take Multiple Shots

Always take two or three shots, with a second or two gap in between shots. Then, consider repositioning yourself (the photographer), or your subject, and/or changing your shooting angle/perspective, and then take a few additional shots.

Capturing Action Shots with Ease

Taking an action shot can mean one of three things:

- You (the photographer) are standing still but your subject is moving.
- You (the photographer) are moving but your subject is motionless.
- Both you (the photographer) and your subject are in motion.

Regardless of which of these scenarios you encounter, capturing a great shot is going to require a bit of preplanning and perfect timing. Also, make sure you use the best camera setting(s) for the task at hand.

For example, consider using your camera's Burst shooting mode in situations when timing is essential. If you're the one moving, turn on the camera's Image Stabilization feature, if applicable. (This is a feature offered in the Camera app of Android-based mobile devices and by all point-and-shoot and digital SLR cameras, for example. Refer to Chapter 2 for more information about these features.)

Take Advantage of Motion Effects

Some third-party camera apps available for smartphones and tablets have special shooting modes for capturing sports or action shots and incorporating special effects into them. However, if both you (the photographer) and your subject are moving at relatively the same speed, and if you focus on your intended subject, the background will blur and create a motion effect within the background of your image while the subject appears in focus.

Making Your Travel Photos as Memorable as Your Adventures

Travel photography is all about storytelling using images. While one standalone photo of a location can set a scene, if you add the people you're traveling with to that image, you can create a one-of-a-kind keepsake related to that travel memory.

However, during your travels, if you take a lot of different types of pictures of the place you go, the activities you engage in, the restaurants you dine at, and the people you're with or that you encounter, you can then create an online album, animated digital slide show, photo book, scrapbook, or photo collage that retells the story of your adventure with photos.

The following strategies help you capture your travel experiences.

Keep Taking Photos Throughout Your Travels

Start taking photos as you leave your home, and continue taking pictures as you journey to your destination(s) and as you're experiencing your trip. Your smart-phone, tablet, or the memory card in your digital camera might be capable of holding thousands of photos. As long as you keep your device's battery charged, you can keep taking photos.

Before leaving on your trip, make sure your mobile device has enough memory to store the photos you plan to take. On an iPhone or iPad, you might need to free up space by copying images stored in your device to iCloud (or another cloud-based service that enables you to store photos, such as Dropbox, Google Drive, or Microsoft OneDrive) or your computer, and then deleting them from your smartphone or tablet.

If you're using an Android-based device that supports an optional memory card, consider investing in a high-capacity memory card to use with your smartphone or tablet, so that you can store hundreds or even thousands of images without worrying about maxing out the storage capacity of your device.

Take Photos Throughout Your Journey

A family photo taken while boarding an airplane, a photo taken through the air-plane's window of a sunset or as you're landing at your destination, a group shot

as you board a cruise ship, selfies taken in front of popular tourist destinations or landmarks, plus photos of the people you're traveling with engaged in vacation-oriented activities, for example, are all travel shots you should consider taking.

Take Photos of Signs Wherever You Go

Photograph signs you encounter or signs you create. For example, you can use your finger or a stick to write a message in the sand at a beach. A sign photo can be used as a title image at the start of a slide show or be used as the cover art for your photo book or scrapbook. Then, additional sign images can be used as you showcase the different locations you visit.

Be Creative When Taking Sign Photos

When photographing signs, avoid using a head-on camera angle. Try shooting the sign from an angle to make the photo of a sign more visually interesting. Also, consider positioning one or more of the people you're traveling with in your sign photos.

Photograph wording on the sides of buildings or on other objects that explain where you've been using text in an interesting way. Ultimately, these images can be used instead of text-based captions as you're showcasing your images.

Mix and Match Different Types of Shots

Shoot many different types of photos to help tell your story. Your collection of travel photos by the end of your journey should include

- Landscape/cityscape shots (or photos of landmarks or popular tourist attractions) that show where you've been.

- Posed shots of people you traveled with (or selfies) in front of landmarks or tourist attractions. These shots should be taken using Landscape mode, to incorporate more of the subject's surroundings in the background.

- Candid photos of the people you traveled with engaged in various activities you experienced.

- Sign photos that visually explain with text where you were.

- Use a "selfie stick" with your smartphone or camera so you can snap photos of yourself at the places you visit.

By taking many different types of shots, as you group images together later to showcase them, they will be more interesting to look at, plus they will tell your story in a more visually creative way.

Seek Out Inspiration

Most popular tourist destinations and landmarks, for example, have gift shops or souvenir stands nearby. Here you can find postcards for sale. Before you start taking your own pictures at that location, take a look at the professionally shot postcards or artwork for sale at these gift shops and acquire creative inspiration from these images.

These shots are typically taken from the best angle or perspective, for example, so you can mimic the approach used in the postcards, but place yourself and/or the people you're traveling with in your own shots to personalize them.

Ideally, you want to be able to show off a group of your photos, without having to verbally describe where you were or what you did, or without needing to use a lot of text-based captions. Just by looking at a group of your travel photos, someone should be able to see where you were and what you did.

Shoot Through Glass

In many situations it becomes necessary to take a photo through glass. For example, if you're in a car (not driving), if you're at a museum (that allows photos to be taken), or at a zoo or aquarium. To achieve the best results when shooting through glass, follow these steps (shown here using an iPhone 6, although the steps apply when using any camera):

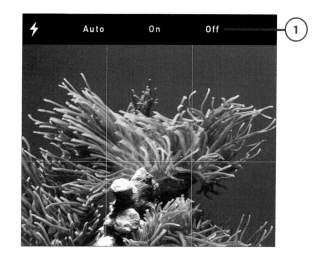

(1) Turn off your camera's flash. If the flash is turned on, the light from the flash will reflect off the glass and cause unwanted glares and/or an overexposed image.

(2) Make sure the glass you're shooting through is as clean as possible. Try to wipe away dirt or fingerprint smudges from the glass using a handkerchief, microfiber lens cleaning cloth, or a paper towel, for example.

(3) Turn on HDR mode on your camera.

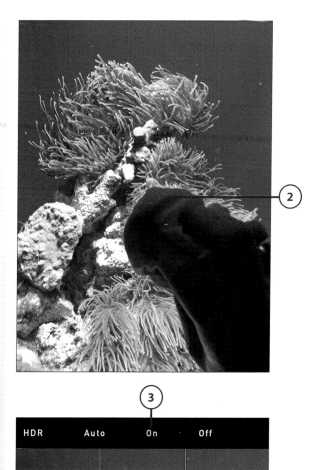

(4) Hold the camera directly up to your side of the glass or window. On your side, no light should seep between the glass and the camera's lens. If necessary, put your hand or something else in place to block any light seepage. Whenever possible turn off the lights on your side of the glass, so all the light is emanating from the opposite side of the glass, where your subject is located. Hold the camera very steady.

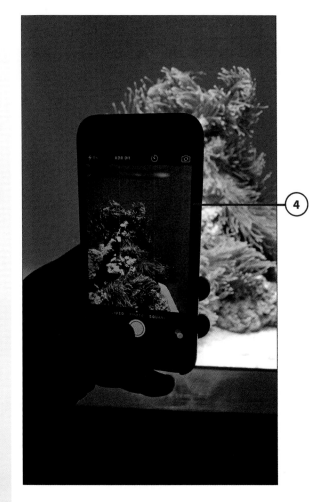

5 Frame your shot in the view-finder. Adjust the camera's zoom, if desired or necessary.

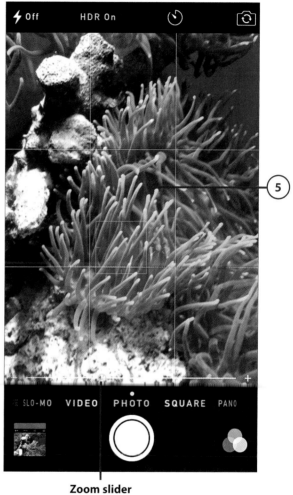

Zoom slider

6 Tap on the viewfinder, directly over your subject, to activate the autofocus sensor.

7 Press the Shutter button to snap a photo.

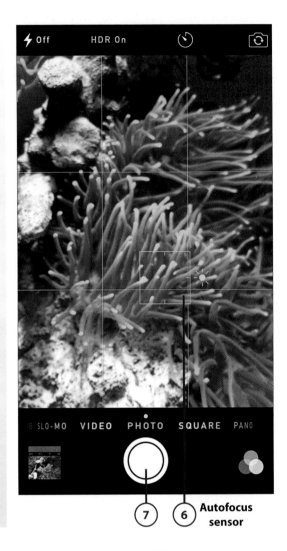

Overcoming Common Shooting Challenges and Mistakes

The following are 10 of the most common mistakes or oversights amateur photographers make when taking pictures. To achieve the best results, avoid these mistakes whenever you're taking pictures.

(1) **The camera's battery dies too soon.** The easiest way to overcome this is to always begin your day with a fully charged battery, and if you know you will be out and about using your mobile device (or digital camera) all day, bring along your charger and/or an optional external battery pack to extend the device's battery life.

(2) **There's not enough storage space on your mobile device or on your memory card for new photos.** After you've taken photos, transfer them to your computer or to an online service, and then delete them from your mobile device or your camera's memory card. (See Chapter 8, "Organizing and Managing Photos On Your Mobile Device.")

Don't Plan to Permanently Store Photos on Your Smartphone or Tablet

Chapter 4, "Transferring Photos to Your Computer," explains how to move photos from your smartphone or tablet to your computer wirelessly or by using a USB cable connection. Chapter 10, "Sharing Photos Online," offers information about how to transfer and archive your digital photo collection "in the cloud" using an online-based photo sharing and storage service like Flickr.com, Apple's iCloud Photo Library, Google Drive, or Microsoft's OneDrive.

(3) **The camera's lens is dirty when pictures are taken.** Even the tiniest speck of dust, sand, or dirt (or a fingerprint) that covers your camera's lens will ruin all your images until the lens is cleaned. Always clean the lens with a microfiber lens cleaning cloth. It is not necessary to use water or cleaning solutions on the camera's lens.

(4) **The photographer's finger(s) accidentally covered the lens or flash.** Practice holding your mobile device or camera in your hands so that your finger(s) doesn't accidentally cover the camera's lens or flash. Otherwise, you'll wind up with great finger shots, as opposed to photos of your intended subject.

(5) **Too many shadows appear in photos.** Shadows are caused by your primary light source, which could be the sun, overhead lights, or your camera's flash. Whenever possible, move the light source, yourself (the photographer), or your subject, so that the light source is positioned behind the camera and shines evenly onto your subject.

(6) **The pictures are blurry or the coloring is wrong.** There are a few potential causes for these problems. First, the camera was not held steady as the photo was taken. Second, the camera's settings were not correct. Third, you selected the wrong shooting mode for the task at hand. Fourth, too much or too little light was available in your shooting location.

(7) **An "action shot" was taken too early or late due to poor timing.** Anytime you need to capture an action shot where timing is essential, make sure you (the photographer) are in the right place at the right time and that your camera is preset to the appropriate shooting mode and settings. Then, seriously consider using the Burst shooting mode by pressing and holding down the Shutter button starting a second or two before the action takes place, and keep holding the Shutter button down until after the subject's action is completed.

(8) **The intended subject is out of focus.** The two most common reasons for this are that the camera was not held steady when the photo was taken, or you didn't properly use the autofocus sensor to lock on to your intended subject just before pressing the Shutter button. If the camera needs to guess your intended subject, it often chooses the wrong object in your viewfinder.

(9) **The same shot was saved by the camera or mobile device many times.** Instead of tapping the Shutter button to take a single photo, you wound up holding down the Shutter button for a second or two, which resulted in the Burst shooting mode kicking in and capturing a handful of images in quick succession. If this happens, choose the best image and delete the unwanted shots.

(10) **An image didn't look right, so it was immediately deleted.** Especially when viewing your images on the small screen of your smartphone or digital camera, it's difficult to see all the detail in a photo. Before deleting any images, transfer them to your computer and view them on a larger screen. Keep in mind that using a photo editing and enhancement app or software, it's possible to fix problems with images after they've been shot, and in some cases, dramatically alter the appearance of an image.

>>>Go Further
TINKERING WITH AN IMAGE CAN OFTEN IMPROVE IT

You can fix an image or dramatically improve its appearance simply by using the Auto Enhance editing tool built in to most photo editing apps and software or adding a filter to it. Using specific editing tools such as Exposure, Shadows, Brightness, Contrast, Saturation, Crop, or Straighten can also allow you to fix particular problems in photos, or quickly improve (or alter) their appearance.

With this in mind, don't immediately delete a photo that doesn't look perfect. Even if the coloring in a shot is off, if you can't fix it to your liking, try converting a full-color image into black and white, and see whether you like the image better. If an image is slightly out of focus, try using the Sharpen feature built in to your photo editing app or software.

Chapter 5, "Viewing, Editing, and Enhancing Your Photos on Your Mobile Device," and Chapter 6, "Viewing, Editing, and Enhancing Your Photos Using Your Computer," explain how to use these and other image editing and enhancement tools.

Once you take photos using your smartphone, tablet, or digital camera, you'll probably want to transfer them to your PC or Mac. One way to do this is to sync your images via Apple's iCloud service.

In this chapter, you'll learn how to transfer photos from your smartphone, tablet, or the memory card in your digital camera to your PC or Mac computer. Topics include

→ Transferring photos from a mobile device to an online (cloud-based) service, and then syncing them with your other computer(s) and mobile device(s)
→ Transferring photos from your mobile device to your computer using a USB cable
→ Transferring photos from your smartphone or tablet to your computer wirelessly
→ Freeing up internal storage space within your mobile device by manually deleting photos
→ Transferring photos from your camera's memory card to your PC or Mac computer

4

Transferring Photos to Your Computer

Each time you snap a photo using the Camera app built in to your smartphone or tablet, your photo is stored automatically as an individual digital file in the internal storage of the device you're using.

Based on the internal storage capacity of your mobile device and what other apps, content, and data are stored in it, how many photos you can store at any given time on your mobile device varies. At some point it will fill up, and it becomes necessary to transfer photos from your smartphone or tablet to your Windows PC or Mac computer, an external hard drive connected to your computer, or to an online service.

Transfers Can Be Done Anytime

You don't have to wait until the capacity of your mobile device fills up before transferring images to an online service or a computer. This can be done anytime.

The focus of this chapter is on how to transfer photos from your smartphone or tablet to your computer. Then, after your photos are transferred, you can view, organize, edit, enhance, print, archive, or share them using specialized photo management and editing software that I cover in upcoming chapters.

Meanwhile, if you're taking pictures using a standalone, point-and-shoot digital camera or digital SLR camera, the photos you take are stored on the camera's memory card, which can also fill up and require you to transfer those images to your computer. How to do this is also covered later in this chapter.

Free Up Storage Space

After you've transferred your photos from your smartphone or tablet (or your camera's memory card) to your computer, you're then free to delete that content from the mobile device's internal storage or your camera's memory card to free up storage space.

It is not necessary to purchase a new smartphone or tablet or buy a new memory card for your camera when its storage capacity is reached. However, you don't want to delete photos from your mobile device or camera's memory card until you know that content has been safely transferred and stored elsewhere.

Regardless of the device you're using, there are multiple ways to transfer photos from that mobile device to your computer. For example, this can be done using a USB cable that connects your mobile device directly to the computer.

The image transfer process can often be done wirelessly, when both the mobile device and the computer are in close proximity and connected to the same Wi-Fi network or linked via a Bluetooth connection.

What's Bluetooth Anyway?

Bluetooth is an industry-standard wireless technology built in to mobile devices and some computers. When the Bluetooth feature is turned on, computers and/ or mobile devices can exchange information, data, documents, or files (including photos) wirelessly. The radius of a Bluetooth signal varies but is typically around 150 feet.

As you'll learn shortly, and in Chapter 10, "Sharing Photos Online," it's also possible to wirelessly upload your photos from your Internet-enabled mobile device to a specialized online service and then access those images from any of your computers or mobile devices once they're stored "in the cloud."

Assuming you have a wireless (Wi-Fi) network in your home, which gives all of your computers and mobile devices high-speed Internet access while you're at home, this is typically the fastest and easiest option for transferring and syncing your digital photos between your desktop computer, laptop computer, smartphone, and/or tablet.

Determining Your Available Storage

At any given time, the internal storage of your smartphone or tablet is used for a variety of things, including to store optional apps, app-specific data and content, multimedia content (music, TV shows, movies, eBooks, audiobooks, or videos you shoot), as well as the digital photos you take using the cameras built in to your mobile device.

To see how the internal storage of your iOS (iPhone or iPad) or Android mobile device is currently being used, and to manage that storage space, follow the steps described in one of the following sections.

Manage Your iOS Mobile Device's Internal Storage

To see how your iPhone or iPad's internal storage is currently being used and determine how much free (unused) storage space is available, follow these steps:

(1) Tap the Settings app from your device's Home screen.

iOS 8

These steps are based on the iOS 8.2 version of the iPhone and iPad operating system.

(2) Tap on the General option in the Settings menu.

3 Tap on the Usage option. Under the Storage heading, you see how much of your device's internal storage has been used, as well as how much internal storage space remains available.

4 Tap on the Manage Storage option to see a detailed listing of the apps installed on your device and how much internal storage the third-party apps and their data are using.

Storage available Storage
for use used up

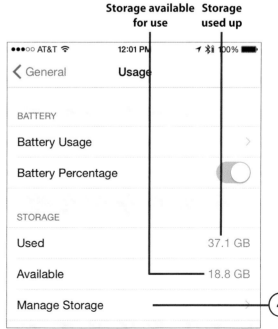

Total amount of storage still available

5) Tap on a specific app listing for more details about how an app is using up space. Here, the Photos & Camera option is selected.

6) Review the information on the page to see how much space an app or its data is taking up. Press the Home button to exit out of Settings and return to the Home screen.

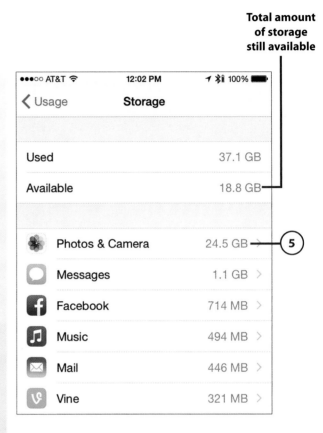

FREE UP SPACE BY REMOVING APPS AND THEIR DATA

One way to free up space on your mobile device is to delete any third-party apps (and their data) that you're not using. You can always reload the app at any time in the future, for free, from the App Store. However, before you delete an app from your mobile device, make sure you've backed up the data from that app if it's important to you.

How to delete unwanted photos currently stored on your iPhone or iPad is explained later in this chapter in the "Manually Deleting Photos from Your Mobile Device" section.

Manage Your Android Smartphone or Tablet's Internal Storage

If you're using an Android 4.x-based smartphone or tablet, follow these steps (shown here on a Samsung Galaxy Note 4 running Android 4.4.4) to see how your mobile device's internal storage is currently being used and determine how much free (unused) storage space is available:

1. Tap on the Apps icon from your device's Home screen.

(2) Tap on the Settings icon.

(3) Swipe your finger from right to left to locate the General tab.

(4) Tap on the General tab.

(5) Tap on the Storage menu option. The Device Manager screen that appears displays a general rundown of how your device's internal storage is being used, as well as the device's total capacity.

6) Tap on any listing to see additional information pertaining to Used Space (selected here), Cached Data, or Miscellaneous Files, for example.

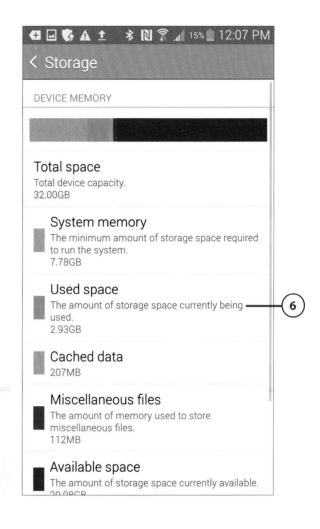

< Storage

DEVICE MEMORY

Total space
Total device capacity.
32.00GB

System memory
The minimum amount of storage space required to run the system.
7.78GB

Used space
The amount of storage space currently being used.
2.93GB

Cached data
207MB

Miscellaneous files
The amount of memory used to store miscellaneous files.
112MB

Available space
The amount of storage space currently available.
20.08GB

⑦ Tap the Pictures, Video option to access the images and video presently on your device. See the section "Manually Deleting Photos from Your Mobile Device" later in this chapter for information on how to delete any images you select.

⑧ Press the Home button to exit out of Settings and return to the Home screen (not shown).

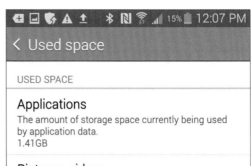

< Used space

USED SPACE

Applications
The amount of storage space currently being used by application data.
1.41GB

Pictures, videos
The amount of storage space currently being used by pictures and videos taken using the camera.
1.50GB

Audio
The amount of storage space currently being used by alarms, music, notifications, podcasts, ringtones, etc.
148KB

Downloads
The amount of storage space currently being used by files downloaded from the Internet.
8.00KB

>>>Go Further
REMOVING APPS AND THEIR DATA

One way to free up space on your Android device is to delete any third-party apps (and their data) that you're not using. One way to do this is from the Settings app.

After launching Settings, tap on the Applications tab displayed at the top of the screen. Next, tap on the Application Manager option. A listing of optional apps downloaded and previously installed is displayed, along with how much internal storage each app is using.

Tap on an app listing to manage the app and its app-specific data, and/or delete the app altogether from your device. However, before you delete an app from your mobile device, make sure you've backed up the data from that app if it's important to you.

Syncing Your Digital Photo Library Between Your Mobile Device and Computer Via the Internet

When it comes to storing and managing your digital image collection, you have two main options. First, you can store your entire digital photo library locally on your computer. This can use up a significant amount of hard drive space, either on the hard drive built in to your Windows PC or Mac computer or on an external hard drive connected to your computer.

Alternatively, you can store your photos online in the cloud. To do this, you need Internet access for each of your computers and mobile devices. You also must set up a free account with a cloud-based photo management service.

For storing and syncing apps, data, documents, and files, including photos, online, Microsoft offers the Microsoft OneDrive service, which also works on iOS and Android devices. Apple offers the iCloud service. You can also use an independent online service, such as Dropbox.

By downloading the appropriate app or software onto your computer or mobile device, any of these cloud-based services can be used by any type of computer or mobile device.

Pick One Service to Manage Your Photo Library

When it comes to storing your digital photo library online, it's best to choose and work with just one online service. Otherwise, you must keep track of where you stored specific photos or albums, and then make sure you have the right software or app installed on the computer or mobile device you're using to manage those photos.

Ultimately, you want your entire photo library stored in at least one safe location and organized into appropriately named albums or folders, so you can easily find and access your images in the future.

You'll soon discover that the photo management software that comes preinstalled on your Windows PC and/or Windows Mobile smartphone or tablet is

set up to integrate seamlessly with Microsoft OneDrive, so if you're primarily a Windows user, you should consider using this service to store your photos.

Meanwhile, the Photos app that comes preinstalled on all Macs, iPhones, and iPads is designed to operate seamlessly with the iCloud Photo Library feature of Apple's iCloud service. Thus, if you're primarily an Apple user (who utilizes a Mac, iPhone, and/or iPad), storing your photo library on iCloud makes sense.

Android users can take advantage of Google Drive, which is integrated into the mobile apps used to manage digital photos but also works with Windows PC and Macs, as well as iOS mobile devices.

Other independent cloud-based file sharing services, such as Dropbox, are designed to work with any Internet-enabled computer or mobile device. Dropbox, for example, enables users to store and sync any type of documents, data, files, or content, including photos, with an online-based account. There are, however, online services dedicated exclusively to storing, syncing, managing, and sharing digital photos.

What You Need to Know About Cloud-Based Services

Before choosing a cloud-based service to store, manage, sync, and share your digital photos, there are a few common things you should understand about these services in general:

- To use one of these services, you first need to set up a free account.

- Each service provides you with a predetermined amount of free online storage space that you can use to store your digital photo library. If you require additional online storage space, a monthly or annual fee is often charged, based on how much additional online storage space is needed.

- The majority of these cloud-based services are designed to integrate with multiple apps and not just sync your photos. For example, if you're an Apple user, iCloud can be used to sync Contacts, Calendar, Notes, Reminders, Safari, Mail, and other app-specific data, plus handle a wide range of other tasks, above and beyond simply storing your digital photo library.

- Once you set up an account with one of these services, your computer or mobile device must have Internet access to connect to the service. When

you're dealing with the large file sizes associated with high-resolution photos, most of these services require a high-speed Internet connection. If you're using a smartphone or tablet, you typically need Wi-Fi access, as opposed to using your device's cellular data connection to handle most digital photography–related uploading and downloading tasks.

- In addition to storing your photos online, these cloud-based services enable you to sync your photo library or specific albums with all your own computers and/or mobile devices. Thus, you can take a photo using your smartphone, and within seconds it automatically becomes accessible on your tablet, notebook computer, and/or desktop computer(s).

- Regardless of which cloud-based service you use to manage your digital photo library, your images can be sorted or grouped together into albums.

- By default, all the photos you store online using one of these cloud-based services are only accessible by you from any of your own computers or mobile devices linked to the same cloud-based service account.

- Even if you're using a desktop computer, laptop computer, smartphone, and a tablet to access a particular cloud-based service, you need only one account for that service. Each computer or mobile device, however, might need the appropriate software or app installed to access that service.

- Once albums containing groups of your images are stored online, you always have the option of sharing specific albums with specific people, while keeping all your other albums (and photos), as well as other content stored in your cloud-based account, private and secure.

You Control Who Has Access to Your Photos

When you opt to share a specific album via one of these cloud-based services, you decide exactly who you share it with and can always revoke access later. When you grant access to an album, that invitee has access only to that album, not your entire photo library.

As you learn Chapter 10, this is not always the case when you share photos using social media, such as Facebook, Twitter, or Instagram.

- If you use a computer or mobile device that does not have the necessary software or app installed for accessing your cloud-based content, there's typically a website you can visit using any computer's web browser. Then, you can securely sign in to your account and access your photos. For example, if you're using iCloud Photo Library, from any computer, visit www.iCloud.com (shown here), and sign in using your iCloud username and password. Then click on the Photos online app icon to access the photos you have stored on that service.

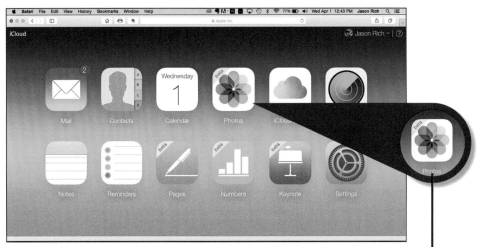

Access your iCloud photos through a web browser.

Using Microsoft OneDrive to Sync Your Photos

Microsoft OneDrive is designed to integrate directly with the Windows operating system running on Windows-based PCs (running Windows 8 or later), smartphones, and tablets. Thus, the various photo management and photo editing apps that come preinstalled with the Windows or Windows Phone operating systems, as well as many third-party photography-related software packages and apps, work with OneDrive.

>>>Go Further

DOWNLOAD THE MICROSOFT ONEDRIVE APP OR SOFTWARE

Although Windows 8 and Windows 10 come with OneDrive support right out of the box, if you use Windows 7 or a Mac, you must use a web browser to download and install the free Microsoft OneDrive software onto your computer. To use OneDrive on your mobile device, you must download it from your device's App Store. (Windows Mobile comes with OneDrive support out of the box.)

To find the appropriate software or app for your computer(s), visit https://onedrive.live.com/about/en-us/download/. Then you need to set up one free Microsoft OneDrive account, regardless of how many of your own computers and/or mobile devices you'll be using the service with.

If you already have a Microsoft account you already have a OneDrive account. (This includes any email address you use to log in to a Windows 8 or Windows 10 computer, or one using @hotmail, @live, or @outlook.)

When you set up a OneDrive account, it includes 15GB of free online storage space. Additional online storage space can be acquired, as needed, for a monthly fee. For example, 100GB of online storage is priced at $1.99 per month, 200GB of online storage is priced at $3.99 per month, and 1TB of online storage is priced at $6.99 per month.

An Online Storage Alternative

For less than $100, it's possible to purchase an external 1TB hard drive for your computer that can be used to store or back up your digital image library. If you use this option, the images are not readily available online, but over time, you can save money by not having to pay a monthly or annual fee for online storage space. Meanwhile, some cloud-based services, like Microsoft OneDrive, give you unlimited online storage space if you are a paid subscriber to a premium service, such as Office 365, for example.

If you use OneDrive exclusively to manage your online photo library, the free 15GB of online storage might be enough to hold all of your individual photos, in as many separate albums as you need or want. However, based on what other content you also store in your OneDrive account, it might become necessary to upgrade your online storage space allocation.

Manage Microsoft OneDrive from Your Windows Computer

On your Windows PC, access to your OneDrive account is treated just like a hard disk, except the photos, content, documents, or data are stored online as well as on your computer. To access or manage your OneDrive account from your Windows PC, log in and follow these steps:

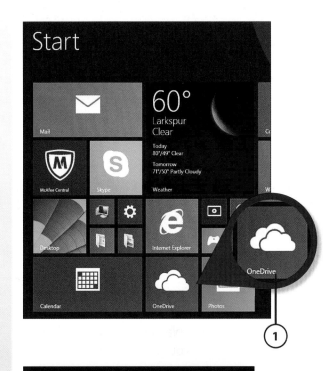

1 Click on the OneDrive tile from the Windows Start screen.

Search for OneDrive

If you don't see a OneDrive tile you can access it from the Apps screen or by typing OneDrive from the Start screen.

2 The first time you use this app it takes you to its Settings screen. If it does this, click on the Camera Roll option. (If it doesn't, skip ahead to Step 4.)

Logging In

If you're not already logged in to OneDrive, the app asks you to log in before you can follow this step. It also asks you to select a quality setting to use for photo uploads. In most cases you should choose Best.

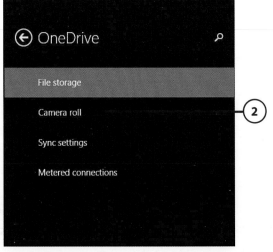

(3) Select a quality to use for photo file uploads.

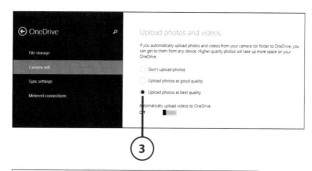

(4) Exit out of PC Settings and launch the OneDrive application by clicking on the OneDrive tile from the Start screen (refer to Step 1). Your OneDrive account is divided into folders. In terms of managing your photos online, the Pictures folder is where you ultimately store your images and albums online.

(5) Click the Pictures folder.

(6) Initially, your Pictures folder is empty, unless you already populated it from another computer or mobile device. Shown here, one picture folder, called Camera Roll, already is created. As you move forward, from the Windows Desktop, you can manually copy (drag-and-drop) picture files already stored on your computer to this OneDrive Pictures folder and place them in a specific album, or you can sync your content in the Photos app with your OneDrive account.

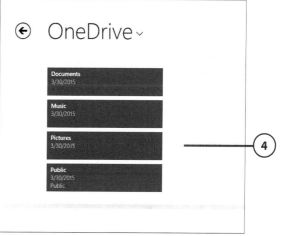

(7) Once photos are stored in the Picture folder of your OneDrive account, you can access that content from any other of your computers or mobile devices that has access to your OneDrive account (not shown).

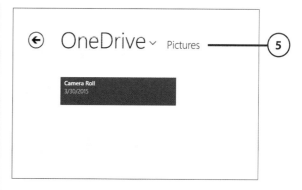

Changing Upload Settings

If you have already configured this option you can adjust it later by launching PC Settings, clicking on the One Drive option, and then clicking on the Camera Roll option.

Storage Resolution Is Important

OneDrive enables you to store your photos in good or best quality. Ideally, you should choose the best quality option. This, however, results in a larger file size for each image and requires additional online storage space to store your images. Photos with larger file sizes also take a bit longer to upload to and then download from the service.

Access OneDrive from a Mac or PC Running Windows 7

To access your OneDrive account from your Internet-connected Mac, launch your favorite web browser, such as Safari, and visit https://onedrive.live.com.

Sign in using your OneDrive username (email address) and password, and you have full access to your Files, Recent Docs, Photos, and Shared folders in your OneDrive account. There's also free OneDrive software you can install on your Mac by visiting https://onedrive.live.com/about/en-us/download.

Manage Microsoft OneDrive Content Via Your iOS Device

Access to your online-based OneDrive account is also possible from an iPhone or iPad. You need to access your online account using the optional Microsoft OneDrive app (which works with iOS 7 or later), available for free from the App Store. To work with the OneDrive app, follow these steps:

1. After downloading and installing the OneDrive app onto your iPhone or iPad, launch the app and sign in to your OneDrive account by tapping on the Sign In button. Enter your account-related email address and password when prompted.

(2) Tap Turn On if prompted to activate the camera backup feature. (This appears the first time you launch the OneDrive app.) Once you log in to your OneDrive account using the OneDrive app on your iPhone or iPad, you have full access to photos and albums stored in the Pictures folder.

●●●○○ AT&T 🛜 2:14 PM ⯅ ⚹🔋 84% ▭

Turn on Camera Backup

Back up full-resolution photos and videos automatically to OneDrive and earn an **extra 15 GB** of storage.

Turn On ——————(2)

Not now

CAMERA BACKUP

Camera Backup automatically uploads all new photos you take with your iOS mobile device as well as those already stored in your device's Camera Roll folder to your OneDrive account. This can be done in addition to or instead of having the Camera and Photos apps that come preinstalled on your iPhone or iPad automatically sync new photos with your iCloud account.

At anytime, to adjust the Camera Backup setting while using the OneDrive app on an iOS mobile device, launch the app, tap on the Menu icon (which looks like three horizontal lines), tap on the gear-shaped Settings icon, and then tap on the Camera Backup menu option. Turn on the virtual switch associated with the Camera Backup feature.

(3) Tap on the Photos icon at the bottom of the screen to see your photos. The All Photos, Albums, or Tags tabs appear at the top center of the screen.

(4) Tap on one of these options (All Photos is shown) to view and manage your photos stored online in your OneDrive account. If you have the OneDrive Camera Backup featured turned on, the photos you see upon tapping on the All Photos option should correspond with the photos stored in your iPhone or iPad's Photos app.

>>>Go Further

ACCESS MICROSOFT ONEDRIVE FROM ANDROID

Just as you can access your OneDrive account from your iPhone or iPad, this can also be done from any Android-based mobile device, as long as you first download and install the OneDrive app, which then works very much like the iPhone/iPad or Windows Mobile version of the OneDrive app.

The free OneDrive app for Android-based devices can be found in the Google Play store (shown here).

Using iCloud Photo Library to Sync Your Photos

iCloud functionality is integrated directly into the OS X Yosemite operating system for the Mac, iOS 8 for the iPhone and iPad, as well as the Photos app and software. It can be used with earlier versions of OS X and iOS as well. And you can use iCloud with Windows PCs, provided you add Apple's iCloud software to the PC. For more information on using iCloud with a compatible Mac, iOS mobile device or Windows PC, visit www.apple.com/icloud/setup/pc.html.

All iCloud accounts are initially free and come with 5GB of online storage space, which can be used with any or all of iCloud's various features and functions, including iCloud Photo Library.

An additional 20GB of online storage (which gives your account a total of 25GB) costs $0.99 per month. For 200GB, the monthly fee is $3.99. For 500GB, the monthly fee is $9.99, and for 1TB of online storage space, the fee is $19.99 per month.

Your allocated online storage applies only to your own data, documents, content, and files. Any additional online storage needed for app or content purchases from the Mac App Store, iOS App Store, iTunes Store, iBookstore, or Apple Newsstand is provided free of charge.

The Photos App Has Replaced iPhoto on the Mac

Until mid-2015, the photo management and editing app that came preinstalled on all Macs was called iPhoto. However, Apple has replaced the iPhoto app with a new and free app, called Photos, which more closely resembles the Photos app available on all iPhones and iPads. Both iPhoto and Photos for the Mac fully integrate with iCloud Photo Library.

As soon as photos are taken on an iPhone or iPad, for example, your mobile device can be set up to automatically upload those images to your iCloud Photo Library, so they become accessible to all of your computers and/or mobile devices linked to the same iCloud account. iCloud functionality must be turned on in each computer and/or mobile device it will be used with.

Once turned on, instead of automatically syncing all photos with iCloud, you can manually pick and choose which photos or albums you want to sync using the Photos app on your Mac or iOS mobile device.

Create an Apple ID Account

If you have an existing Apple ID and password, you already have an iCloud account set up and ready to use. If not, you can create one from scratch by visiting https://appleid.apple.com, and then clicking on the Create an Apple ID button.

Set Up iCloud Photo Library on Your Mac

To set up iCloud Photo Library to work on a Mac, follow these steps:

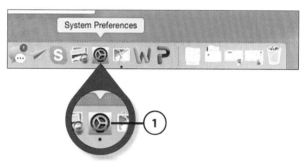

1. From the Dock on the Desktop, launch System Preferences.

2. Click on the iCloud icon in the System Preferences menu.

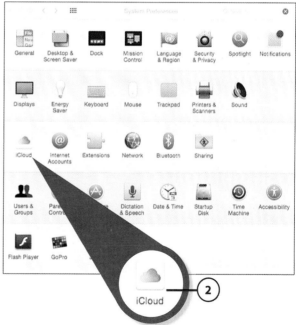

(3) Sign in to your iCloud account using your Apple ID username and password (which is the same as your iCloud username and password). Your account information is then displayed on the left side of the iCloud Control Panel window.

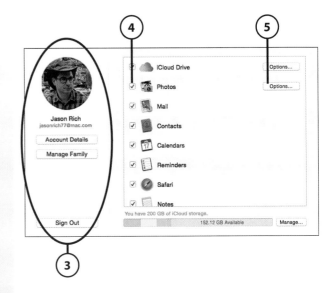

(4) From the iCloud Control Panel, add a checkmark to the Photos option.

(5) Click on the Options button to turn on the iCloud Photo Library functionality. Once iCloud functionality is turned on in the Photos or iPhoto app, the app continues working as needed in the background to keep all your photos synced and accessible.

Adjust iCloud Settings from Within iPhoto or Photos

From within the iPhoto or Photos app running on a Mac, select the iPhoto (or Photo) pull-down menu, and then click on the Preferences option. From the Preferences window, click on the iCloud option.

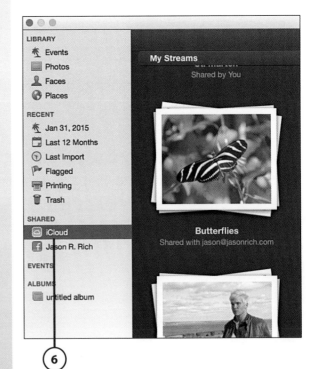

(6) Anything having to do with iCloud Photo Library and your Mac is done via the Photos or iPhoto app. The iPhoto app is shown here, with the iCloud option selected from along the sidebar.

ICLOUD ON WINDOWS AND ON THE WEB

By downloading the free iCloud for Windows software from Apple's website (https:// support.apple.com/kb/DL1455), you can sync and share photos via iCloud Photo Library directly from a Windows PC. After the software is downloaded, run the iCloud Photos app, sign in to your iCloud account using your Apple ID and password, and you then have full access to all photos stored online in your online-based iCloud Photo Library.

When you begin using iCloud Photo Library to store your images, using any computer or mobile device connected to the Internet, you can visit www.icloud.com, sign in using your Apple ID and password, click on the Photos icon, and then view and manage your photos. Most other cloud-based photo services offer a similar feature.

Set Up iCloud on Your iPhone or iPad

The first time you want to use iCloud and the iCloud Photo Library feature with your iPhone or iPad (shown here), you must turn on this option. To do this, follow these steps:

(1) From the Home screen, launch Settings.

2 From the main Settings menu, tap on the iCloud option.

3 When prompted, enter your Apple ID and password (which is the same as your iCloud username and password).

(**4**) Tap on the Photos option from the iCloud Control Panel.

(**5**) Turn on the virtual switch associated with iCloud Photo Library, and adjust the other settings offered from this menu as you see fit. Once iCloud Photo Library functionality is turned on in Settings, exit out of Settings by pressing the Home button.

Conserve iPhone/iPad Internal Storage Space

While the full-resolution version of your photos can be stored online, if you select the Optimize iPhoto Storage option from the Photos menu in Settings, the images stored in your mobile device are kept at a lower resolution to conserve internal storage space.

6. Launch the Photos app. Most interaction with iCloud Photo Library from your iPhone or iPad is ultimately done via the Photos app. Shown here, the Shared option (at the bottom center of the screen) is selected, so all albums available on iCloud are displayed.

>>>Go Further
ANDROID USERS CAN USE GOOGLE DRIVE

Instead of using iCloud with an Android-based smartphone or tablet, consider using Google Drive, which is fully integrated with the Android operating system but can also be used with Windows PCs and Macs. For more information about Google Drive, visit https://drive.google.com/drive/my-drive.

Another option is to use Dropbox (www.dropbox.com), which supports all computer and mobile device platforms. Both Google Drive and Dropbox offer the capability to sync and back up a photo library.

Using Dropbox to Sync Your Photos

If neither iCloud nor OneDrive fits your needs you have plenty of other options. One of the most popular is Dropbox, a service that makes it easy to store and sync photos from any type of computer and/or mobile device. Setting up a Dropbox account with 2GB of storage is free.

If you need more than that (and you likely will), a Dropbox Pro account costs $9.99 per month. It offers 1TB of online storage space, which is more than enough to store several hundred thousand photos, as well as other types of content, documents, data, and files. While online storage isn't always the cheapest option (when compared to purchasing an external hard drive for your computer, for example), storing your photos in the cloud protects your images if something happens to your computer. For example, if it crashes, gets damaged, or is stolen, your photos can always be retrieved from the cloud.

One benefit to Dropbox is that many third-party software applications and mobile apps have Dropbox integration built in. Otherwise, using the free Dropbox software or mobile app, you can set it up to automatically sync your digital photos between all your computers and/or mobile devices, and when you want, share specific photos or albums with other people.

Use the Dropbox Software or Mobile App

To access the Dropbox service from a PC or Mac computer and create a free Dropbox account, point your web browser to www.dropbox.com and download the free Dropbox software.

To create, access, or manage your Dropbox account from your mobile device, first download and install the free Dropbox app onto your smartphone or tablet. To find the appropriate app for your mobile device, visit www.dropbox.com/mobile.

Finding Other Cloud-Based Photo Storage Options

Almost any popular cloud-based file sharing service enables you to store and sync photos. However, a variety of services are set up exclusively for this purpose. Some of them, such as Flickr.com, Shutterfly.com, and Google's Picasa, are

discussed in Chapter 10, because in addition to enabling you to store, sync, and archive photos, these services enable you to order prints and share your photos in a variety of ways.

Transferring Digital Photos from Your Mobile Device to Your Windows PC or Mac Via a USB Cable

Instead of storing your files online and syncing them between several different computers and mobile devices, it's possible to use the USB cable that comes with your smartphone or tablet to connect the mobile device directly to your computer, and then transfer photos from the mobile device to that computer (or vice versa).

Once you establish a connection between a mobile device and computer, the photo editing and management software running on your computer identifies this connection and can be set up to automatically transfer photos on your mobile device to your computer. This transfer process can also be done manually after the connection is established.

Macs Get Along Great with iOS Mobile Devices

If you're syncing or transferring photos between an iPhone, iPad, or iPod Touch and your Mac, this can happen automatically using the Photos (or iPhoto) app when a USB cable connection is established between your iOS mobile device and Mac.

To adjust these autosync settings, from the Photos or iPhoto app, access the Photos or iPhoto pull-down menu, click on the Preference option, and then click on the iCloud icon. After turning on the automatic sync process once, it continues working in the future until you manually change this setting.

Transfer Content from Your Mobile Device to a Windows PC

To connect your Android mobile device with your Windows PC and manually select and transfer photos, connect them via a USB cable (small end to the mobile device, large end to your computer), and follow these steps (shown here using a Samsung Galaxy Note 4 Android-based smartphone):

1. Once connected (and powered on), your computer identifies the Android-based device as an external storage device and enables you to access it from the Desktop. Double-click on the Mobile Device to open its contents. (If you're using an iOS mobile device, use the iTunes software on your PC or Mac to manage the image transfer.)

2. Open (double-click) the Phone folder. The folder structure you see may vary with the specific brand and model of device you have. You want to open folders until you locate one labeled Pictures or Photos.

3. Double-click the Pictures folder to open it. If you have albums set up, double-click the album you want to open. Thumbnail images for each image stored in your mobile device are displayed on your computer's screen.

4 Select the images you want to copy to your computer. You can do this using the mouse by drawing a box over the images you want or holding down the Ctrl key and clicking each individual image.

5 Open the Copy To folder from the Manage tab on the menu bar.

6 Select the Pictures folder to copy them to that folder on your computer's hard drive.

Copy and Paste

You can also press Ctrl+C (copy) or Ctrl+X (cut) to copy or move selected images, navigate to the folder where you want them placed, and press Ctrl+V (paste) to place the images in that folder. The destination can be an existing subfolder within the Pictures folder, for example, a cloud storage folder like OneDrive or Dropbox, or a custom folder that you create.

7 When the transfer is completed, disconnect the USB cable from your computer and mobile device. There is no need to turn off either device first (not shown).

Deleting Photos

At this point, if you want to delete the transferred photos from your mobile device, after making sure they're safely stored on your computer, do this using the steps outlined in the section "Manually Deleting Photos from Your Mobile Device" later in this chapter.

TAKING THE NEXT STEP

Using any photo editing or photo management software, you can now import the images from the folder on your computer's hard drive to that program. These images can also be added (as an attachment) to an outgoing email message, for example.

Transfer Content from Your Mobile Device to a Mac

To transfer photos from your device to a Mac you need to first power on and connect them using the cable provided with your device. To manually select and transfer photos to your Mac, follow these steps (shown here using a Samsung Galaxy 4 Android-based smartphone):

1. When the computer identifies a connection, the Android File Transfer software automatically launches. If it doesn't launch on its own, you can launch the Android File Transfer app from your Mac's Applications folder. The Android File Transfer software displays all the folders in your mobile device on your computer's screen in a window (shown). This includes the Pictures folder.

2. Click on the Pictures folder, and locate the image(s) you want to copy to your Mac.

Before You Begin

If you're using an Android-based mobile device, download and install the free Android File Transfer software onto your Mac. You can find it here: www.android.com/intl/en_us/filetransfer.

3 If necessary, double-click to open subfolders containing the pictures you want.

4 Select the images you want to copy. To do this, click on one image, and then hold down the Shift key and click on the additional image files you want to highlight and select.

5 Open a Finder window to the location you want to store your photos (such as the Pictures folder).

6 Drag and drop or cut and paste the selected and highlighted files to the folder you selected. Once the files are stored in a folder, you can import them into any photo editing software, such as the Photos, iPhoto, or Photoshop Elements app, or attach any of the image files to an outgoing email, for example.

Transferring Images Wirelessly

Built in to the Mac, as well as the iPhone and iPad is a wireless transfer option, called AirDrop, that enables you to wirelessly transfer photos that you select between your computer(s) and iOS mobile device(s).

If you want to transfer from Android to Mac this can be done using Bluetooth. Turn on the Bluetooth feature on your computer and mobile device, and select the Bluetooth option from the Share menu.

Using AirDrop to Transfer Photos from iOS to Your Mac

To turn on AirDrop, access the Control Center on your mobile device and then tap on the AirDrop option.

Next, choose between AirDrop Everyone or AirDrop Contacts Only. If you select the latter, a wireless connection is only established with computers or devices that belong to people who have an entry in your Contacts database.

Then, from within the Photos app on your mobile device, select one or more photos that you want to wirelessly transfer, tap on the Share icon, and select the AirDrop option by tapping on the name or picture icon of the intended recipient. The AirDrop option is also available from the Share menu of the Photos or iPhoto app on the Mac.

Use Bluetooth to Transfer Images from an Android Mobile Device to Your Computer

With Bluetooth already turned on for your computer and your mobile device, follow these steps:

Turning On Bluetooth

You can turn on Bluetooth on an Android device via the Settings menu.

1. Open the Photos app on your device.

(2) Tap on the More icon.

(3) Tap on the Select option.

(4) One at a time, tap on the image thumbnails you want to transfer.

(5) Tap on the Share icon. This opens the Share menu.

(6) Tap on the Bluetooth option to open the Select Device screen.

Enabling Bluetooth

If you haven't already enabled Bluetooth, Android phones now prompt you to turn on the feature. Select the Turn On option from the Enable Bluetooth pop-up window that appears on your mobile device's screen.

(7) Select the destination computer or mobile device. In this example, the destination is Jason's MacBook Air. If your computer is Bluetooth enabled and Bluetooth is turned on, you should see your own computer in this list.

(8) When the Incoming File Transfer window pops up (on your computer), tap on the Accept button. The selected image files from your mobile device now transfer to your computer.

Finding Your Pictures

You find the newly transferred files in the Downloads folder of your computer. You can then move or copy them to your Pictures folder or any other folder using a drag-and-drop or cut-and-paste method. (See "Transferring Digital Photos from Your Mobile Device to Your Windows PC or Mac Via a USB Cable" earlier in this chapter.)

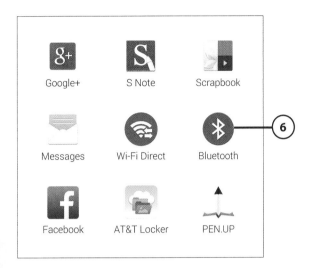

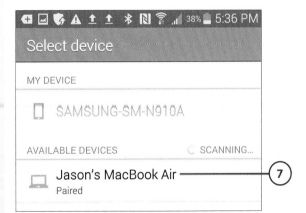

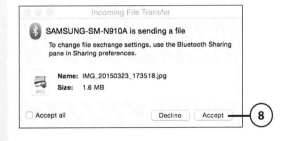

Manually Deleting Photos from Your Mobile Device

After transferring photos from your mobile device to your computer, your computer might ask whether you want to delete the images on your smartphone or tablet.

To be safe, select No for this request, and then manually ensure the photos have in fact transferred correctly and are safely stored on your computer. Then manually delete one or more images using the steps outlined in this section.

Delete Photos from Your iPhone/iPad

To manually select and delete one or more photos stored on your iOS mobile device, launch the Photos app and follow these steps:

1. Tap on the Photos or Albums tab at the bottom of the screen and locate the image(s) you want to delete.

2. Tap on the Select option displayed in the top-right corner of the screen.

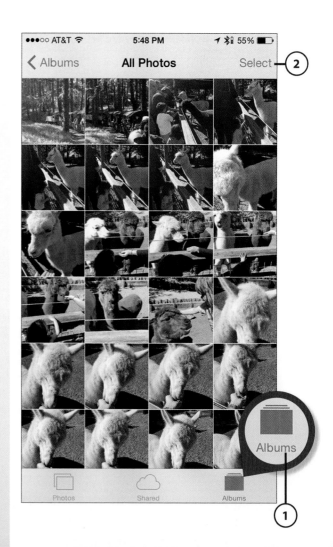

3 One at a time, select the images you want to delete. As images are selected, a circular blue-and-white check mark icon appears in the lower-right corner of its thumbnail.

4 When all the desired images are selected, tap on the Trash icon to delete those images.

5 Confirm your deletion decision by tapping on the red Delete [number] Photos option displayed near the bottom of the screen.

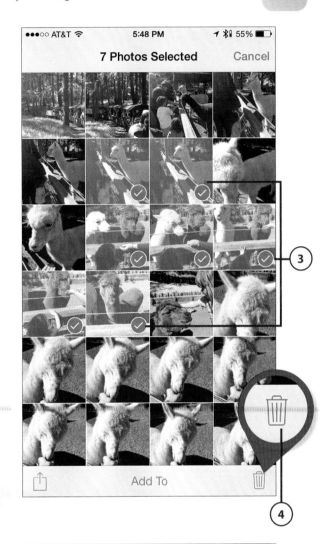

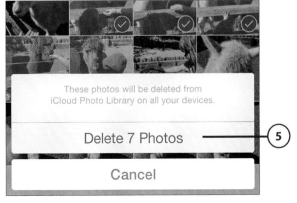

Delete Photos from Your Android-Based Mobile Device

To manually select and delete one or more photos stored on your Android-based smartphone or tablet, launch the Photos app and follow these steps:

1. From the Photos app, open the album or locate the photos you want to delete.

2. Tap on the More icon to open its menu.

3. Tap the Select option.

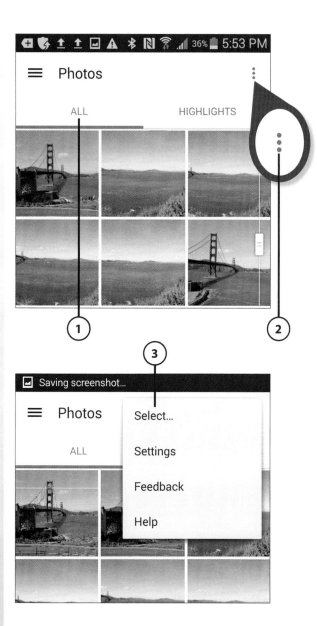

4 One at a time, tap on the thumbnails for the images you want to delete.

5 Tap on the Trash icon displayed in the top-right corner of the screen to delete those images.

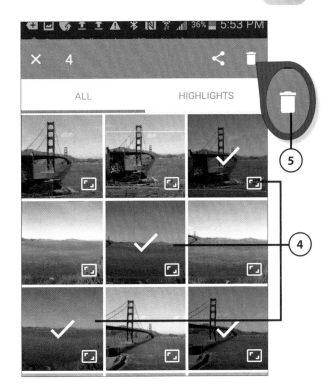

Working with Images Stored on Your Computer

In this chapter, you learned about the various ways you can transfer your images from your mobile device to your computer. Once they're stored on your computer's hard drive, or on a hard drive connected to your computer, you can view, organize, edit, enhance, manage, print, share, and archive the images, plus back them up to an online-based service.

Working with digital image files on your Windows PC or Mac computer is the focus of Chapter 6, "Viewing, Editing, and Enhancing Photos Using Your Computer." As you discover in the next chapter, however, you also can do a lot with your images directly from your Internet-enabled mobile device.

There are many ways to quickly edit and enhance a photo directly from your smartphone or tablet.

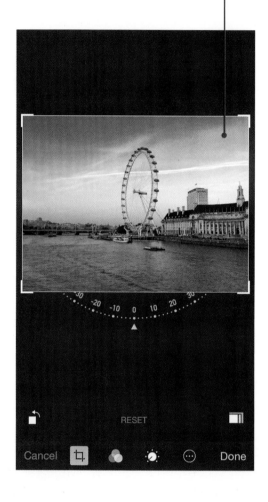

In this chapter, you'll learn how to use some of the common photo editing and enhancement tools found in most photo editing mobile applications. You also learn about the apps for this purpose that come preinstalled on your smartphone or tablet, as well as some that are available to be downloaded and installed. Topics include

5

→ Differentiating between image enhancement and editing tools

→ Discovering how to use common photo editing and enhancement tools

→ Learning quick strategies for editing or enhancing your photo

Viewing, Editing, and Enhancing Photos On Your Mobile Device

One of the great things about taking photos using a smartphone or tablet is that in addition to serving as a camera, that same mobile device can be used to view, edit, enhance, store, print, and/or share your digital images—all without using a computer. Thus, you can take photos while you're out and about, quickly edit or alter their appearance, and using the Internet connection offered by your smartphone or tablet, share those images online via social media. The capability to quickly edit and/ or enhance your photos after they are shot is not something point-and-shoot or digital SLR cameras offer.

This chapter focuses on ways to edit and enhance your photos after they're stored in your smartphone or tablet.

Enhancing and Editing Photos

Often, when you simply snap a photo using a digital camera, even if you set up everything correctly, the image might not look perfect. However, using the image editing and enhancement tools available to you from a mobile device, or using specialized software on your computer, a wide range of powerful and easy-to-use tools are at your disposal. These tools enable you to quickly edit, enhance, or dramatically alter the appearance of a digital image before you share it via the Internet, create prints, or showcase it in other ways.

There is a slight distinction between enhancing and editing a photo. Most photo editing mobile apps and software packages for computers offer a one-tap or one-click enhancement tool, as well as a variety of special effect image filters. In addition, they offer individual image editing tools that allow the photographer to alter one aspect of an image (or a portion of an image).

>>>Go Further
WHAT THE ENHANCEMENT TOOL DOES

With a single tap or click, an image enhancement tool analyzes your image and then automatically adjusts the color, contrast, saturation, brightness, white balance, and other aspects of a photo, based on what it determines is appropriate.

The Enhancement tool won't fix a blurry photo, but it will make a dark image brighter, make an overexposed image darker, or enhance colors within an image to make it look more vibrant.

The icon for the Enhancement tool typically looks like a magic wand or paintbrush.

Shown on the following page is a "before" and "after" photo demonstrating the Enhancement tool taken using an Android-based HTC One smartphone. The "before" photo (left) shows the original image in the Photos app, just after it was shot with no changes made to it. The "after" photo (right) shows the altered image after the one-tap Enhancement tool was used. Notice the green leaves are brighter, as are the colors of the flower petals. In some cases, the edits made with the Enhancement tool will be subtle (look closely at the green leaves in these images), while in other situations, they'll be much more noticeable.

When you use the Enhancement tool or an image filter, it improves or changes an entire image, but you often can't adjust the intensity of the effect. In most cases you can only turn it on or off.

Image Filters Vary

Each photo editing app or computer software package offers its own unique collection of filters. In some cases, additional filters can be downloaded and used with an app. An image filter is typically used to quickly and radically alter an entire image's appearance.

Beyond the quick-and-easy one-tap or one-click Enhancement tool and special effect filters, the photo editing mobile app or computer software you use also offers a selection of separate image editing tools.

An image editing tool can impact an entire image, or in some cases, only a portion or section of an image, and each tool alters the image in a specific way. In addition, as the photographer, you can often manually adjust the impact each particular tool has on your image, plus mix and match various editing tools to fix or alter an image to your liking. Thus, editing tools tend to offer customizable options for fixing or altering your photos.

Regardless of which photo editing app or computer software you use, a handful of common editing tools are available to you, such as Crop, Straighten, Exposure, Brightness, Contrast, Color, and Saturation, each of which has a different impact on your image.

Using Common Photo Editing Tools Built in to Smartphone and Tablet Apps

Every iOS, Android, and Windows Mobile smartphone and tablet comes with an app preinstalled, called Photos. While these apps share the same name and the same overall function, each is totally different in terms of its user interface, layout, and design, and what features and functions are offered. However, the primary purpose of the Photos app offered on each mobile device is to allow you to view, edit, enhance, print, share, and organize your images.

Built in to each of these Photos apps are a handful of common editing tools, which you learn about in this section. Then, in the next section, you discover how to access and use these tools on the particular iOS or Android smartphone or tablet you're using. Windows Mobile is not covered in this chapter, but these devices include the same sorts of features you see demonstrated here.

Straightening Shots

One of the most common mistakes photographers make when taking a photo, especially when they themselves are in motion or have trouble seeing the viewfinder screen when a picture is being taken, is that the camera (your smartphone or tablet) is accidentally held at an angle when the Shutter button is pressed. As you can see in the photo on the left, this causes the photo to look rather odd and crooked.

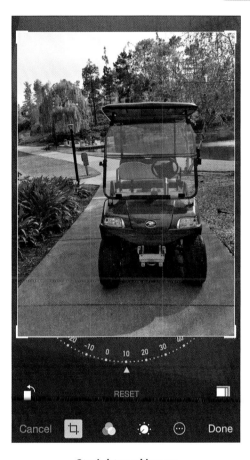

Crooked image **Straightened image**

Luckily, most photo editing mobile apps and computer software applications have a Straightening tool to easily fix this problem. To access and use it, you typically select the Crop tool, and then use the Image Straightening feature, which enables you to manually rotate the image until it appears straight in the Crop Frame.

Once the image has been straightened, you can further use the Crop tool, or any of your other image editing or enhancement tools, as you deem necessary.

Rotating Images

While the Straightening tool is used for potentially minor straightening adjustments to a photo, the Rotation tool is used to rotate an image 90-degrees at a time, with each tap.

As you can see here, on an iOS, Android, and Windows Mobile-based smartphone, the Rotation tool icon typically looks like a square or rectangle with a curved arrow around it, or is represented by just a curved arrow.

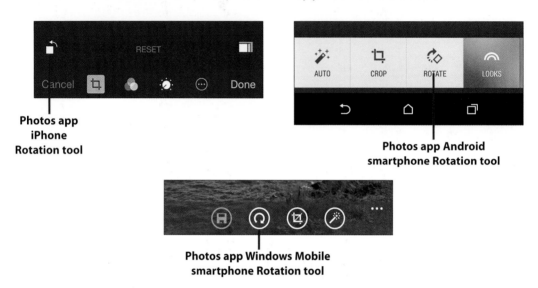

**Photos app
iPhone
Rotation tool**

**Photos app Android
smartphone Rotation tool**

**Photos app Windows Mobile
smartphone Rotation tool**

Cropping Images

The Crop tool enables you to remove areas around the outer edges of your photo, create a virtual zoom effect on your intended subject, or reframe your image after it's been shot.

When you're viewing an image, if you select the Crop tool during the editing process, a frame appears around the image. It's then possible to move any of the corners of the frame inward (at a diagonal) to cut away part of the image's outer edges. Shown here is an example of the impact this tool can have when trimming an image's outer edges.

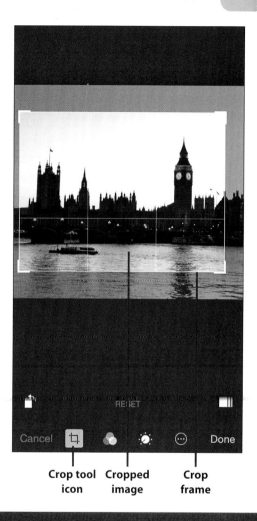

Original image Crop tool Cropped Crop
 icon image frame

It's Not All Good

Cropping Reduces an Image's Resolution

When you use the crop tool, this does negatively impact an image's resolution. Thus, depending on the initial resolution of the image, you might discover that when you try to create a print or printed enlargement, the print will be pixelated or blurry as a result of the crop. This tool is best used on higher-resolution images if you're planning to create prints or enlargements.

Additional Editing Tools

Depending on which photo editing mobile app you're using, most group together editing tools based on their overall purpose. Editing tools can typically be manually adjusted separately, as needed, using an onscreen slider.

Most of the available editing tools can be used with one another, enabling you to add creative or unique effects or fixes to your images. Although in some cases, using just one tool improves an image to the point you are proud to show it off, some images may require you to apply two, three, or more editing tools to make them look more professional.

In the next set of sections, to demonstrate the impact common editing tools have on an image (when used on their own), we start with one original image and then adjust the image using one editing tool at a time.

Keep referring back to this original image see how each tool impacts its appearance. Keep in mind that, in addition to these tools, each photo editing mobile app offers a unique selection of other useful tools.

Original image

> Go Further

DIFFERENT APPS OFFER DIFFERENT TOOLS

Because each photo editing app offers its own unique collection of editing and enhancement tools, if you become serious about taking and editing pictures from your mobile device, it makes sense to install two or three different photo editing apps on your smartphone or tablet to give you the broadest range of options when editing images that require specific types of adjustments or enhancements.

The following is a brief description of popular editing tools and an example of each being used on a sample image. For most of these examples, the Photos app running on the Android-based HTC One smartphone was used.

- **Brightness**—Use this tool to make an image lighter or darker. If the image appears too bright (overexposed) after it was shot, use the Brightness tool to darken it. If it appears too dark (underexposed) after it was shot, use the Brightness tool to lighten it.

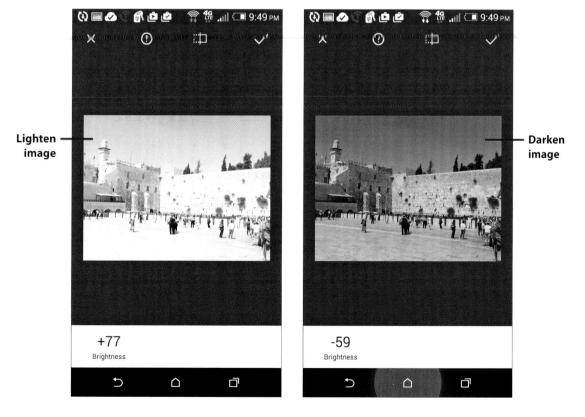

Lighten image

Darken image

- **Contrast**—Use this tool to alter the contrast between the light and dark tones and colors appearing in the image. Thus, some pixels within the image are either lightened or darkened. The Brightness tool, however, simply lightens every pixel within the image.

Lighten contrast

Darken contrast

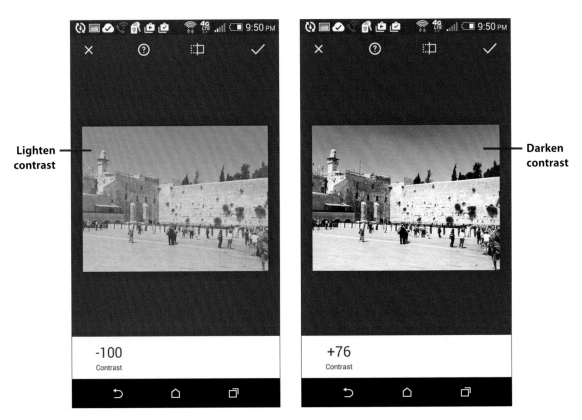

- **Saturation**—Use this tool to intensify or reduce the intensity of the colors appearing in your photo. For example, when you use the Saturation tool on an image taken outdoors, the color of the sky becomes richer, brighter, and more vibrant. Like many editing tools, this one typically uses some type of onscreen slider to manually adjust its intensity.

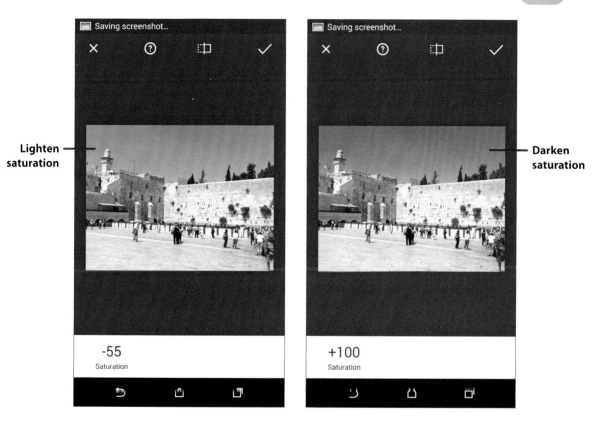

Lighten saturation

Darken saturation

- **Sharpness/Sharpen**—If an image (or a portion of an image) is slightly blurry, for whatever reason, the Sharpness (which is sometimes called Sharpen) tool can correct this. While this tool can make a slightly blurry image appear more in focus, it can't transform a very blurry image into a clear one. (Not shown.)

- **Highlights and Shadows**—In some cases this is one tool, while other apps use two tools to enable you to alter highlights and shadows separately in a photo. Using a slider, this adjustable tool can be used to reduce unwanted glares, reduce the negative impact of shadows, and/or enhance the detail of an image. (Shown on the next page using the Photos app on an iPhone.)

Highlights enhanced 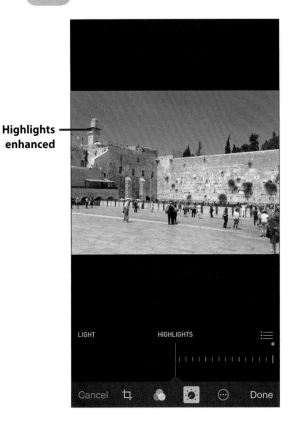 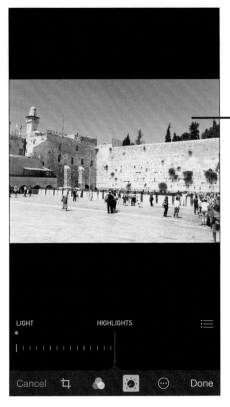 **Highlights reduced**

- **Blur Background/Center Focus/Vignette**—To help make your intended subject stand out in a photo, this tool, which goes by different names depending on the app, either enables you to tap on your intended subject and then blur what surrounds it, or the tool simply blurs (or darkens) everything around the edges of your image, depending on the app.

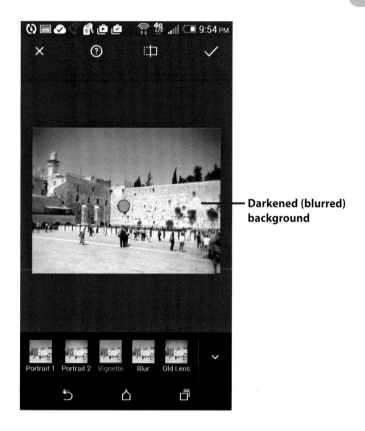

Darkened (blurred) background

THE VIGNETTE TOOL VERSUS SELECTIVE FOCUS

When using the Camera app on an Android-based mobile device, one of the shooting modes is called Selective Focus. It enables you to tap on your intended subject within the viewfinder and then have the background blurred out as you're taking the photo. The Center Focus editing tool, however, can create a similar visual effect during the editing process, after the photo has been taken. When using the official Instagram app on your mobile device to edit a photo, this tool is called Vignette.

Using the Photo Editing and Enhancement Apps On Your Device

Now that you know what's possible using some of the more common photo editing and enhancement tools, let's take a brief look at the Photos app that comes preinstalled on iOS and Android smartphones and tablets, so you can see where these and other tools are located, and how to access them. (The information included here can be adapted to Windows Mobile devices.)

Attention Point-and-Shoot and Digital SLR Camera Users

Most point-and-shoot and digital SLR cameras do not enable you to edit photos directly in the camera. Thus, it's necessary to first transfer the images from the camera's memory card to either your mobile device or computer, and then edit them.

Edit with the iOS Photos App

To begin using the Photos app on an iPhone or iPad (running iOS 8.2) to edit or enhance an image, follow these steps:

(1) Tap the Photos app from the Home screen.

(2) Select the album that contains the photo you want to work with.

(3) Tap on the image you want to work with to view it on the iPhone or iPad's screen.

(4) Tap on the Edit option displayed in the top-right corner of the screen to access the app's photo editing and image enhancement tools.

(5) Tap on the Enhancement tool to enable it and see its effect. (When the feature is turned on, the Enhancement tool icon turns blue.)

Turn Off the Enhancement Tool

As soon as you tap on the magic wand-shaped icon, the app automatically enhances the image. If you don't like the results, simply tap on the Enhancement tool icon again to turn off the feature.

Additional Editing/Enhancement Tool Icons

On the iPhone, displayed along the bottom of the screen from left to right are the Cancel, Crop, Filters, Editing Tools, More, and Done/Revert icons and options. These same icons are displayed along the right margin of the screen. Using any of these tools is optional, based on how you're trying to fix or alter an image.

(6) Tap on the Crop tool icon to access the Crop tool, Image Straightening tool, Rotation tool, and Aspect Ratio menu. Notice that a white frame appears around the image.

(7) To use the Crop tool use your finger to adjust the corners or sides of the frame.

(8) To use the Straightening tool, place your finger on the Straightening dial below the Crop Frame and slide it sideways, left or right. For demonstration purposes, this image has been adjusted by 20 degrees.

(9) To rotate the image 90 degrees at a time, tap on the Rotation icon.

Crop, Straightening, and Rotation Tool Tip

If you alter an image by cropping, straightening, or rotating it but don't like the results, tap on the Reset option to return these settings to their original positions. All your other edits remain intact.

(10) To adjust the Aspect Ratio of an image, tap on the Aspect Ratio icon, and then select an option from the pop-up menu displayed (not shown).

(11) Tap on the Filters icon to add an optional special effect filter to your image. The nine filters built in to the Camera app are also available in the Photos app, and one can be added to each image, but the intensity of the filter effect is not adjustable using the Photos app.

(12) Tap on the icon that represents the filter you want to apply to your image, or select the None filter option.

Additional Third-Party Filters Are Available

From the App Store, it's possible to download and install additional third-party filters that can be used with the Photos app. However, other photo editing apps, including a few described in the "Using Optional Photo Editing and Enhancement Apps" section later in this chapter, offer a much better selection of built-in filters.

(13) Tap on the Editing Tools icon to access any of the Photos app's other editing tools.

(14) Tap on the Light menu option.

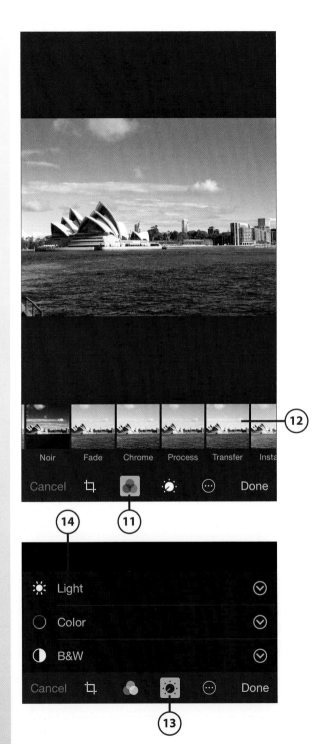

(15) Use your finger to move the slider to increase (right) or decrease (left) the intensity of the colors in your image.

More Lighting Options
Tap on the Light Menu icon to access additional sliders for Exposure, Highlights, Shadows, Brightness, Contrast, and Black Point.

(16) Tap the Color menu option.

(17) Use the slider to adjust the color usage in the photo.

More Color Options
Tap on the Color Menu icon to separately adjust the Saturation, Contrast, and Cast options related to the image you're working with.

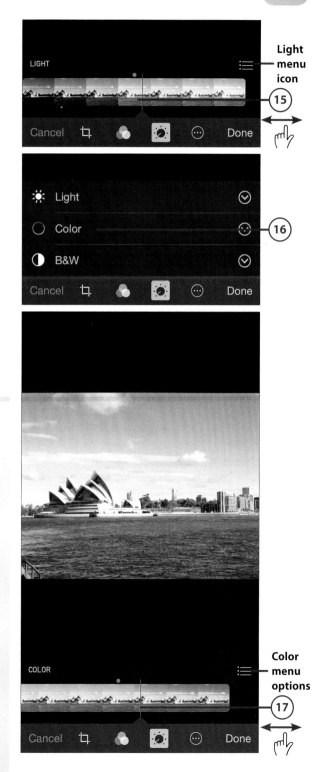

(18) Tap on the B&W option to remove the color and create a black-and-white image instead of keeping the image you're working with in full color.

(19) Tap on the B&W Menu icon to manually adjust the Intensity, Neutrals (shown), Tone, and Grain tools, one at a time. Each has a slider associated with it.

(20) Tap on the More icon to access any third-party filters or apps you might have installed that work with the Photos app.

(21) Tap Done when you're finished editing or enhancing the image to save your changes. The image, with all your edits or enhancements, is saved in whatever album the image came from and, by default, replaces the original version of your image.

Discarding Changes

If you want to get rid of the edits you made, instead of clicking Done, click the Cancel button.

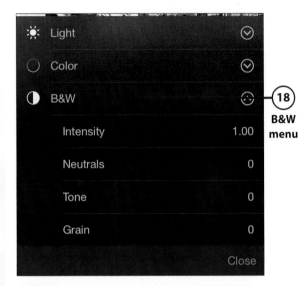

**18
B&W
menu**

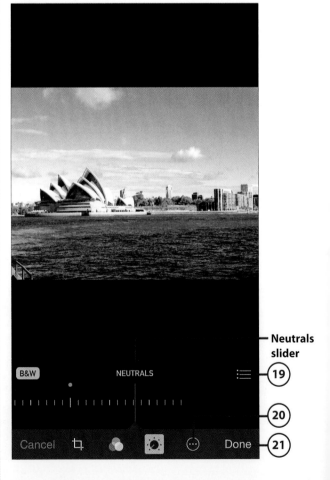

**Neutrals
slider**
19
20
21

>>>Go Further

EDITED PHOTOS ARE SYNCED

If you have the Photos app set up to sync with iCloud Photo Library, for example, as soon as you save an edited image, the new version of the photo will sync with your iCloud account and become accessible to all your other computers and mobile devices linked to that iCloud account. The new version of the image, by default, replaces the old one.

At any time, you can reload the edited photo into the Photos app on your iPhone, iPad, or Mac, and then add additional edits, revert the image to its original form, or remove specific enhancements. However, if you transfer the edited image to a different photo editing app and then resave it, this will no longer be possible.

Once you've fully utilized the photo editing or image enhancement tools built in to the Photos app, you always have the option of loading the same image into a different app for further editing or enhancement. This enables you to take advantage of filters or editing tools not offered by the Photos app.

Using the Photos App on an Android Smartphone or Tablet

Android's Photos app has an array of different tools you can use. This section explores some of the most useful tools. To begin using the Photos app on an Android-based smartphone or tablet to edit or enhance an image, follow these steps:

(1) From the Apps screen, tap on the Photos app icon to launch the app.

Android Variations

Depending on which version of the Android operating system your smartphone or tablet uses, the options available, the appearance of screens, and the location and appearance of command options and icons can vary. The steps shown in this section are demonstrated on an HTC One Android-based smartphone (running Android version 4.4.4).

Automatic Backup and Enhancement

The first time you use this app, you can turn on the Automatic Backup and Auto Enhancement tool, which applies to all images in the future. Tap on Sign In to activate these features with your existing online-based Google Drive account.

(**2**) From within the albums stored on your mobile device, find and select the image you want to edit or enhance. The single image you select is displayed on the screen.

(**3**) To edit the image, tap on the pencil-shaped Edit icon.

Tap the Back Button to Take a Step Backward

Anytime you select an option and then change your mind about using it, tap on the Back button at the bottom of the smartphone's screen to return to the previous screen without saving your latest changes.

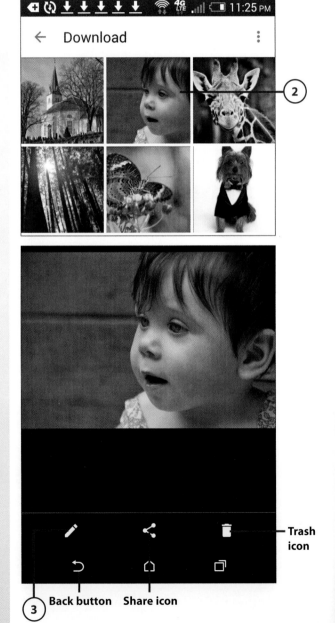

Trash icon

Back button Share icon

(4) Tap the More icon to see its menu options.

(5) From this menu, tap the Revert command at any time to remove all the edits you've added to an image and return to its original appearance.

Tap the Check Mark to Save a Change

Anytime you use an editing or enhancement tool to make a change that you want to keep, tap on the check mark icon displayed near the top-right corner of the screen to save that latest edit or change. You then are returned to the main image editing screen.

(6) Tap the Before/After icon after applying a new edit or enhancement to an image to compare the altered image to the original version.

(7) Scroll horizontally with your finger along the bottom of the screen to view all the editing tools available to you: Auto, Crop, Rotate, Looks, Tune Image, Selective, Details, Vintage, Drama, Black & White, HDR Scape, Retrolux, Center Focus, Tilt Shift, and Frames.

(8) Tap on the Auto Enhancement tool.

Some Editing and Enhancement Tools Come in Sets

Depending on which editing tool icon you tap on, multiple editing or enhancement tools may become available to you, also in the form of icons. Instead of using a traditional horizontal slider, the Photos app on Android devices requires you to place your finger on the actual image, and then drag it up or down to reveal and select submenu options, or drag your finger horizontally to increase or decrease a selected tool's intensity.

(9) Tap Off, Normal, or High to select a level of enhancement. The High setting uses stronger adjustments than the Normal setting, while none shows the photo without any enhancement.

(10) Tap the check mark icon to save your changes and return to the previous screen.

(11) Tap on the Crop tool.

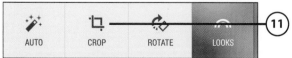

(12) Tap and drag on the corners of the frame that appears around the photo to adjust the amount of cropping.

(13) Tap the check mark icon to save your changes.

Crop Styles

Below the Crop Frame are three command tools: Free, Original, and Square. Free enables you to adjust the Crop Frame to any dimensions and shape. Original keeps the image's original aspect ratio. Square crops your image into a square (instead of a rectangular) shape.

(14) If you want, tap the Rotation tool to rotate your image 90 degrees.

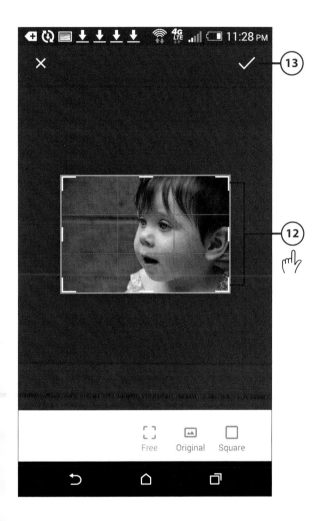

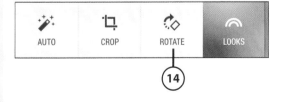

(15) Tap the clockwise or counter-clockwise rotate icons to rotate the photo 90 degrees in that direction.

Rotate Images

To rotate the image less than 90 degrees, place your finger near the bottom or top of the image and drag it slowly left or right.

(16) Tap the check mark icon to save your changes.

(17) Tap on the Looks tool to apply one of 15 image filters built in to the app. You can only add one Filter to an image.

(18) Tap on the Tune Image tool to change the photo's Brightness, Contrast, Saturation, Shadows, or Warmth. (To adjust these settings place your finger near the center of the image and drag it downward.)

Using the Tuning Tools

When the tool you want is highlighted in blue, lift your finger and then place it back on the image and drag it left or right to decrease or increase the intensity of that tool.

(19) To apply edits or enhancements to one particular part of an image, tap on the Selective icon. Next, tap on the plus-sign icon, and tap on the area of the image you want to work with (such as the focal point of your image.)

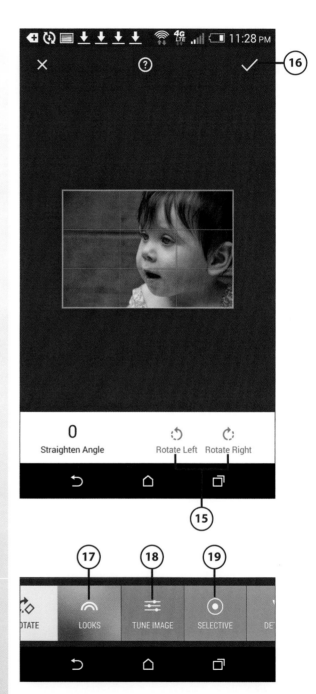

>>> Go Further

SELECTIVE EDITING TOOLS

A huge variety of editing tools is available to you in the Selective category—too many to cover in detail here. Among the tools you can use to enhance your photos are controls for adjusting contrast and saturation, sharpening, a variety of specialized filters, focus adjustment, and much more. The best way to get to know these tools is to experiment with them one by one and observe how they affect the photo to which you're applying them.

When you're finished using the editing and image enhancement tools, be sure to tap on the Done option to save your changes. If you have the Auto-Sync feature turned on, the image automatically uploads to your Google Drive account and replaces the original (unedited) image.

As long as you don't load the edited image into a different photo editing app, you can later reload the edited image back into Photos and remove or add edits or revert the image back to its original appearance.

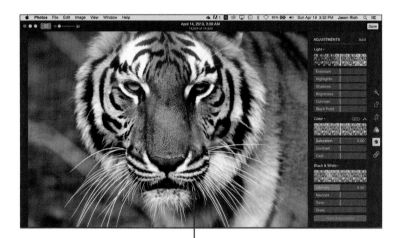

There are many PC or Mac photo editing and
enhancement software packages you can use to
fix or alter your images.

In this chapter, you'll learn how to use special-
ized computer software (as opposed to an
app on your smartphone or tablet) to edit or
enhance your images prior to sharing or show-
casing them. Topics include

6

→ Learning about your photo editing software options
→ Exploring popular software-based photo enhancement
 tools
→ Using the photo editing software that comes preinstalled
 on your computer
→ Discovering other popular photo editing and enhance-
 ment software applications available for PCs and Macs

Viewing, Editing, and Enhancing
Photos Using Your Computer

The Windows operating system (8.1 and later) for PCs and OS X Yosemite
operating system for Macs both come with photo editing and enhance-
ment apps. This software enables you to view, edit, enhance, and ulti-
mately organize, print, and/or share your digital images directly from
your computer.

As you'll discover, many of the photo editing and enhancement
tools available from the mobile apps you learned about in Chapter 5,
"Viewing, Editing, and Enhancing Photos On Your Mobile Device," are
also available for your computer, along with a selection of additional
tools.

The Photos app that comes preinstalled with Windows (on PCs) and OS X Yosemite (on Macs) has the same name, but each functions differently. Both offer a decent collection of editing and enhancement tools that will meet your basic needs when it comes to fixing or improving the look of digital images stored on your computer.

However, if your digital image editing and enhancement needs go beyond what these basic photo editing and enhancement apps offer, there are many optional software packages you can purchase and download for your PC or Mac that offer far more powerful and versatile tools. You learn a bit more about these optional applications toward the end of this chapter.

Editing and Enhancing Images on Your PC Using the Photos App

The Photos app that comes preinstalled on your PC that's running Windows offers a selection of quick and easy-to-use photo editing and enhancement tools, the majority of which get applied to an entire image.

Windows 10 Might Be Different

Although this book is written based on Windows 8.1, if you've upgraded to 2015's release of Windows 10, you should expect a similar version of the Photos app to still be there, although it might include additional image editing/enhancement tools. It's also possible that the appearance and onscreen location of existing tools and icons may vary once you upgrade to Windows 10.

This chapter assumes you already transferred photos to your computer, as described in Chapter 7, "Organizing and Managing Photos on Your Computer."

Get Started Using the Photos App

To get started using the Photos app, follow these steps:

(**1**) Click the Photos app tile from the Start screen.

No Photos Tile

If you don't see the Photos app, click on the downward-pointing Apps Listing icon displayed in the bottom-left corner of the Start screen and when the alphabetical listing of apps installed on your PC is displayed, click on the Photos item to launch the app.

(**2**) Click on the downward arrow icon to choose a location where your pictures are stored.

(**3**) Click a location. Most pictures are automatically stored in the Pictures Library folder.

(**4**) Click on a folder to open it.

Drilling Deeper

If the folders in your Pictures Library contain their own folders with pictures, you can click on those folders to see the pictures they contain.

(5) Click on the photo thumbnails you want to work with.

(6) Click a second time on the image to reveal the Editing and Enhancement tool icons available to you.

Your Toolbox

The tools displayed along the bottom of the screen, from left to right, include Delete, Open With, Set As, Slide Show, Rotate, Crop, and Edit. How to use these tools is described in the next section.

(7) To edit or enhance the image, click on the Edit icon displayed in the bottom-right corner of the screen. (See the section "Using the Editing and Enhancement Tools" later in this chapter for more details on these tools.)

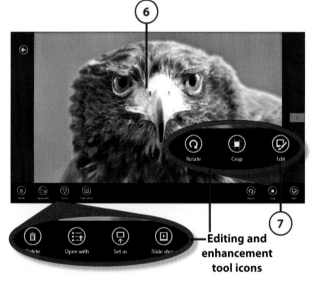

Editing and enhancement tool icons

Understanding the Photos App's Main Tools

The following editing/enhancement tool command icons are displayed along the bottom of the screen:

- **Delete**—Click on this icon to delete the selected image.

- **Open With**—To open and work with the selected image in another (compatible) application installed on your PC, click on this option. A listing

of compatible apps is displayed. Click on which software you want to use instead of the Photos app.

• **Set As**—Make the selected image your computer's Lock screen wallpaper, or use it as the image to be displayed on the Photos app tile on the Start screen.

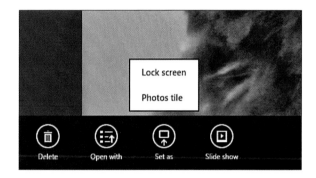

• **Slide Show**—Create an animated slide show using a group of selected photos. See Chapter 15, "Creating and Sharing Animated Digital Slide Shows," for directions on how to use this feature.

• **Rotate**—Each time you click on this icon, your image rotates 90 degrees clockwise.

• **Crop**—Crop and/or reposition your image within the Crop Frame, as well as adjust the Aspect Ratio of the selected digital image using this tool.

• **Edit**—Click on the Edit button to gain access to all of the Photo app's other image editing and enhancement tools, which are described in the next section.

Using the Editing and Enhancement Tools

When you click on the Edit icon, five additional editing and image enhancement tools are displayed along the left side of the screen. From top to bottom, these tools include Auto Fix, Basic Fixes, Light, Color, and Effects. When you click on each tool, additional (and related) tools and options become available.

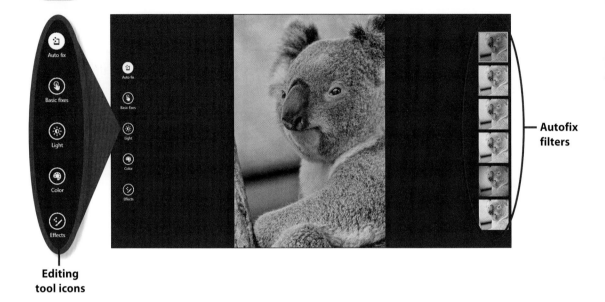

Autofix filters

Editing tool icons

Use Any Combination of Editing Tools

Keep in mind that, when editing/enhancing a single image, it's possible to mix and match the use of tools as you see fit to fix, alter, or tweak an image to your liking before saving and sharing or showcasing it.

After you've made any changes using the editing or enhancement tools available to you, click on one of the app's Save options:

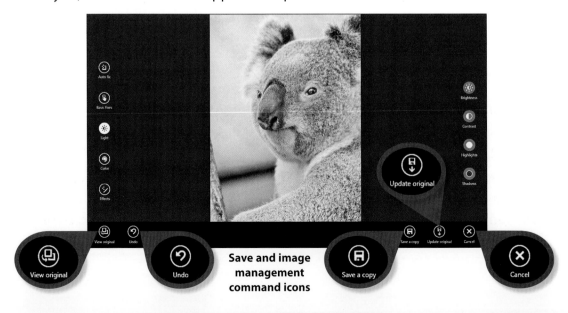

Save and image management command icons

- Click on the View Original icon displayed at the bottom of the screen to compare the original image with the newly edited version.

- Click on the Undo icon to remove a selected change from the image.

- Click on the Save a Copy option to make a copy of the image with the changes but keep the original version as well. The copy is given a different filename, but the new file is saved in the same folder/album as the original.

- Click on the Update Original icon to save your changes and replace the original version of the image with the newly edited one.

- Click on the Cancel icon to exit out of the selected tool (or whichever tool you're using) without saving anything or altering the selected image in any way.

The following sections offer a more detailed rundown of each of the main editing tools and what they're used for.

Auto Fix

The Auto Fix filters works just like the Auto Enhancement feature found on mobile devices (refer to Chapter 5). When using this tool, however, on the right side of the screen six Auto Fix options are selected, each of which enhances the image's contrast, brightness, saturation, and other related tools slightly differently. So, after clicking on the Auto Fix option, click on each of the one-click Auto Fix filters on the right side of the screen to see how they impact your selected image. Choose the one you like best.

Basic Fixes

When you click on the Basic Fixes icon displayed on the left side of the screen, five additional edit tool icons are displayed on the right side of the screen, which from top to bottom include Rotate, Crop, Straighten, Red Eye, and Retouch.

From Chapter 5, you already know how Rotate, Crop, and Straighten work. The Red Eye tool needs to be used only if you've taken a photo of a person using the flash, and the subject's eyes appear bright red. This tool removes the red color.

When you click on the Red Eye tool, the mouse cursor displays a purple dot. Place the dot over one of the subject's eyes and click the mouse. Repeat this on the other eye.

The Retouch tool enables you to remove aspects of an image that you don't want displayed, such as a wrinkle or blemish on someone's face, or some other relatively small element in an image.

Use the Retouch Tool

To use the Retouch tool to remove, in this example, the anchor chain seen coming out of the cruise ship's bow, follow these steps:

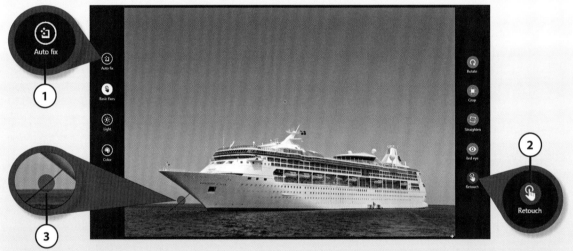

① After opening an image within the Photos app, click on the Basic Fixes icon.

② Click on the Retouch icon. The Retouch tool displays a purple dot below the mouse cursor.

③ Position the cursor over one part of an image that you want to fix, remove, or repair, and either click the mouse once over that spot or hold down the mouse, and then drag the cursor over the area you want to retouch. Shown here, the anchor chain coming out from the front of the ship is being removed.

(4) This tool automatically examines what surrounds the area of the image you're retouching, removes whatever aspect of the image you "painted" over with the Retouch tool (the purple dot), and then blends in the retouched area to make the whole image look seamless.

Light

When you click on the Light icon displayed on the left side of the screen, on the right side of the screen, four additional light-related editing tools become available. Displayed from top to bottom, these tools include Brightness, Contrast, Highlights, and Shadows.

One at a time, click on each of these tools (as they're needed). A circular slider for that tool is displayed. Using the mouse or the arrow keys on the keyboard, rotate the white circle around the slider to increase or decrease the intensity of the selected tool.

As you adjust each slider, changes to the selected image are displayed in real time, so you can see the impact of increasing or decreasing each tool's intensity. Remember, you can mix and match the use of these tools as needed. It's possible to adjust the Brightness and Contrast, for example, but leave the Highlights and Shadows tools at their default settings.

What's Hidden In The Shadows?

When it comes to "fixing" the lighting in an image, Highlights and Shadows, as well as Brightness and Contract, are often the tools you'll use. If you want to bring out otherwise hidden detail in darker areas of an image, such as in the shadows, tinker with the Highlights and/or Shadows tools.

Color

When you click on the Color tool displayed on the left side of the screen, on the right side, four additional Color-related tool icons are displayed, which from top to bottom, include Temperature, Tint, Saturation, and Color Enhance.

Using Color-Related Tools

Your photo editing software probably offers a handful of color correction tools. Each impacts your image slightly differently. When you need to fix or enhance the colors in an image, one at a time, tinker with the Temperature, Tint, Saturation, and Color Enhance tools that are offered. See the Help feature in your software for a more detailed explanation of how these tools differ, or simply experiment with each of them until you achieve the results you desire.

Click on each icon, one at a time, to adjust that tool's intensity setting. Each time you do this, a circular slider for that tool is displayed. Use the mouse or the arrow keys to adjust each tool's intensity, as needed. These tools are used to increase or decrease the clarity, vibrancy, and visual impact colors have on each image.

Effects

Two additional editing/enhancement tools are available to you when you click on the Effects icon. These tools include Vignette (top-right) and Selective Focus (bottom-right).

When you click on the Vignette tool, its circular slider appears. Depending on which way you move this slider, the edges of your image are blurred and replaced by a light (white) or dark (black) vignette. This effect helps accentuate your intended subject displayed near the center of the frame.

Shown here is the image of the cruise ship used previously with the Vignette tool used at 90% on the white (negative) side.

— **White Vignette effect**

Although you can increase or decrease the intensity of this tool, the vignette effect that's created appears only around the outer edge of the entire image and not the center.

The Selective Focus tool enables you to manually select the focal point (subject) of your image, and then blur out the outer edges of the selected area to better accentuate and draw the viewer's attention to an area of the image that you, as the photographer, choose.

Use the Selective Focus Tool

To use the Selective Focus feature, locate the image in the Photos app that you want to edit, select the Edit icon, and follow these steps:

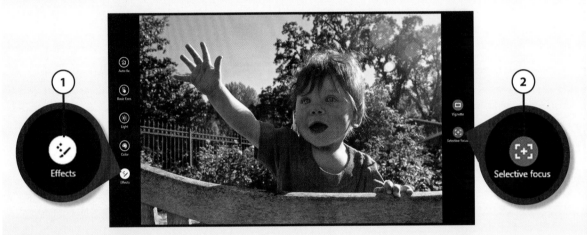

1. Click on the Effects icon.

2. Click on the Selective Focus icon. The cursor displays a large circle over your image, with four adjustable repositioning dots displayed on the circle.

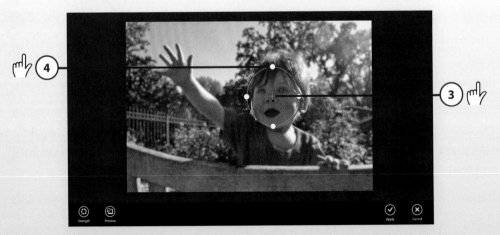

3. Place the cursor on the "+" displayed in the center of the circle and drag it so that it's positioned directly over the intended subject (or the area of the photo you want people to focus on).

4. Place the mouse on one of the repositioning dots and drag it inward or outward to alter the shape of the Selective Focus circle and/or increase or decrease its size. This enables you to select the in-focus area (what's seen inside the circle), plus determine the area of the image that will be slightly blurred (outside the circle).

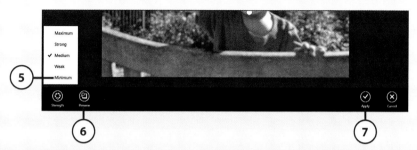

5 Click on the Strength icon to choose the intensity of this effect on your image. Your menu-based options include Maximum, Strong, Medium (shown here), Weak, or Minimum.

6 Click on the Preview icon to compare the original image with the latest edited version.

7 Click on the Apply icon to save your edits, or click on the Cancel option to return to the previous screen without saving your changes.

SHARING YOUR CREATIONS

From the Photos app, it's then possible to share your edited images in a variety of ways. Image sharing is covered in Chapter 9, "Sharing Pictures with Family and Friends via Email and Instant Messages," and Chapter 10, "Sharing Photos Online."

Editing and Enhancing Images on Your Mac Using the Photos App

The Photos app that comes bundled with all Macs was released in April 2015 and replaced iPhoto. This new streamlined application is designed to help Mac users manage all aspects of their entire digital photo collection. Thus, it offers a well-rounded collection of photo editing and enhancement tools.

The Photos App Works with iCloud

The Photos app fully integrates with all online-based iCloud Photo Library features and functions, so as images are taken on a mobile device, they can be uploaded to iCloud Photo Library and then made accessible from the Photos app running on a Mac, typically within seconds. Be sure to adjust the Photos Preferences menu options (in the Photos app on your Mac and iOS mobile devices) to determine exactly which photos will sync with your iCloud account.

>>>*Go Further*

INSTALL PHOTOS ONTO YOUR MAC

If your Mac still has iPhoto installed and you want to upgrade to the Photos app, it's free to do this. However, your Mac must be running the OS X Yosemite operating system.

Launch the Mac App Store application on your computer when it's connected to the Internet, and click on the Updates button displayed near the top-right corner of the screen. Then, click on the OS X Update option to select, download, and install it. In addition to updating your computer's entire operating system, doing this replaces iPhoto with the Photos app.

Before updating your operating system and installing Photos, it's a good idea to create a backup of your Mac's contents using the Time Machine backup feature.

To make working with the Photos app easier, many of the tools and options are accessible from the pull-down menus displayed at the top of the screen, as well as via keyboard shortcuts. The keyboard shortcuts supported by this app are displayed to the right of each pull-down menu option. Here's an example of this.

Keyboard shortcuts

As you'll see, as you're editing or enhancing an image, all the editing tools and options are also displayed as icons and/or sliders, when they're accessible, on the left side of the screen.

Edit Images Using the Photos App on a Mac

When you're ready to begin accessing images using the Photos app to edit or enhance them, one at a time, launch the Photos app and follow these steps:

Double-click

1. To locate any images stored on your Mac (in the Photos app), click on the Photos, Shared, Albums, or Projects button displayed near the top-center of the screen.

2. When you open an album that contains thumbnails for a group of images, double-click on the image you want to open and edit or enhance.

>>>*Go Further*

QUICKLY FINDING PHOTOS

When you click on the Photos button, displayed near the top center of the Photos app, it displays thumbnails for all images stored in the Photos app in chronological order. Your newest images are displayed last, so scroll down on this screen.

Click on the Shared button to view thumbnails for images stored in shared albums using iCloud Photo Library. These images are currently online and accessible from your Mac but not necessarily stored on your Mac.

Click on the Albums button to select and open a specific album that contains images stored on your Mac. When you open an album, thumbnails for all images in that album are displayed.

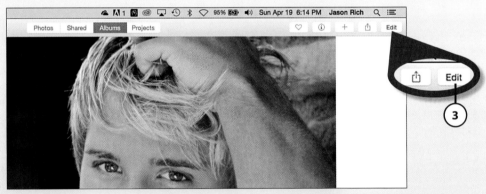

3 As you're viewing the single image, click on the Edit button displayed in the top-right corner of the Photos app screen. Displayed along the right margin of the screen are options and icons that represent the editing and enhancement tools available to you.

Available Tools

From top to bottom, the Edit tools available to you include Enhance, Rotate, Crop, Filters, Adjust, and Retouch. When you click on many of these options, additional editing or enhancement tools or options are displayed.

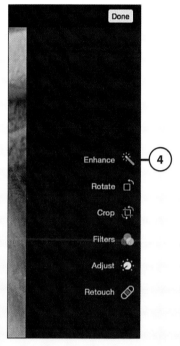

4. One at a time, click on one of the editing/enhancement tool options and use any of the displayed tools on your image, as needed.

Using Multiple Tools

As you're editing a photo using the Photos app, you're free to mix and match the use of these tools to achieve the overall visual effects, fixes, or improvements you want to incorporate to that image. More information about how to use the Photos app's editing tools is included in the next section of this chapter.

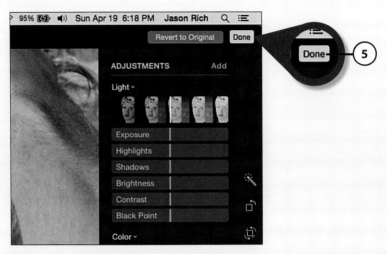

5 After you've edited or enhanced the image so it's to your liking, be sure to click on the Done button displayed in the top-right corner of the screen to save your edits and changes.

Saving Images

As soon as you click the Done button, the old version of the image is replaced. If you have iCloud Photo Library syncing turned on in the Photos app, your newly edited image also is uploaded to your iCloud account and becomes accessible from all your mobile devices and computers linked to that account.

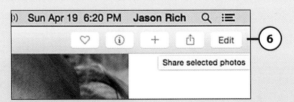

6 When you're finished editing an image, additional options are displayed near the top-right corner of the screen that allow you to manage that image from within the Photos app. From left to right, these options include Favorite, Info, Move, and Share. Repeat steps 2 through 6 to edit/enhance another image.

It's Not All Good

Consider Duplicating Before Editing

As soon as you click on the Done button after editing or enhancing an image, the newly edited image replaces the original. (The replacement happens on your computer and then syncs with iCloud Photo Stream almost instantly if you have the sync feature turned on.) If you want to keep the original image but also make edits to it, use the Duplicate command to first make a copy of the image (within the same album) before starting the editing process.

After you locate and open a single image, the Duplicate command can be found under the Image pull-down menu. The keyboard shortcut for the Duplicate command is Command+D.

Getting Acquainted with the Photo App's Editing Tools

After selecting a single photo to view and then clicking on the Edit button, a handful of icons for the app's main image and enhancement tools are displayed along the right margin of the screen. Then, when you click on many of these tools, additional editing/enhancement tools are revealed.

You should already be acquainted with many of these tools from previous chapters. The following sections provide a rundown of the available editing and enhancement tools and what they're used for. Many of these tools are also virtually identical to their counterparts found in the iOS edition of the Photos app for the iPhone and iPad.

Undo Edits Later

After making edits or enhancements to an image using the Photos app, as long as you do not open that image in another photo editing/enhancement app and resave it, you can always return to that same image using the Photos app and undo or remove the edits you've made.

To do this, select the image, click on the Edit button, and then click the Revert To Original button.

Enhance

This is a one-click feature that gets applied to an entire image. When turned on, the Enhance tool auto-adjusts the lighting, contrast, saturation, color, and other editing-related features, and typically makes your photo look better while enhancing the clarity and colors. When turned off, this tool has no impact on the image whatsoever.

Rotate

Each time you click on the Rotate tool, your image gets rotated 90 degrees (in this case, counterclockwise).

Crop

When you click on the Crop tool, you have a variety of options available. A white frame appears around your image. Using the mouse, you can adjust this frame manually to crop your image. Once the Crop Frame has been adjusted, place the mouse anywhere within the image, hold down the mouse button, and then drag the image around to reposition it within the frame.

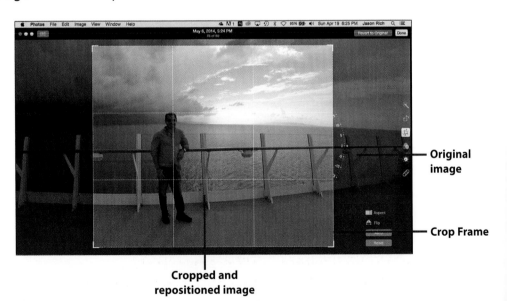

Original image

Crop Frame

Cropped and repositioned image

It's also possible to zoom the image in or out within the Crop Frame. Plus, the image straightening tool is accessible once you select the Crop tool. The Straightener feature is the dial option displayed on the right side of the image. Move this dial up or down to slowly move the image to straighten it by up to 45 degrees in either direction.

Unlike the Rotation tool, you can use the Straightening tool to adjust the image one degree at a time.

Also available once you click on the Crop Tool icon are the Aspect Ratio and Flip tools. They're displayed near the bottom-right corner of the screen. Click on the Aspect Ratio icon to adjust the image's Aspect Ratio by choosing an option from the menu.

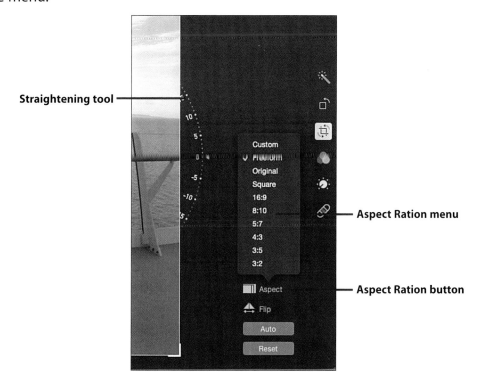

Straightening tool

Aspect Ration menu

Aspect Ration button

Use the Original Aspect Ratio Menu Setting

Unless you have a specific need to change the aspect ratio of an image to meet certain printing or sharing requirements, you're better off selecting the Original Aspect Ratio option from the menu. This gives you the most flexibility later when it comes to printing or sharing images and ensuring they're displayed properly.

Flip is a one-click tool that enables you to, as the name suggests, flip an image horizontally.

Filters

As you're editing/enhancing a specific image, when you click on the Filters icon, thumbnails for eight special effect filters are displayed along the right margin. These are the same one-click filters available from the Photos app running on the iPhone or iPad (refer to Chapter 5).

When you choose and click on a filter, it is applied to an entire image. Using the Photos app, only one filter can be added to an image.

Adjust

By clicking on the Adjust icon displayed on the right side of the screen, a wide range of individual and user-adjustable options become available, starting with the Light, Color, and Black & White sliders. Here, the Saturation slider (under the Color option) has been adjusted to boost the colors in the photo.

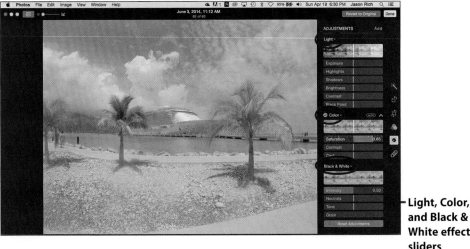

Light, Color, and Black & White effect sliders

One at a time, enhance or alter an image by using the mouse to reposition the Light, Color, or Black & White slider left or right to increase or decrease the intensity of that effect on your image.

Use the Auto Option

By positioning the mouse directly over a slider, a tiny Auto button appears. Click on this button to allow the Photo app to analyze the photo and then automatically adjust that feature, as opposed to doing it manually using the slider.

The Light, Color, Black & White options each have additional user-adjustable Levels tools associated with them that give you even greater visual control over your image. To access these additional tools, hover the mouse over the Light, Color, Black & White slider, and then click on the downward-facing arrow icon that appears to the right of the Auto button. These individual slider tools can be used for specific tasks, like correcting for over- or underexposed images, enhancing detail within images, or making colors appear more vivid.

RESET SLIDER ADJUSTMENTS

As you tinker with the various editing tools that have sliders associated with them, if you don't like how your image is turning out, click on the Reset Adjustments button located near the bottom-right corner of the screen to reset all slider adjustments to their original default settings.

At any time, however, if you don't like an edit or enhancement that you've made to an image, you can always click on the Revert to Original button displayed near the top-right corner of the screen, or from the Edit pull-down menu, select the Undo option to remove only the last edit you've made. The keyboard shortcut for the Undo command is Command+Z.

Retouch

The Retouch tool offered by the Photos app enables you to remove something small that appears in your photo that's not wanted. In this example, I remove a flying bird from the sky portion of the photo. To use the Retouch tool offered by the Photos app on a Mac, follow these steps:

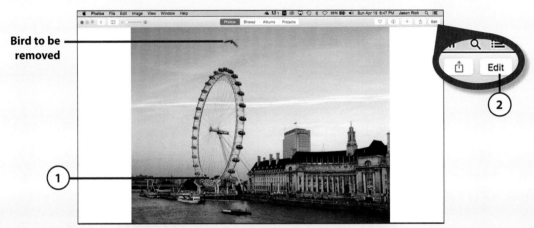

Bird to be removed

1. Select and open a single image that you want to edit. (Not shown.)
2. Click on the Edit button.

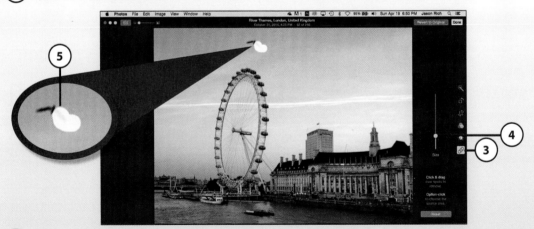

3. Click on the Retouch tool icon. A vertical slider appears between the Editing Tool icons and the image.

4. When you move the mouse over the image you're editing, the cursor takes on a circular shape. This is your Retouch tool. Use the slider to make this circle larger (up) or smaller (down).

5. Either click on the content you want to remove (as long as it fits within the circle) or hold down the mouse button and paint over the unwanted content using the Retouch tool.

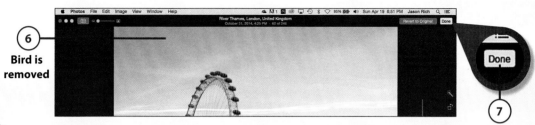

6
Bird is removed

Done

7

(6) Whether you opt to click or paint, the Photos app analyzes what's around the content you want to remove and blends in that surrounding area as the content you want removed gets deleted from the image. If you hold down the Options key, the area where the mouse is located is used as the source as content is blended.

(7) Click on the Done button to save your changes.

For the Best Retouch Results…

To achieve the smoothest results when using this tool, select a smaller Retouch tool side using the slider, use the image zoom feature to get a closer look at the content you want to remove, and then apply the Retouch tool to that area by clicking or painting over the unwanted content.

If you don't like the results of the Retouch tool, click on the Reset button, readjust the size of the Retouch tool using the slider, and try again. This time, instead of clicking the tool, try painting with it, or vice versa.

You can organize images into folders/albums,
rename them, and adjust their metadata.

→ Creating folders/albums within the Pictures folder
→ Copying and moving digital image files between folders
→ Renaming images

Organizing and Managing Photos On Your Computer

Whether you're using a PC or Mac, it came with a Pictures folder already created for you. This folder can be used as a centralized location for you to store your digital images after they've been transferred to your computer. Within this folder, it's ultimately up to you to decide how you want to organize its contents.

Keep in mind that if you want to make this process a bit easier, specialized photo management software (also called *photo organizing software*), such as Photos on the Mac, will partially automate this photo management and organizational process.

Using just the tools offered by the Windows (PC) or OS X (Mac) operating system, it's possible to manage your picture files and handle the following tasks:

- Create custom-named subfolders within the Pictures folder or within any other parent (or top-level) folder where you want to store your photos.

- Copy or move images between folders.
- Rename folders and/or individual images.

Images Can Be Placed Within Any Folder or Subfolder

The Pictures folder has been set up for you by your computer's operating system. However, you are free to store your images in any folder or subfolder on your computer's hard drive, on an external hard drive connected to your computer, or on a flash drive connected to your computer. It's also possible to create subfolders (or albums) for your photos on the various online photo sharing services.

Ultimately, how you organize your images is up to you. However, creating an organized system that uses custom-named folders and, if you choose, custom image filenames, makes your images that much easier to find and manage in the future, especially as your personal digital image collection grows.

>>>*Go Further*

USING PHOTO MANAGEMENT SOFTWARE

The photo management software you use, such as the Photos app that comes preinstalled on PCs or Macs or third-party software, almost always enables you to organize your images into separate albums or folders or to rename your images. Often they do so more quickly and easily than the methods you see in this chapter. How to do this, however, varies based on what software you're using, while the content you find here works for any computer running a current version of Windows or Mac OS.

Using Custom-Named Folders

Without using specialized software, it's possible to create custom-named folders and then organize all your digital images within those folders and subfolders.

Using the Pictures folder as the parent (top-level) folder, you can then create a subfolder, called Travel, for example, in which you store all your travel or vacation-related images. Then, as subfolders within the Travel folder, you can create additional folders to store the images from each of your trips or vacations.

You could also organize by date, setting up a folder for each year in which you took pictures. If you take hundreds of images per year, you could create folders for each month within each year.

From whichever parent (top-level) folder you choose, such as the Pictures folder, it's possible to create as many subfolders as you want and then further create an unlimited number of subfolders within those subfolders to keep your images organized.

On PCs, the Top-Level Pictures Folder Is Called a Library

If you're using Windows, the parent (top-level) Pictures folder is referred to as a Library. Within the Pictures Library go custom folders and subfolders, and within those go your files (in this case digital image files).

The following chart shows how your image folders can be organized.

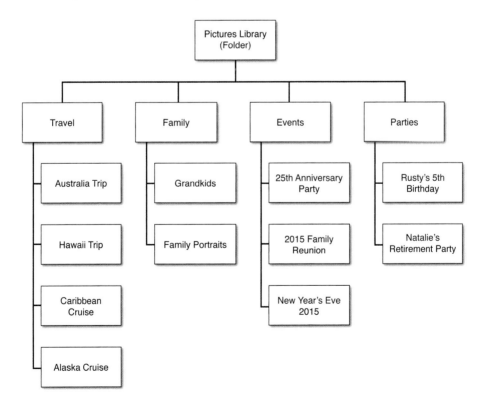

The best part about keeping photos organized in this way is that it lasts. You can still use the photo management software of your choice to sort and filter your photos all in one place, but by keeping the actual files organized you allow your photos to remain organized even if you change software in the future.

Create Custom Folders on a PC

To create custom subfolders in the Pictures Library, within which you store your image files, follow these steps:

① Access the File Explorer from the Start screen or from the Taskbar.

② Click on the Pictures Library that's listed under the This PC heading in the Navigation pane.

(3) Any folders you've already created appear in the Pictures Library.

(4) To create a new subfolder within the Pictures Library, first click on the Home option found on the toolbar.

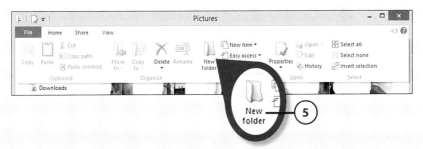

(5) Click on the New Folder command icon.

Manage Folders from the Home Toolbar

Commands that appear when you click on the Home option on the toolbar also enable you to delete or rename a selected folder, copy or move content into it, and adjust its properties (which offer Sharing and Security-related options).

(6) Displayed just below the newly created folder is the name field. Type the name for the newly created folder, such as Travel or Events, and then press Enter.

Create Subfolders as Needed

Using these same steps, it's possible to create as many subfolders as you need, each with a different name.

>>>*Go Further*

CREATE NEW FOLDERS IN THE PHOTOS APP

To create a custom-named album in the Photos app, launch the app, access and click on the Pictures Library, and then right-click on the screen to access the New Folder icon. When prompted, type the name for your folder, and then click the Create button. Drag and drop images into the newly created album.

Copy or Move Images into a PC Folder

After creating a folder, which starts out empty, you want to copy or move image files into that folder. Open File Explorer as described in the previous section and follow these steps to learn just one of the ways to accomplish this:

1. In the Navigation pane, click on the right-pointing arrow icon displayed to the left of the Pictures Library option.

2. Click on the folder that currently contains the images you want to copy into a different folder. Doing this opens that folder in the main view.

3 Select the image (or images) you want to move. The simplest way to do this is to hold down the Ctrl key as you click each image.

4 Drag and drop the selected images to the desired destination folder listing in the Navigation pane. The image is moved.

Moving Versus Copying Images

When you're moving images between two folders stored on the same hard drive, each image is moved from one folder to the other. Thus, only one copy of the image continues to exist, and you don't wind up with duplicates.

However, if you're moving the file between two folders located on different hard drives (or storage mediums), the image is copied. In this case, the image file remains in its original folder, but an identical copy of the image file is placed in the newly selected folder. Thus, two copies of the image now exist.

USE TWO FILE EXPLORER WINDOWS SIMULTANEOUSLY

Some people find it easier to open two separate File Explorer windows on the screen at the same time to move or copy images. To open a second window, in the Navigation pane, right-click on the folder/library listing you want to open. When the menu appears, click on the Open In New Window option.

Reposition the two windows, one at a time using the mouse, so they're displayed side-by-side for easy viewing and access.

Images being dragged from one folder to the other

In one window, open the folder where your digital images are currently located, and in the second window, open the destination folder. Then use the drag-and-drop method by selecting images from the originating folder and dragging them into the destination File Explorer window.

Rename Images on a PC

Although manually renaming all your images can be cumbersome and time consuming, it's a good strategy to rename at least your favorite images to something useful rather than the meaningless names given to files by your camera. To rename an image file, open File Explorer and follow these steps:

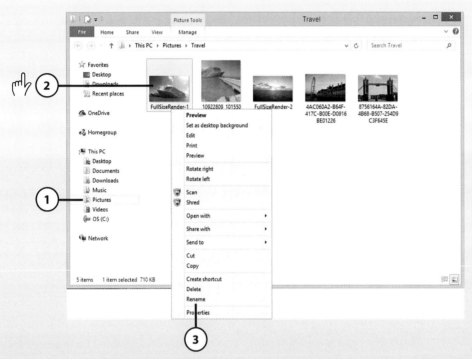

(1) From the Navigation pane, click on the Pictures folder or select and open the folder that contains the image(s) you want to rename. (Not shown.)

(2) When you're looking at the image thumbnails, right-click on a thumbnail for one image you want to rename.

(3) From the menu, click on the Rename option.

(4) Enter the new, more descriptive filename. The image is re-sorted (alphabetically) and displayed using its new filename.

Create Custom Folders on a Mac

The Mac version of File Explorer is called Finder and it can be used in the same way. To create a custom folder for an album, follow these steps:

(1) Open the Finder from the Desktop or Dock. From the Dock, click on the Finder icon.

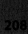
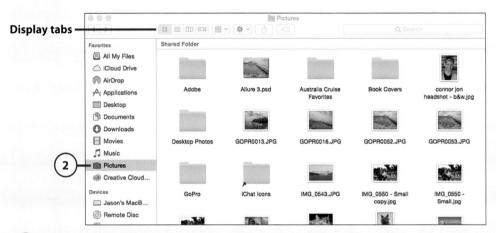

Display tabs

(2) Click on the Pictures folder in the sidebar of a Finder window. Listings or thumbnails are displayed for each image or folder already stored in the Pictures folder.

Changing Your View

Four display tabs enable you to adjust the type of view you see in the Finder view. Click them to see what each does.

(3) With the Pictures folder open, access the File pull-down menu and select the New Folder option. A new untitled and empty folder (in this case, a subfolder in the Pictures folder) is created.

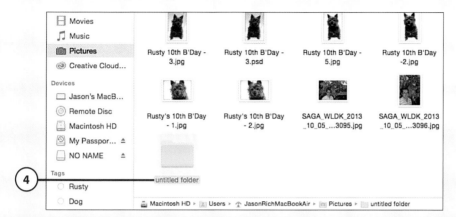

(4) Hold down the Ctrl key and click the folder icon's name to change the name of this folder. Type the name and press the Return key. You can now copy and paste or drag and drop image files into this newly created folder. See the next section for information on how to accomplish this.

CREATE AN ALBUM USING THE PHOTOS APP

To create a custom-named album in the Photos app, launch the app, click on the Albums tab near the top center of the screen, access the File pull-down menu, and then select the New Album option. When prompted, type the name for the album. Use the drag-and-drop or copy-and-paste options in the Photos app to then populate the album with images.

Copy or Move Images into a Mac Folder

After you have created your folders, there are several ways to move image files between folders, either by copying and pasting them or dragging and dropping them. Shown here are the steps to drag and drop image files between two folders using the OS X's Finder:

1. Open a Finder window, and from the sidebar, locate the folder that currently contains the images you want to transfer to another folder. Adjust this window so it takes up less than half the screen.

2. From the File pull-down menu, select the New Finder Window option to open a second Finder window.

3. In the second Finder window, locate the folder where you want to move the images to (the destination) and open it.

4. In the first Finder window, select each image that you want to move. To select multiple images, hold down the Shift key as you click on each thumbnail or listing.

5. Hold down the mouse button and drag the selected files from the original window to the destination folder's Finder window. This moves the image files from one location to the other.

COPY INSTEAD OF MOVE

When you copy an image from one folder to another, the single copy of that image is moved. However, if you use the Copy and Paste commands, a duplicate of the image is created, and the copy is then placed in the destination folder while the original version of the image remains in its original folder.

To use the Copy and Past commands, follow steps 1 through 4. Instead of dragging and dropping the images between folders, access the Edit pull-down menu and select the Copy command. Next, click the mouse on the destination folder's Finder window, and then access the Edit pull-down menu and select the Paste command.

You can also use the keyboard shortcuts, which are Command+C (Copy) and Command+V (Paste).

Rename Image Files on a Mac

Although manually renaming all your images can be cumbersome and time consuming, it's a good strategy to rename at least your favorite images to something useful rather than the meaningless names given to files by your camera. To rename an image file, open Finder and follow these steps:

(1) Open the folder that contains the image(s) you want to rename.

Thumbnail Size

To adjust the thumbnail size for the images, access the View pull-down menu, click on the Show View Options menu option, and then adjust the Icon Size slider. Move it to the right to increase the thumbnail size to make them easier to view on the screen.

(2) When looking at the listing or thumbnail for the image, click on the filename so that it's highlighted in blue, and then press the Return key.

(3) In the filename field, type the new filename for the image and then press the Return key.

Keep the File Extension Intact

When renaming an image file, be sure you do not change the extension part of the filename, which may be .jpg, .tiff, or .png, for example. Thus, if you wanted to change an image filename that was IMG_1234.jpg to something more descriptive, it should be changed to [filename].jpg.

RENAME A GROUP OF IMAGES

If you're using the latest version of OS X Yosemite on a Mac, instead of renaming one image file at a time, you can highlight and select multiple image thumbnails (or files), and then press Control and click the mouse at the same time to access the contextual menu that offers a Rename option. It's then possible to replace part of a common image name with something else. For example, if a group of images are named IMG_####, you can replace the IMG portion of the filenames with something more descriptive, like "Italy Vacation_".

Altering Image Metadata

Your camera and the photo management software you use automatically create metadata that is associated with each of your images. However, you can manually apply some pieces of metadata to image files. In most cases, this can be done from your photo management software. For example, from the Photos app on the Mac, you can associate the location where the image was shot, link the names of the people appearing in the image to its file, associate a text-based description to the image, and add text-based tags to the image.

To do this, as you're looking at a photo in the Photos app, click on the Info icon and then fill in the fields in the Info window (shown here).

Info icon

Info window

However, if you can't use an app or prefer to use Finder or File Explorer (in Windows), you can do so, as explained in the following sections.

Adjusting Image File Metadata from a PC

To edit or add various pieces of additional metadata to an image file on a PC, follow these steps:

(1) Locate the photo you want to alter and right-click it.

(2) Select the Properties option.

(3) Click on the Details tab.

(4) Click on one field at a time, and enter the appropriate information. Later, you can sort or locate images using any of this metadata as your search criteria. (Filling in any or all of these fields is optional.)

Available Fields

From this menu you can alter a photo's metadata for its Title (separate from the file name), Subject, Rating, Tags, Comments, Authors, Date Taken, Date Acquired, Copyright, and more than a dozen other fields. Any photo management software you use to access this photo can read and interpret this data.

(5) Repeat these steps for each of your images. (Not shown.)

Adjusting Image File Metadata from a Mac

Using a Mac, to adjust an image file's metadata, open a Finder window and follow these steps:

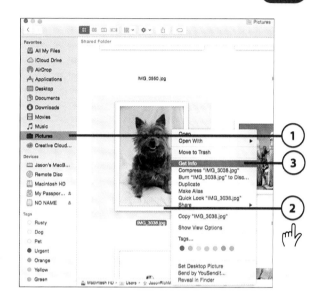

(1) Locate the image you want to work with.

(2) Hold down the Control key and click on the image to open its menu.

(3) Select the Get Info option. Alternatively, select and highlight the image thumbnail/listing, and from the File pull-down menu, select the Get Info option.

Using Photos

Keep in mind that this can also be done from within the Photos app by selecting and viewing a photo, and then clicking on the Info icon that's displayed in the top-right corner of the screen in Photos.

(4) Rename the image by typing in the Name & Extension field.

(5) Add tags (keywords) to the image by clicking on the Add Tags field, and then typing one word or phrase at a time. Press the Return key after typing each word or phrase.

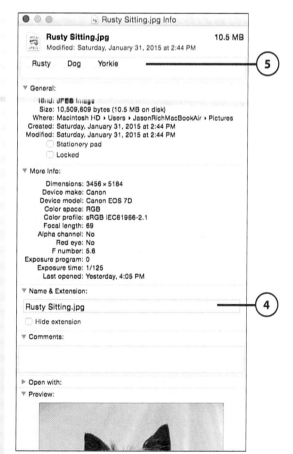

Adding Color to Tags

You can also assign a color to the tag for easy visual reference later, or to make it stand out when you open the folder it's stored in.

(6) Fill in the optional Comments field with additional text-based information about the image.

(7) Click on the red dot in the top-left corner of the window to close it and save your changes.

(8) Repeat these steps on other image files, as needed. (Not shown.)

As you take digital photos, your
device stores them in an album.

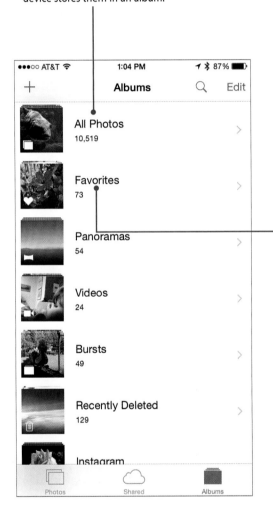

●●●○○ AT&T 📶 1:04 PM ✈ ✳ 87% ▮▮▮▮

+ **Albums** 🔍 Edit

All Photos >
10,519

Favorites >
73

Panoramas >
54

Videos >
24

Bursts >
49

Recently Deleted >
129

Instagram

Photos Shared Albums

You can create and
store photos in the
albums of your choice.

In this chapter, you'll learn how to organize your digital photos while they're stored on your smartphone or tablet, and keep them organized when they get transferred to a computer or online photo sharing service. Topics include

→ Ways to sort your images

→ How to create custom albums

→ Moving images between albums

Organizing and Managing Photos On Your Mobile Device

As you take photos using the camera built in to your smartphone or tablet, they're automatically assigned a generic filename (with a sequential number associated with it) and stored in a central album where they can easily be found using the Photos app, the Gallery app on Android-based devices, another third-party photo editing/enhancement app, a social media app, or your email app, for example.

At some point, especially as your personal photo collection expands to include hundreds or thousands of images, taken at different times and in different places, you'll want to organize them on your mobile device. This organization process typically includes creating custom-named albums in which you store groups of photos.

Get Organized, Stay Organized

As your photo library grows, it's much easier to organize your images as they're taken, as opposed to after you've amassed hundreds or thousands of photos that get stored by default into a single folder.

Ultimately, you have the opportunity to add additional metadata to your images (see "Making Photos More Useful with Metadata" in Chapter 2, "Taking Amazing Pictures with Your Smartphone or Tablet"), give them each a custom filename, and be able to sort them in other ways, either on your mobile device, or after they're transferred to a computer or online service.

Organizing Your Photos On an iPhone or iPad

After taking photos using the Camera app built in to your mobile device, images are stored automatically by the Photos app in the All Photos album. (In past versions of the iOS and the Photos app, this folder was called Camera Roll.)

However, if you used the Burst shooting mode to take multiple photos in quick succession, you'll find these images in a separate album, called Bursts. Panoramic photos are automatically stored in a folder called Panoramas.

Open an Album

To access the All Photos, Bursts, or Panoramas folder, follow these steps:

(1) Launch the Photos app from the Home screen.

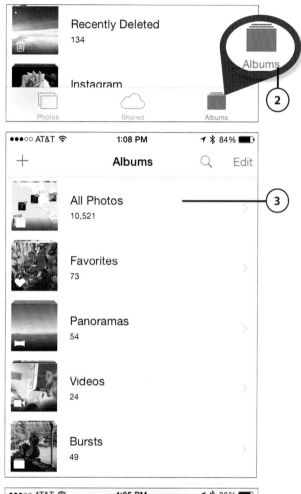

2) Tap on the Albums icon displayed at the bottom of the screen. This allows you to view albums currently stored in your mobile device.

3) Tap on the thumbnail that represents the album you want to open. The All Photos album displays your photos in chronological order, for example, so your newest images always are displayed last (by scrolling to the bottom of the album).

4) Tap a photo to view it full screen.

Moving Pictures Around

When you're viewing images in an album, it's possible to organize specific images by moving any of them to a different album, for example. How to do this is explained in these sections.

Browse Collections

Instead of viewing your images based on the albums they're stored in, you can view all your images together in chronological order, regardless of the album. To do this, launch the Photos app and follow these steps:

(1) Tap the Photos icon. The Photos option enables you to sort images and view them based on the year they were shot, the location they were shot, or as a collection or moment—which automatically sorts and displays the photos based on where and when they were shot.

(2) Tap on the photos for a selected year. This opens the Collections page, which sorts photos by the location and the month they were taken.

Starting Out

Photos might not start you out on the Years page shown here. If it doesn't, you can back out to it by tapping the < option near the top-left part of the screen until you get to the Years page.

(3) Tap on the photos for a collection to view that collection's Moments. This page organizes photos based on the location and day they were taken.

4 Tap on a photo on the Moments page to see that photo.

MAPPING PHOTOS

Tap on Location or Date to display a detailed map that showcases where the images in that Moment, Collection, or Year were taken. As you're viewing the map, use the reverse-pinch finger gesture to zoom in or the pinch figure gesture to zoom out.

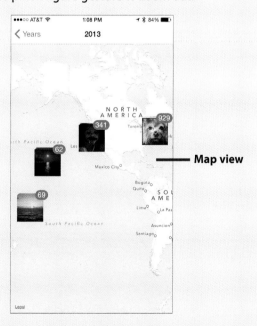

Map view

Create New Albums

One of the best ways to organize your personal photo collection is to organize your images into custom-named albums, using names that make sense to you. For example, you can group photos together by events, such as "2015 Christmas Vacation," "40th Anniversary Cruise," or "Natalie's 3rd Birthday Party." To create a new album, open the Photos app and follow these steps:

1. Tap on the Albums icon displayed at the bottom of the screen.

2. Tap on the Create Album (plus-sign icon).

3. In the New Album pop-up window, type the name for the new album you're creating.

4. Tap Save to create the album, which is displayed instantly on your Albums screen.

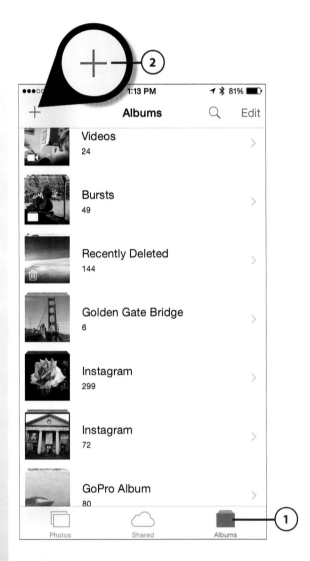

(5) Under the album's name you see a zero, indicating that no images are currently stored in it. You can now begin copying images into the album by following the directions listed in the section "Copy Photos Between Albums," later in the chapter.

ORGANIZING WITH ALBUMS

You can just as easily create albums to store photos sorted by who's in them or what they contain. For example, it's possible to create separate albums called "Grandchildren," "Friends," or "Images from the Garden."

Once you create a new, custom-named album, it's possible to copy into it as many separate images as you want (based only on the storage limitations of your mobile device). Plus, it's possible to create as many separate albums as you deem necessary to organize your entire photo collection.

Delete or Move an Album

Although it is not possible to delete the default albums that come precreated in the Photos app (All Photos, Favorites, Panoramas, and so on), any album you create yourself can later be deleted from your mobile device. To delete an album open the Photos app and follow these steps:

1. Tap on the Albums icon displayed at the bottom of the screen.

2. From the Albums screen, tap on the Edit option displayed in the top-right corner.

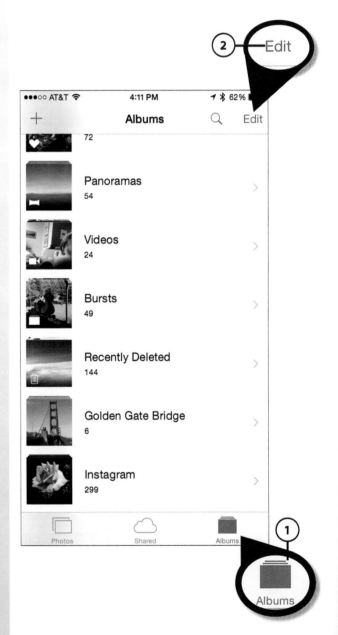

3 Tap on the red-and-white negative sign icon associated with an album listing, when applicable, to delete an unwanted album.

4 Tap on the Delete button to confirm your decision.

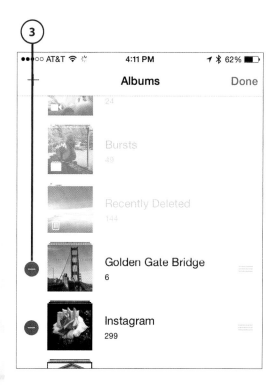

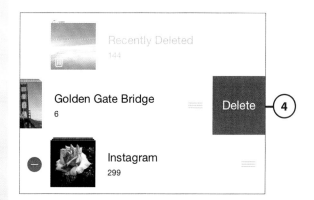

5 To change the order in which albums are listed, tap and hold on the move icon (three rows of lines) and drag the album to the position you want it placed in.

6 Tap on the Done option to save your changes. Keep in mind that the albums created by the Photos app (All Photos, Favorites, Panoramas, and so on) are always listed first.

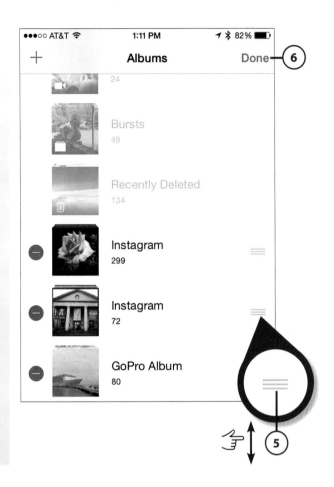

It's Not All Good

Synced Albums Get Deleted Everywhere

If the album you choose to delete is automatically being synced with an online service, such as iCloud Photo Library, as soon as you delete the album from your mobile device, it also (almost immediately) is deleted from the online service as well (depending on how you have the Photos app and iCloud integration set up). There is no "undo" option, so proceed with caution.

Copy Photos Between Albums

Once you've created one or more custom-named albums, the next step is to populate those albums with your photos to better organize them. To do this, open the Photos app and follow these steps:

1. Tap an album, such as All Photos, that contains the image(s) you want to move into the newly created album (or any other album). (Not shown.)

Create an Album First

If you haven't yet created a custom album, make sure to follow the steps earlier in this chapter in the section "Create New Albums."

2. Tap on the Select option displayed in the top-right corner.

(3) One at a time, tap on the thumb-nail for each image that you want to move into the newly created album. A blue-and-which check mark icon appears in the bottom-right corner of each thumbnail you select.

(4) Tap on the Add To option displayed at the bottom center of the screen after you've selected each photo you want to move. The Add To Album screen is displayed.

(5) Tap on the album where you want the photos placed. (Although all the albums in your mobile device are shown, only the custom albums you've created are accessible.) The selected photos now appear in the designated album.

No Copies

If you copied the image(s) from the All Photos album, you can see them both there and in the new album you selected. This does not mean you've made copies of the images. They merely appear in both albums.

Delete Images from Albums

In addition to adding images to albums, you can just as easily remove (delete) individual images from an album. To do this, open the Photos app and follow these steps:

(1) Open the album that contains the image(s) you want to delete.

(2) Tap on the Select option.

(3) Tap on the thumbnails for the images you want to delete. A blue-and-white check mark icon appears on the thumbnail of each selected image.

(4) Tap on the Trash icon displayed in the bottom-right corner of the screen.

(5) Tap on the Remove From Album
option to confirm your decision.

Not All Images Can Be Deleted

If an album was created on another com-
puter or mobile device and has been cop-
ied to the mobile device you're using, for
example, you might not have the option
to delete those images, unless you're using
the device used to create the album.

These photos will be removed from this album, but
will remain in your Photo Library.

Remove from Album

Cancel

Add Images to Your Favorites Album

The Photos app on the iPhone and iPad comes with an album called Favorites
precreated for you. To add images to this album, launch the Photos app and tap
on any image thumbnail, within any album, to view the desired image.

As you're viewing the image, tap on the heart-shaped Favorite icon displayed at
the bottom center of the screen. The image remains stored in the album it's cur-
rently in, but when you access the Favorites album from within the Photos app,
all the images that you have favorited are displayed together.

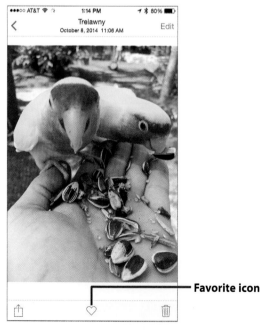

Favorite icon

Organizing Your Photos On an Android-Based Smartphone or Tablet

After taking photos using the Camera app preinstalled on your Android mobile device, images are stored automatically within the device's internal storage and are accessible using the Photos or Gallery app, both of which come preinstalled on your device.

Photos Versus Gallery

The Photos app is ideal for editing and then sharing or syncing photos via mail or Google Drive. The Gallery app allows images to be viewed by Timeline, Album, Tags, or Location, for example, and is designed more for organizing the images stored on your mobile device.

Although the Gallery app has built-in tools that enable you to sort and view images by when and where they were shot or by tags you associate with individual photos, one of the best ways to organize your personal image library is to create a series of custom-named albums and then store your images in those appropriately named albums.

Using the Gallery app that comes preinstalled with Android (version 4.4.4, for example), it's possible to create as many different custom-named albums as you want or need, and then include any number of images in each album. You are limited only by the storage capacity of your mobile device.

Access and View Your Albums

To access your images using the Gallery app, open the Apps page on your device's Home screen and follow these steps:

1. Tap on the Apps icon Gallery app.

2. Tap the Menu icon, if necessary, and select the Albums option that appears. (The Tags option is shown here.)

Understanding Albums

Each album is then displayed as a graphic banner labeled with the album's name. Below each album title is a number in parentheses that tells you how many images are stored in that album.

(**3**) Tap on an album's banner to view its contents. You can also tap on the More icon displayed to the right of an album's title and select the View option. The images in the selected album are displayed as thumbnails.

Album name **Number of images** **Album More menu icon**

Albums

Camera shots
(21)

All downloads
(5)

Highlights
(4)

(**3**)

4 Tap on an image's thumbnail to view that specific image, or manage the images in that album from this album thumbnail screen.

Finding Your Pictures

To display all the images you've taken using the cameras built in to your mobile device within the Gallery app, choose the album called Camera Shots.

Images downloaded from other sources, by default, are placed into an album called All Downloads, while pictures you favorite by tapping on the Highlight option are placed in the Highlights album.

Create New Albums

In addition to the precreated albums that are part of the Gallery app, it's possible to create your own custom-named albums and then move images into those albums. To create and populate a new album, open the Gallery app and follow these steps:

1 Tap on the Menu icon.

2 From the menu, select the Albums option, if it's not already selected.

(3) From the Albums screen, tap on the More menu icon. It looks like three vertical dots.

(4) Tap the Create Album option.

(5) Type the name of the album you want to create in the Create Album window.

(6) Tap the OK button. The new album is now ready to be populated with images you select.

(7) You can either copy or move images into the new album by tapping on the appropriate button. This sends you to the Select an Album page.

Copy Versus Move

If you select Copy, the image you select from its current album is also displayed and made available in the new album. Thus, the same image is accessible from two albums within your device. If you select Move, the selected image(s) are transferred from one album to another and listed only in one place.

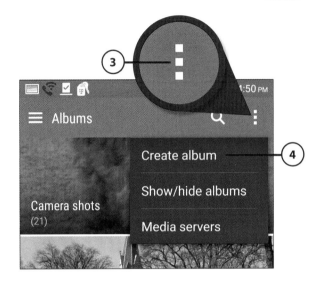

(8) Tap on the album that currently contains the image(s) you ultimately want to place into the new album.

9 Tap on the thumbnails that represent the images you want to place into the new album. As each is selected, a check mark icon appears on the thumbnail.

10 Tap on the Next button. The images are copied or moved (depending on what you selected in step 7) to the new album. Gallery returns you to the Albums screen.

11 Tap on the newly created album to view its contents.

New Albums Will Sync Online

Based on how you set up the Gallery app to work with Google Drive or any other compatible online service, anytime you create a new album, that album along with its contents automatically syncs with your account and becomes accessible from all your other mobile devices and computers also linked to that account.

>>>Go Further

MOVING SINGLE PHOTOS

If you want to copy or move individual photos, from within their current album, select the photo, tap the More menu icon, and select either Move To or Copy To. When prompted, select the album to which you want to copy or move the selected image.

More menu icon

Move or copy a single photo

Hide Albums

You can hide any album (along with its contents) that you create from within the Gallery app. When an album is hidden, it remains stored on your mobile device but is not listed with the rest of your albums.

To do this, from the Albums screen, tap on the album you want to hide. When the album opens, tap on the More menu icon and select the Show/Hide Albums option.

All of your albums are listed. To the right of each album listing is a check box. To hide an album, simply remove the check mark from its respective check box.

Show/Hide check boxes

Delete or Rename Albums

Any album you create on your mobile device can be deleted, along with all its content. To do this, open the Gallery app to the Albums view and follow these steps:

(1) Tap on the More icon associated with the album you want to delete or rename.

(2) Tap on the Delete option to delete the album altogether.

(3) Confirm your decision by tapping on the OK button. Keep in mind, there is no "undo" option.

(4) Tap on the Rename option (instead of Delete), if you want to rename the album.

Make sure you are on Albums view.

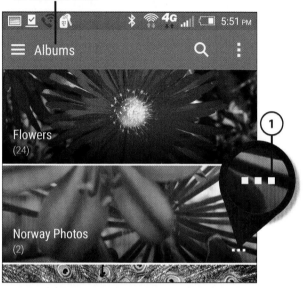

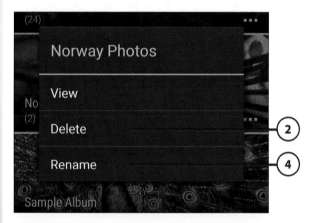

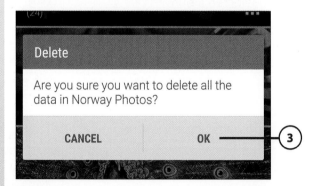

5. When prompted, type a new title for the album.

6. Tap the OK button to save your changes.

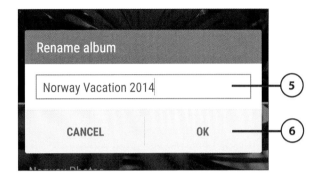

It's Not All Good

Synced Albums Delete Everywhere

If the album you choose to delete is automatically synced with an online service, such as Google Drive, as soon as you delete the album from your mobile device, it is also deleted from the online service as well. (This can vary depending on how you have the Gallery app set up with Google Drive's image sync function.) There is no "undo" option, so proceed with caution.

Delete Images from Albums

To delete individual images from a specific album, first open that album from the Gallery app's Albums screen, and then follow these steps:

1. Tap on the More menu icon for the selected album.

2. Tap on the Delete option. You see a list of thumbnail images that your album contains.

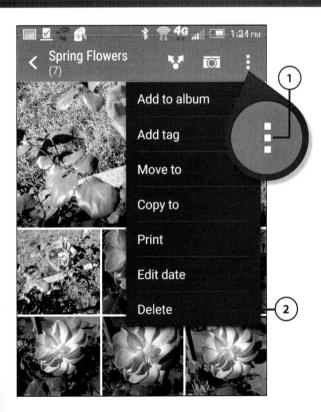

③ Tap on the thumbnails for the items you want to delete. (A red X appears over selected items.)

④ Tap the Delete button to continue.

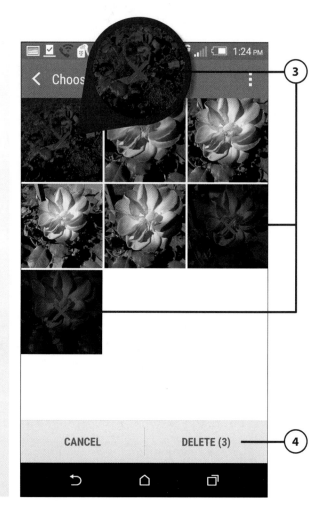

Sorting Images

Instead of viewing your images based on the album they're stored in, tap on the menu icon displayed in the top-left corner of the screen and select one of the following options—Timeline, Tags, and Locations. The next three sections detail each of these options. As you may recall, a tag is a description keyword that is associated with an image.

Timeline

Timeline view lets you see all images stored on your smartphone or tablet in chronological order, regardless of which album they're stored in. After tapping on the Timeline menu option, select the format you want to use to display the image thumbnails.

Four icon choices for sorting and displaying image thumbnails are displayed near the top of the screen. They include

- **Feed**—Displays large size thumbnails
- **Grid**—Displays smaller, square-shaped thumbnails
- **Events**—Displays images sorted by date and shooting location
- **Year**—Sorts and displays images by the date associated with them

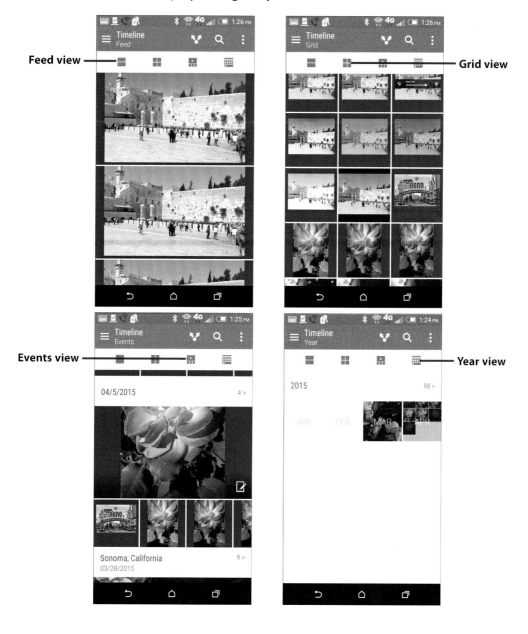

Tags

Once you manually add tags to your images, it's possible to sort them based on those tags by tapping on this menu option. To create a master tag list and then associate images to a tag, open the Gallery app and follow these steps:

(1) Tap on the Menu icon displayed in the top-right corner of the screen.

(2) Tap on the Tags option.

(3) Tap on the More menu icon.

(4) Select the Add Tag option in the menu that appears.

(5) Tap on the Select An Album option displayed in the top-left corner of the screen, and then select the album containing the image you want to add tags to. That album opens when you tap on its thumbnail or listing.

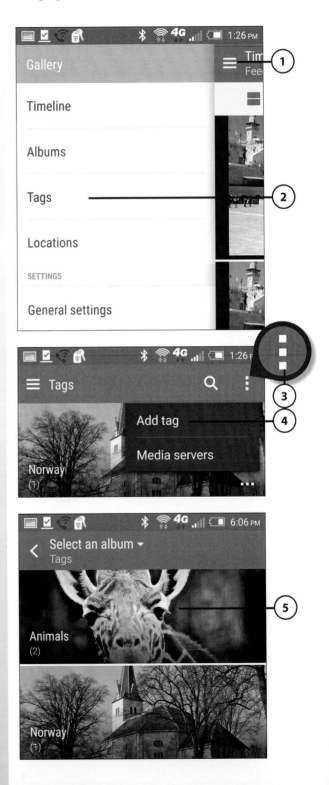

6 Tap on an image that you want to add a tag to. A check mark icon appears on the image thumbnail.

7 Tap on the Next option to open the Tags screen.

8 To create a new tag, enter its name in the field provided. It appears in the list of existing tags.

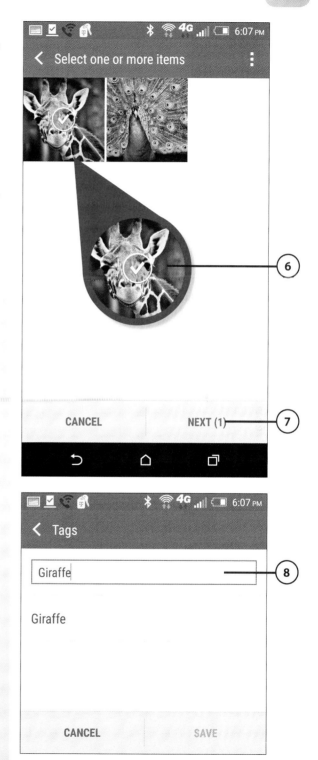

9 Tap on the tags you want applied to the selected photo. (Shown here, the Giraffe and Animals tags have been selected but the Norway tag has not been selected.)

10 Tap on the Save button. The image, with the new tags associated with it, are now displayed in an album accessible from the Tags menu.

11 When you return to the Tags screen, each Tag is listed. Tap on the album with the tag you want to see all images that are linked to that tag. Shown here, the giraffe photo appears in the Animals and Giraffe tag albums, because it now has these two tags associated with it.

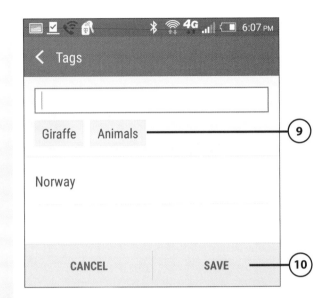

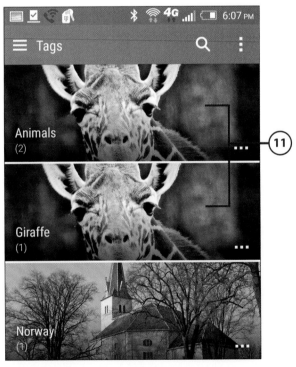

MORE ON TAGS

As you're tagging photos, multiple images can share common tags, and a tag can be a name, place, keyword, or short phrase. Each photo can also have multiple tags associated with it.

Once you assigned one or more tags to each of your photos, you can easily sort and view those images based on tags. For example, if you assign a "Flowers" tag to all your images that contain flowers, when you select that Flowers tag, only those images are displayed, regardless of which album each flower-related photo is stored in.

Locations

Thanks to the GPS capabilities built in to your smartphone or tablet, each time you snap a photo with the GPS feature enabled, the location where that image was taken is automatically recorded.

Thus, the Gallery app can easily sort your photos based on where they were taken when you select the Locations option from the Gallery app's menu. When you select the Locations option, a listing of locations where you've taken photos is displayed as banners. Tap on a banner to view all photos taken at that location, regardless of which album the images are stored in or when they were shot.

To view a detailed map that depicts your various shooting locations, tap on the Map icon displayed in the top-right corner of the screen.

Map icon

**Number of
photos snapped
at this location**

**Map
view**

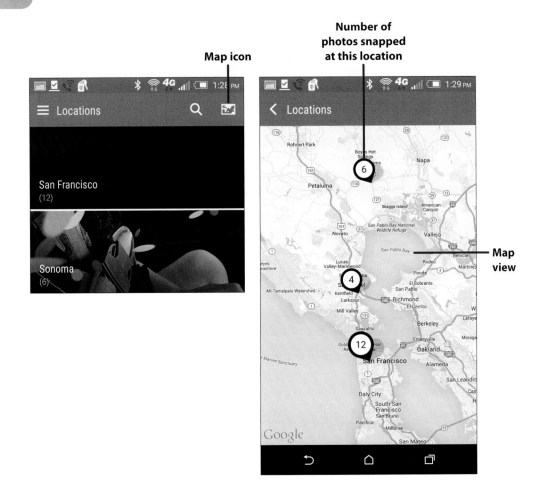

Email is one of many ways you can share photos.

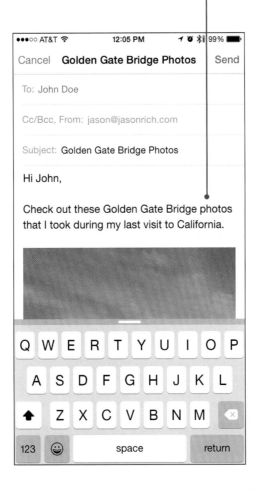

In this chapter, you'll learn how to compose an email from your smartphone or tablet that contains an attachment of one or several of the photos stored on your mobile device. Topics include

→ Composing and sending emails with photo attachments from your mobile device

→ Adjusting the file size when attaching images to your outgoing emails

→ Using alternative ways to send high-resolution digital images to specific people directly from your smartphone or tablet

Sharing Pictures with Family and Friends via Email and Instant Messages

After taking a few photos and then editing or enhancing them, one of the fastest and easiest ways to share those images with specific people is to send them via email. This can be done from directly within a mobile app you're using (such as Photos on an iOS, Android, or Windows Mobile device, or Gallery on an Android device), or from a Mail app.

Thus, within seconds of taking a photo, it's possible to use your device's Internet connection to share one or more images with one or more people.

Email Is for Sending Just a Few Images

When you send an image from the Photos or Gallery app built in to your mobile device, you're typically limited as to the number of images you can attach to an outgoing email. For example, when using the Photos or Mail app on an iPhone or iPad, the maximum number of images you can attach to an email is five.

Another option is to first transfer your images to your computer from your mobile device (or camera), and then once they're stored on your computer, use the email app installed on that computer to send out emails with the photo(s) you want to share attached. How to do this is explained shortly.

A third option for sharing groups of photos is to upload them to a photo sharing service, such as Microsoft OneDrive, Apple's iCloud Photo Library, Google Drive, Flickr.com, or any number of other similar services, create an online-based album, and then invite specific people to view it. How to use this option is covered in greater detail in Chapter 10, "Sharing Photos Online."

Understanding the Pros and Cons of Using Email to Share Photos

The biggest benefit to sharing photos via email is that you can choose one or a few images to share and then select exactly whom you want to receive those images. The images you opt to share become attachments to an outgoing email message that you compose and send directly from your mobile device that has Internet access.

For this feature to work, you first need to set up your own email account, if you don't already have one. Free email accounts are available from Apple, Google, Microsoft, and Yahoo!, as well as other services.

To acquire a free email account (if you don't already have one), visit one of these websites, based on the email service you want to use:

- **Google Gmail**—https://accounts.google.com/SignUp
- **iCloud Mail**—www.icloud.com
- **Microsoft HotMail (Outlook)**—https://signup.live.com/signup
- **Yahoo! Mail**—https://edit.yahoo.com/registration

When you have an email account, it's necessary to set it up to work with your mobile device. This is typically done from within Settings on your mobile device. However, in some cases, the first time you launch the Mail app on your mobile

device, it walks you through this setup process, which needs to be done only once but varies a bit based on the type of email account you are using.

By setting up your existing email account to work with your mobile device, other apps that integrate with the device's mail app also are set up to work with that account. Thus, once the Mail app is set up, you also are able to send emails directly from other apps, including Photos (or Gallery), for example.

There are two potential drawbacks related to using email to share photos. First, due to the file sizes of high-resolution photos, you're typically limited in terms of how many photos can be attached to an individual email message. Thus, this solution is ideal only if you want to send between one and five high-resolution images, for example.

The second drawback is loss of control. When you attach the photos to an outgoing email, the recipient(s) can then view, download, edit, print, and share those images anyway they want. For example, if you send what you consider private photos to someone, that person can turn around and publish them online via social media, making them public within seconds, without your approval.

Sending Emails That Contain Photos from Your Smartphone or Tablet

After choosing to share specific photos with specific people using email, you have two primary options. The first is to use the Mail app and your existing email account.

The second option is to share the images via email directly from your photo editing/enhancement or management app. So, on an iOS, Android, or Windows Mobile smartphone or tablet, this can be done using the Photos app, or on an Android-based mobile device, it can also be done from the Gallery app. Many third-party photography-related apps also have built-in integration with your email device's Mail app, so you can compose and send outgoing emails that contain your photos from these other apps as well.

Send Images via Your Device's Mail App

These are the basic steps to follow to compose and send an outgoing email message from your mobile device's Mail app that contains one or more photos as attachments to the outgoing email message:

1. Launch the Mail app on your mobile device (shown here on the iPhone). On an Android mobile device, this can be done from the Home screen or Apps screen.

Sending Photos from the Mail App

The steps outlined here showcase the Mail app running on an iPhone but generally apply to the iPad, as well as Android or Windows-based smartphones and tablets.

2. From the Mail app, tap on the Compose Message icon. On an Android-based device, the Compose icon looks like a plus sign (+).

3 From the New Message or Compose screen, fill in the To field with the email address of one or more intended recipients.

4 Fill in the outgoing message's Subject field.

5 Enter an optional text-based message that you want to accompany your photos.

USE YOUR CONTACTS DATABASE

If you're using the Contacts app (which is called People on an Android Mobile device) built in to your mobile device to keep track of the people you know, you'll discover the Mail app works seamlessly with this contact management app. Just enter the recipient's name and your device looks up the person in your Contacts app.

6 Press and hold down your finger within the message body area for about two seconds. (For Android, see step 8.)

7 Tap on the > icon of the Command Tab bar that appears.

8 Tap on the Insert Photo or Video tab. If you're using an Android-based device, tap on the paper-clip-shaped Attachment icon. On an iPhone or iPad, the Photos app launches and display listings for each of your albums.

6
Tap and hold

9 Tap on the album that contains the photo you want to attach to the email.

10 Tap on the thumbnail for the desired image to open and view it.

(11) Tap the Choose option to insert the image into the outgoing email message. Repeat steps 9 to 11 to add additional photos.

Android Devices

If you're using an Android-based device, after tapping on the Attachment icon, select the Picture option from the Attach screen. Next, from the Attach From screen, tap on the Gallery option and select an album and photo similarly to what you see here.

(12) If you're managing multiple email accounts from your mobile device, tap on the From field to select which email address you want to send the email message from.

(13) Tap on the Send icon to send your message.

14 If prompted, select the file size for the outgoing image(s).

Send Photos from Your iPhone or iPad's Photos App

Instead of using the Mail app to send photos, it's often faster and easier to edit your photo using the Photos app, and then send the email directly from within the Photos app. To do this, follow these steps:

1 Launch the Photos app.

(2) Open the album that contains the photos you want to share.

(3) Tap on the Select option for that album.

(4) Tap on the image thumbnails for those images.

(5) Tap on the Share icon.

(6) Tap on the Mail icon in the Share menu. The New Message screen of the Mail app appears, with the selected photo(s) already attached to the outgoing email message.

(7) Fill in the To field with the intended recipient's email address.

(8) Fill in the Subject field.

(9) If you want, tap on the message body area, and using the virtual keyboard, type a message to accompany your photo(s).

(10) Tap on the Send option to send your message. Your mobile device must have Internet access.

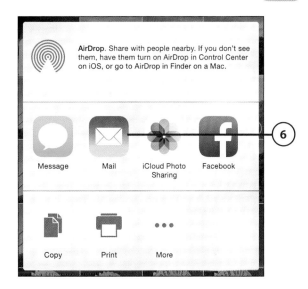

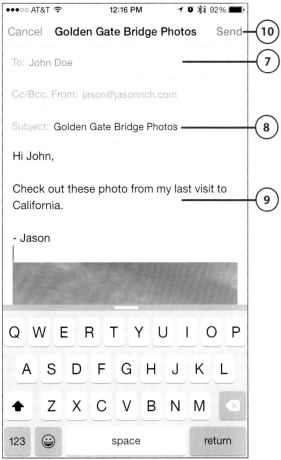

(11) If prompted, select the outgoing file size for the image files. Your options include Small, Medium, Large, or Actual Size.

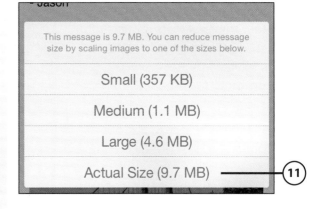

Send Photos from Your Android Device's Gallery App

To attach photos to an email directly from the Gallery app, open the app and follow these steps:

(1) Locate the album that contains the pictures you want to share.

Sharing an Album

If you want to send the contents of an entire album, when the thumbnails for that album are displayed, tap on the Share icon displayed near the top of the screen.

(2) Select a single image to share via email.

(3) Tap on the Share icon. (To make this icon appear, it might be necessary to tap anywhere on the image.)

(4) From the Share menu, select the Mail app. When you tap on the Mail app option, the Compose message screen is displayed. The selected photo(s) are already attached to the outgoing email message.

Multiple Mail Apps

It's possible your device has more than one email app. If you have a Gmail account, for example, you might use the Gmail app or another third-party mail app specific to your email account provider.

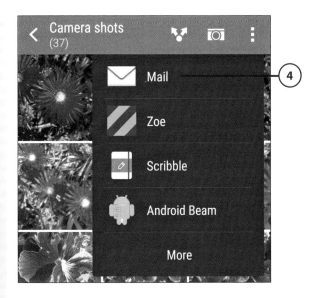

(5) Fill in the To field with the intended recipient's email address.

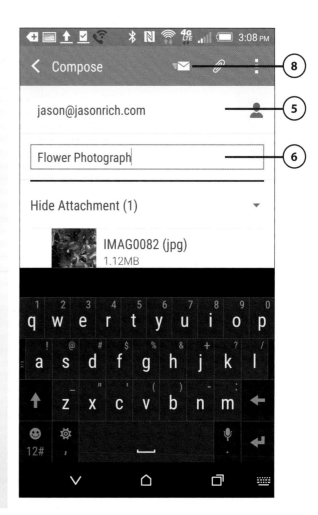

Send the Same Message to Multiple Recipients

As you're filling in the To field, after entering each recipient's email address, press the Return key on the virtual keyboard. You can now add an additional recipient by adding the person's address to the To field, or include it within the Cc: or Bcc: field.

(6) Fill in the subject field, as you normally would when composing an email.

(7) Tap on the body of the outgoing mail message if you want to add a text-based message to the email. (Not shown.)

(8) Tap on the Send icon to send the message. Your smartphone or tablet must have Internet access.

>>>Go Further
EMAILING PHOTOS WITH WINDOWS MOBILE

Like Android and iOS devices, Windows Mobile devices have a Photo app you can use to view photos and send them directly to an email in your device's Mail app. Just choose the Select icon from the album containing photos you want to send, choose the pictures you want, and tap the Share icon at the bottom of the screen.

Emailing from Your Computer

After you have transferred images from your mobile device to your computer, you can view those images via a photo editing/enhancement or photo management app, and then select and email specific photos from within that app. For example, on a Mac, this can be done from the Photos app (or iPhoto on older Macs) or a third-party app, such as Photoshop Elements or Pixelmator. From a Windows 8 or Windows 10 PC, this can be done from Photos or a third-party app, such as Photoshop Elements.

However, images can also be attached to an outgoing mail from the Mail software you typically use to send and receive emails. Often this is from a web browser logged in to Gmail, Outlook.com, or Yahoo! Mail. On a Windows PC, this might be the Mail app. On a Mac, it's probably the Mail app that came preinstalled with the OS X operating system (although it could be Outlook or another third-party mail application).

Regardless of which mail application you use on your computer, the steps to compose an email with image attachments are similar. For demonstration purposes, the following steps use the Mail app on a Mac.

Add Photos to an Email

1. Launch the mail application you typically use on your computer.

2. Click on the New Message/Compose icon.

(3) From the New Message screen, fill in the To field and the Subject field, as you normally would when composing an outgoing email message. If necessary, fill in the Cc: and/or Bcc: field with additional recipients.

(4) In the body of the email, type an optional message.

(5) Click the Attachment icon to attach one or more photos that are stored on your computer. This icon usually looks like a paperclip, regardless of which email program you use.

(6) Locate the image(s) you want to attach to the email, based on which folder they're stored in. (On Macs you use a Finder window. In Windows it's a Windows Explorer window.)

(7) Select one or more images from the album/folder. (You can click an individual image or drag a box around a set of images.)

(8) Click on the Choose File button to attach those selected images to the outgoing email. (On a PC, this button's label is Attach.)

Choose image size.

9) Click on the Send icon to send your email. (Your computer must have Internet access.)

Resizing Images

When the images are attached to the outgoing email, click on the Image Size option, if desired, to adjust the file size of the images being sent. On a Mac, your options include Small, Medium, Large, or Actual Size. Not all email programs support this option.

Sending Images Between Devices

From your mobile device, it's possible to send images wirelessly to another computer or mobile device that's in close proximity. Depending on whether you're using an iOS, Android, or Windows Mobile-based device, follow the appropriate steps to use this feature.

>>>*Go Further*

SHARING LARGE IMAGE FILES VIA EMAIL

If you need to share one or more very large images, and your email account provider does not accept such large files, consider using a third-party service, such as DropSend (www.dropsend.com), Hightail (www.hightail.com), and ShareFile (www.sharefile.com).

After you set up an account with one of these services, it's possible to attach very large files or groups of files to an outgoing message, but those files are uploaded and stored on Hightail's servers (in the cloud) instead of being sent via email.

Your intended recipient receives an email message containing a secure link for downloading those large sized attachments. All the recipient needs to do is click on the provided link.

Send Photos with AirDrop

On an iPhone or iPad, you can use the AirDrop feature built in to the iOS and OS X operating systems to send your pictures to another iOS or Mac user. To use this feature, be sure to turn on the Wi-Fi and Bluetooth features on your Mac(s) and/or iOS mobile device(s). Then, to use AirDrop, follow these steps:

1. Access the Control Center by placing your finger at the bottom of the screen and swiping upward.

2. Tap on the AirDrop button.

3 Tap either Contacts Only or Everyone. If you choose Contacts Only, AirDrop works only with people who have an entry in your Contacts database. By selecting Everyone, this feature works with any Apple device in close proximity.

4 Select the image(s) you want to send.

5 Tap on the Share menu icon.

You can make yourself discoverable to everyone or only people in your contacts.

Off

Contesto Only ── **3**

Everyone

Cancel

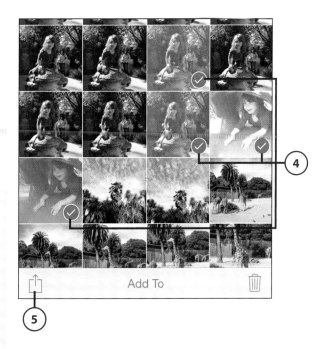

Add To

(6) Tap on the AirDrop icon for the person to whom you want to wirelessly send images, providing that person also has AirDrop turned on. If a wireless connection can be made, the intended recipient's profile photo and/or name is displayed in the AirDrop window.

(7) A message appears on the recipient's iPad screen when the sender establishes an AirDrop connection between the sender's device and the recipient's device. The message disappears when the photos have been sent.

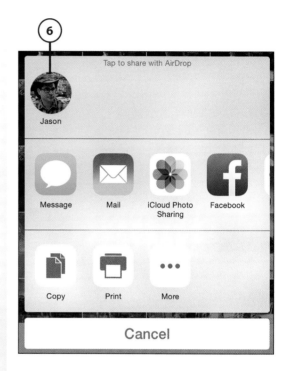

Sharing Photos with Bluetooth (Android Devices)

On an Android device, for Bluetooth to work, turn on the Bluetooth feature on your mobile device and make sure the intended recipient turns on the Bluetooth function on her computer or mobile device. Then follow these steps to send photos via Bluetooth:

1. Launch the Photos app and select the images you want to send wirelessly via Bluetooth.

2. Tap on the Share icon.

3. From the Share menu, tap on the Bluetooth option.

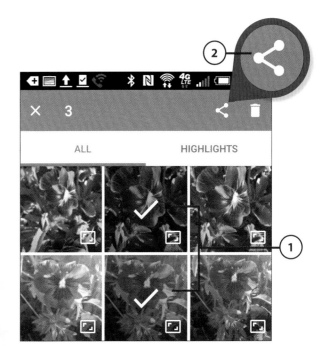

Android Beam

Android devices also support a function called Android Beam, which works only with other Android-based devices. To use it, select the Android Beam option instead of Bluetooth in step 3.

(4) From the Choose Bluetooth
Device screen, tap on the com-
puter or mobile device you want
to send the image file(s) to.
On the recipient's computer or
mobile device, an Incoming File
Transfer window appears. Once
the recipient accepts the trans-
mission, the files are wirelessly
transferred from your mobile
device to the recipient's comput-
er or mobile device.

>>>Go Further

SHARING WITH WINDOWS MOBILE

Windows Mobile devices can also share photos using Bluetooth. Just like for Android, locate
and select the photos you want to share, tap the Share icon, and choose Bluetooth from the
menu that appears. You can then choose which available Bluetooth device you want to share
those photos with.

Sending Photos in Messages

Another way to send one or a few select images to one or more specific other
people is to use text messaging from your mobile device. This can be done
either from the Messages app that comes preinstalled on your mobile device, or
directly from the Share menu offered from the Photos (or Gallery) app, for exam-
ple. Shown on the next page is the Messages app on an iPhone with a photo
attached and being sent to Jane Doe.

When you send a traditional text message, it is sent to another mobile device via your cellular service provider's text messaging network. If you're an Apple user sending messages to other Apple users, take advantage of the free iMessage service to send photos and text messages.

Instant messages (which are similar to text messages and can include photos) can also be sent via Facebook Messenger, for example, or you can send a single image via Direct Message (DM) using Twitter or Instagram, which are popular social networking sites. How to do this is covered in Chapter 10.

It's easy to share your images online with friends, family, or the general public.

In this chapter, you'll learn about some of the ways you can share your photos online. Topics include

→ Sharing your photos online from your computer and/or a mobile device

→ Using an online-based photo sharing service to share and showcase your photos

→ Sharing your photos using social media, including Facebook, Twitter, and Instagram

10

Sharing Photos Online

After you've taken and edited your photos, one of the great things about having Internet connectivity from your computer or mobile devices is that you can almost instantly share your photos with friends or family. If you choose, however, it's also possible to showcase them online in a public forum (known as social media) so virtually anyone can see them.

Other benefits to having your photos stored online is that they become accessible to all your own computers and mobile devices and can be stored or archived remotely (in the cloud), so you always have a backup of your images if something happens to your equipment.

It's important to understand the different types of online services you can use with your photos, and each serves a rather different purpose. Where it gets a bit confusing, however, is that many of these online service types overlap somewhat in terms of the features and functions they offer.

Before we look at specific online-based services and how to use them, let's focus on the features and functions you can expect from the various types of online services, so you can more clearly define your own needs and then more easily choose which service type(s) best fit those needs.

Using Cloud Storage Services

Several examples of cloud-based file sharing services are discussed throughout this book. These include services such as Apple iCloud, Dropbox, Google Drive, and Microsoft OneDrive. These services enable you to back up, sync, and share your files (including your photos) online. In most cases, your computer or mobile device can be set up to automatically sync your digital image files with your cloud-based account, which then enables you to automatically sync the images between all of your own computers and mobile devices linked to that account. These cloud-based services do not, however, have a photo lab directly associated with them, nor are they designed exclusively for managing digital image files.

When it comes to digital photography-related tasks, these services allow you to upload images to your account, where they can be stored/archived in their original file size and resolution. In your account, you can set up an unlimited number of albums or folders in which you organize and store your digital images.

The biggest benefit to using cloud-based storage for file sharing purposes is that once you set up a single account, by installing the service-specific software or mobile app onto each of your own computers, smartphones, and/or tablets, it's possible to sync your digital image library automatically, so all your images are available, whenever and wherever you need them.

Backups and File Syncing Happens Automatically

Once you set up one of these services (using a single account) on all of your own computers and mobile devices just once, your photos automatically back up and sync via that service. This happens on an ongoing basis and in the background.

These services, and others like them, provide a viable and secure online-based backup solution for your digital photos. To make things easier, based on what type of equipment you're using, built in to the operating system of your computer or device is the software needed to use one of these services.

Built in to Windows PCs (version 8 and newer) is integration with Microsoft OneDrive. Incorporated into the Mac, iPhone, and iPad's operating system is integration with Apple's iCloud service, while Android devices have integration with Google Drive built in. That being said, all these services now offer free, download-able software and mobile apps for most or all other hardware platforms.

Dropbox (www.dropbox.com) is an independent cloud-based file sharing service designed to work seamlessly across all hardware platforms, assuming you install the free Dropbox software or mobile app onto each of your PCs, Macs, smart-phones, and tablets.

Chapter 16, "Backing Up and Archiving Your Digital Photo Library," has more information about these services and how they can be used for image backup purposes.

What It Costs

When you set up a free account with any of these cloud storage services, you're given a predetermined amount of online storage space. If you exceed this allo-cated space with your documents, files, content, and/or photos, you must acquire additional online storage for a monthly or annual fee. How much initial storage space you receive upon setting up an account, and what it costs to increase this storage space, varies by service but is typically less than $5 per month for enough online storage space to hold thousands of digital images, plus other content.

Using Online Photo Sharing Services

There are many independent online-based photo sharing services, including Flickr.com, Shutterfly.com, SmugMug.com, and SnapFish.com.

Several things set these services apart from cloud-based services. For example, these photo-sharing services enable you to back up or share your digital image files with others, but they're not designed to automatically sync your image files between your own computers and mobile devices. In addition, these services have photo labs associated with them, so you can order prints and photo gifts, which are then shipped to the address you provide.

Online photo-sharing services are ideal for showcasing your images in the form of online galleries, and for sharing them with other people you invite to see your images.

As you'll discover, social media services, such as Facebook, Instagram, Twitter, and Pinterest, can also be used to share images online. However, these are primarily public forums and give you less control over who can see your images.

It's important to understand that the lines between what cloud-based services, online photo-sharing services, and social media services offer is becoming blurred, and the features and functions that are offered by these various services (all of which are online or cloud-based) often now overlap.

For example, Apple's iCloud Photo Library enables you to back up, sync, showcase, and share your digital images and gives you control over who can view them. Apple's iCloud Photo Library is part of Apple's iCloud service that's designed specifically to manage digital images. iCloud Drive is another iCloud features that can be used with image files but that works with any other type of file as well.

You'll discover that the online-based services, such as Flickr.com, tend to serve two primary purposes for digital photographers. First, it's possible to upload groups of images to these photo-sharing services in the form of online-based albums and then showcase and share those albums with select friends and family whom you invite to see your images. Your photos remain private, except to the people you invite to see them.

Depending on how you set up each album, the people you invite to view it can often download your photos to their computer or mobile device, plus leave comments about or "like" your images.

A TYPICAL ONLINE ALBUM

Regardless of which service you use, a typical online album is comprised of a text-based title, thumbnails for each image in that album, and a caption for each image. It's also often possible to tag the people featured in each photo, plus add geo-tag information to showcase the location where each image was shot.

When someone viewing your album clicks on a thumbnail, she can view a larger-size version of the image on her screen, download the photo, leave a comment about the photo, or "like" the photo.

As the album creator, you decide who can access and view each of your albums. Shown here is a sample online-based album created using the popular Shutterfly service.

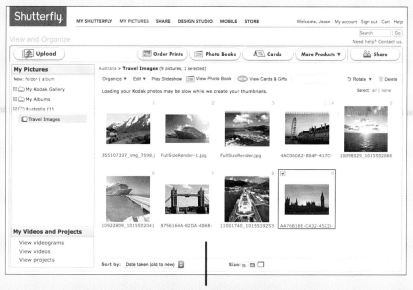

An online album on Shutterfly

Keep in mind that if you grant permission for someone to download your images from an online photo sharing service, that person can then view, edit, and store those images on his own computer, plus share them with others. In other words, you give up control over your images.

In addition to showcasing online-based albums, some of these services enable you to create animated digital slide shows featuring select groups of your images. These slide shows can be viewed online and can include animated slide transitions, background music you select, and title slides and captions that you create.

Second, these services usually have a photo lab associated with them, so you can order professionally created, paper-based prints in many different sizes and have them shipped directly to you or the intended recipient.

Popular online photo sharing services include

- **Flickr**—www.flickr.com

- **iCloud Photo Library**—www.apple.com/icloud/photos

- **Photobucket**—www.photobucket.com

- **Picasa**—https://picasa.google.com

- **Shutterfly**—www.shutterfly.com

- **SmugMug**—www.smugmug.com

- **Snapfish**—www.snapfish.com

Due to its popularity and compatibility with all hardware platforms, the next section demonstrates how to use Flickr. However, regardless of which photo sharing service you use, how each works and the features and functions offered are pretty similar.

>>>*Go Further*

WHAT FLICKR OFFERS

Flickr is an online-based photo sharing services that enables you to set up a free account that includes 1,000GB of free online storage. This is enough space to store up to 500,000 digital images. As you upload your photos, you can place them in custom-named albums to organize them, plus adjust the privacy settings to determine exactly who can view and access your images.

Although you can lock down your images so they're accessible only to you, from your own computers and mobile devices, Flickr is designed so you can also share your images with specific people or the general public. If you opt to make your images public, it's important to understand that *anyone* can search for them based on their filename, description, tags, where they were shot (location), and who appears in them (people's names). People can also search for other metadata-related information that pertains to the photos.

ICLOUD'S PHOTO LIBRARY OFFERS MANY OPTIONS

iCloud Photo Library is part of Apple's iCloud online service. This service has been integrated into the operating system of all Macs, iPhones, and iPads running the latest version of their respective operating system. Integration with iCloud Photo Library has also now been built in to the Photos app, which runs on all Macs, iPhones, and iPads.

The iCloud Photo Library feature can be set up to automatically upload all your digital images to your iCloud Photo Library (which can encompass your entire digital photo collection), and then sync your image files across all your Macs, iPhones, and iPads that are linked to the same iCloud (Apple ID) account. This syncing process can be set up to happen either automatically or manually, depending on your personal preference.

If you're a Windows PC user, optional software can be installed onto your computer that gives you iCloud Photo Library access. To acquire this free software, visit www.apple.com/icloud/setup/pc.html. It's also possible to access and manage your iCloud Photo Library directly from the Web using any popular web browser. To do this, visit the iCloud website (www.icloud.com), and log in to your iCloud account using your username and password.

In addition to automatically (or manually) backing up and syncing your digital image library, iCloud Photo Library can be used to share specific albums (groups of images) with other people. You can decide exactly who will have access to specific albums, while keeping the rest of your image collection private.

Even if you have multiple Macs (such as an iMac and MacBook), and/or one or more iOS mobile devices, you need to set up only one iCloud account. It is then necessary, however, to set up each Mac and iOS mobile device separately to work with your iCloud account. This can be done from System Preferences on a Mac, or Settings on your iPhone/iPad. Additional iCloud Photo Library settings are also offered from within the Mac or iOS edition of the Photos app.

When you set up a free iCloud account, it includes 5GB of free online storage space. Additional storage space must be purchased for a monthly fee, starting at $0.99 per month for 20GB of online storage space.

Use Flickr.com to Showcase and Share Your Photos

To get started using Flickr.com (which is owned by Yahoo!), from your PC or Mac, launch your web browser, visit www.flickr.com. To use this service, you'll need to set up or use your existing Yahoo! account. To access this service, follow the steps listed here:

Click Sign Up if you need to create an account.

1. From the Flickr.com website, click on the Sign In button.

Creating an Account

If you still need to create a Flickr account, click the Sign Up button instead and follow the instructions that the website provides. During this process you can choose, but are not required, to link your Flickr and Facebook accounts or invite people you know to view your images.

2. When you're ready to begin uploading photos to your Flickr account, click on the Upload option.

(3) Click on the Choose Photos and Videos button.

Faster Uploads

You can also choose the option to download the Flickr Uploader software to your PC or Mac to speed up the image uploading process.

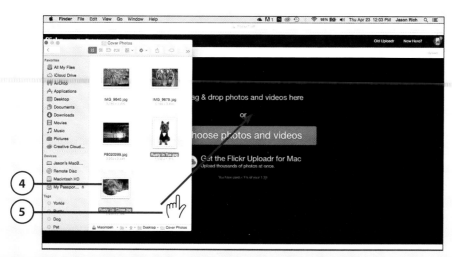

(4) Locate and select the images you want to upload using File Explorer on your PC or Finder on your Mac (shown).

(5) Drag and drop the images from your File Explorer/Finder window into the web browser (Flickr) window, and they immediately begin uploading to your Flickr account. Each uploaded image appears as a thumbnail on the web page.

Speeds Vary

How long this upload process takes depends on the speed of your Internet connection, the file sizes of your images, and how many images you're uploading.

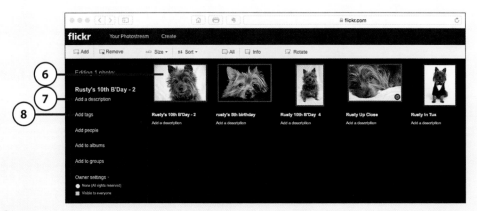

(6) Click an uploaded image to select it.

(7) Click on the Add a Description option to add a text-based description (caption) to that image.

(8) Click on the Add Tags option (optional) to add one-word tags that describe the image.

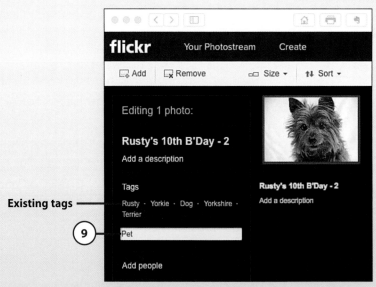

(9) Enter tags in the field provided. These tags are all searchable and make it easier to find your images. You can add as many tags as you want to each photo.

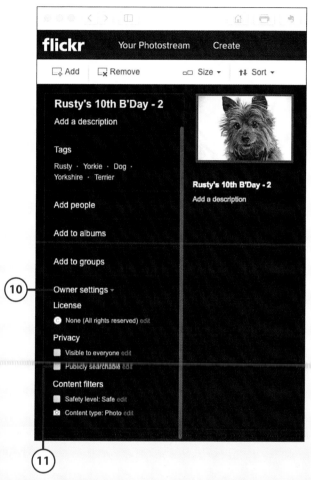

(10) Click on the Owner Settings option to reveal a more extensive menu that enables you to adjust the privacy settings associated with the selected photo.

(11) If you want to keep your images private, do not add check marks to the Visible To Everyone or Searchable options. Repeat steps 6 through 11 for each of your images.

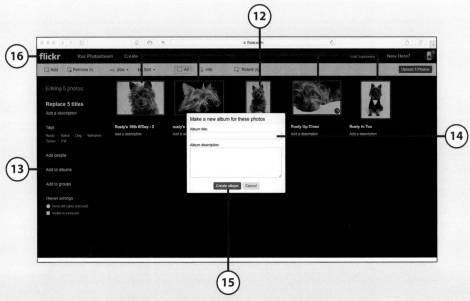

(12) To organize images into an album, select and highlight the uploaded images that you want to include.

(13) Click the Add To Albums link.

(14) Enter an album title and description.

(15) Click on the Create Album button. The selected images are now placed in that newly created album. You can create as many online albums as you want to store, organize, and showcase your images using Flickr.

(16) Click on the Flickr logo to return to the main Flickr screen.

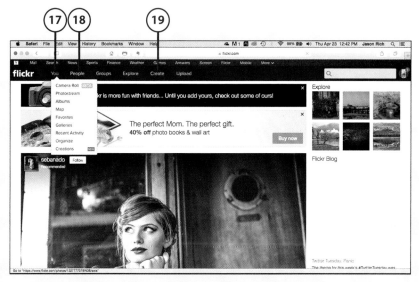

(17) Click on the You menu to access this pull-down menu that gives you a variety of options related to managing, viewing, and organizing your images.

(18) Click on the People option to share your images with specific people (or the general public) and to view other people's images.

(19) Click on the Create option to design and order prints, photo gifts, or photo products, including photo books, that feature your images.

FLICKR WORKS FROM MOBILE DEVICES TOO

All the features and functions offered by the Flickr website to upload, view, manage, organize, and share your images, as well as order prints and photo gifts/products, can also be done from the Flickr mobile app available for all popular mobile devices. Regardless of how many computers, smartphones, or tablets you use, remember that you need only one Flickr account. Flickr integration is also built in to the Mac and iOS Photos app.

Social Media Services

Facebook, Instagram, Pinterest, Snapchat, Tumblr, and Twitter are all popular online social media services that enable you to showcase and share your digital images in an online-based public forum.

In some cases, you can limit who sees your images to just friends, family, and real-life acquaintances, but in most cases, these services are designed to be public forums, meaning that anyone can search for and find (or stumble upon) your images and view them.

People love using social media as a way to share their images and interact informally with other people. However, it's important that you understand who has access to your images and information once you publish content online.

Before you become active using one or more of these services, manually adjust the privacy settings associated with each service you use to limit your public exposure to a level you're comfortable with.

Social Media = Public Forum

In general, if there are photos you do not want made public, for whatever reason, do not post them on social media, even on services that let you keep photos private. Anyone you invite to see a private photo can easily copy or share that image and make it public without your permission in a matter of seconds.

In general, using social media is fun, safe, and a great way to communicate with people you know, as well as meet new people from around the world. It's important, however, to use common sense before sharing personal information or photos with strangers.

The following sections show you how to publish photos on different social networks. Because each network operates a little differently and it goes beyond the scope of this book, the sections do not cover service basics like creating an account or activities other than posting photos.

Getting Started with Facebook

Facebook is currently the world's most popular social media service, with more than 1 billion active users worldwide. Using Facebook is free; however, it is an advertiser-supported service, so you will see ads on the screen as you use it. One of the reasons why Facebook is so popular is that you can manage your Facebook account from your computer or mobile device. From your computer, simply point your web browser to www.Facebook.com. From your smartphone or tablet, download and install the free Facebook app.

Beyond posting photos onto your Wall, in the form of Status Updates or Check Ins (an option available from the Facebook app on your mobile device), Facebook enables you to create and showcase custom-named, online-based photo albums.

Each album can contain as many images as you want, and you can have as many albums as you want within your Facebook account. Each photo and/or album can have a title, description, tags, location information, and additional metadata associated with it. For example, you can tag the people who appear in your images or showcase images by the time and date they were shot.

By Default, All Images Are Public

By default, all photos you upload to Facebook are public. This means any other Facebook user, anywhere in the world, can potentially see your images. Be sure to adjust the privacy settings to a level you're comfortable with to determine who can view your images. To do this, click on the Privacy Shortcuts icon displayed near the top-right corner of the browser window when you visit www.facebook.com, after logging in to your account.

In addition to publishing photos on your Facebook Wall, or within an online-based album, it's possible to send (or receive) private messages via Facebook that can also contain images. These messages are accessible only to the sender and recipient(s).

It's Not All Good

Facebook Decreases Image Resolution

When you upload images to Facebook, it automatically decreases the file size and resolution of each image to make the uploading and sharing (downloading) process faster. Thus, Facebook is ideal for sharing photos with others but is not a viable image backup solution.

Publish Photos on Your Facebook Wall

To publish a single image or a small group of images on your Facebook Wall as a Status Update (or Check-In, if you're using the mobile app), log in to your account and follow these steps:

1. On your Wall or News feed, type a short text-based message that you want to include with your photos.

2. Click on the Camera icon to select one or more photos or video clips and attach them to the Status Update message you're composing.

3. In the File Explorer (PC) or Finder (Mac) window that appears, locate and select the images you want to publish online.

4. Click on the Choose button. Thumbnails for your images appear in the Status Update window.

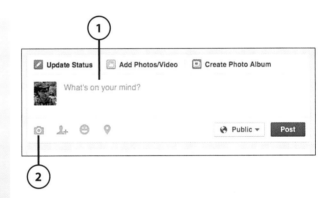

5. Click on the Tag People icon to tag individuals (including yourself) who appear in each photo. This is optional. When you do this, the names of the people you tag in each photo are linked to that digital image, and this information becomes searchable and public.

6. Click on the Emoticon icon to add an optional action to the message that's related to what you're doing or how you're feeling.

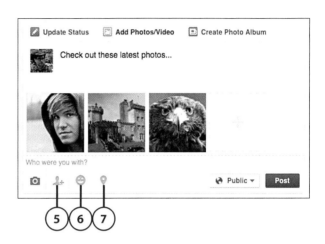

7. Click on the Location icon to include your current location in the Status Update message.

8. From the Privacy pull-down menu, determine who can view your post. Options include Public or one of several other audiences to whom you can narrow access to your post.

9. Click on the Post button to publish your message (and linked photos). What you publish almost instantly appears online.

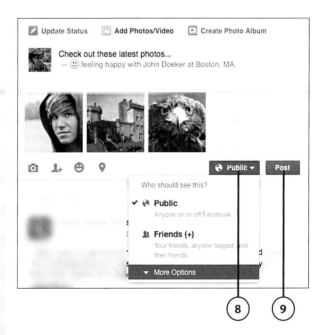

Edit or Delete a Post

You can edit or delete a Status Update by viewing it in Facebook, accessing the menu, and selecting the Edit Post or Delete Post option.

Edit Before You Post

When you upload an image to Facebook, before publishing it for others to see, you can use online-based image editing and enhancement tools to quickly improve or alter the image.

Create a Facebook Photo Album

Every Facebook account comes with the capability to create online-based photo albums that can be shared with your Facebook friends or the public. To create an album from the main Facebook page, follow these steps:

1. From the Status Update window, click on the Create Photo Album option.

2. From the Finder (Mac)/File Explorer (PC) window that appears, locate the images from your computer that you want to upload into this new album.

3. Click on the Choose button.

4. From the Create Album screen, as your photos are uploading (or after they've uploaded), click on the Untitled Album field and add a descriptive name to your album.

5. In the Say Something About This Album field, enter a one- or two-sentence description of the album.

6. Facebook automatically accesses the metadata stored in your image files and collects the date and time each image was taken. If you want to change this date, click on the Pick a Date option; otherwise, click on the Use Date from Photos option.

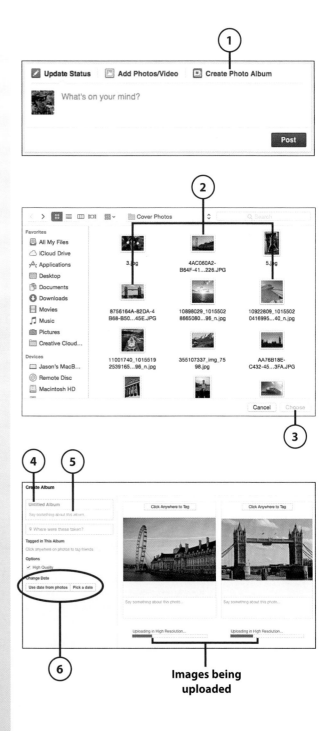

Images being uploaded

7 Click on the Privacy menu to determine who can access and view the album you're creating. Each album can have different privacy settings associated with it.

8 Below each image thumbnail, type an optional caption for the photo in the Say Something About This Photo field.

9 Once all the desired images have been uploaded and inserted into the album, and you've filled in all the desired fields and metadata information for each image, click on the Post button to publish the album on Facebook in your account.

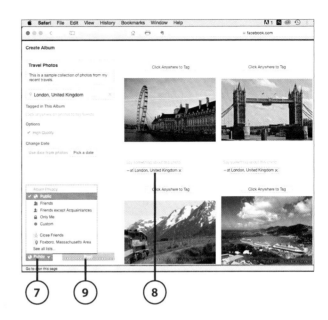

MORE CUSTOMIZATIONS

Just as with uploading a single photo, you can add extra information to each image you upload to an album. Click on a person's face, for example, to tag people in the image. If you want to upload and add more photos to the album click on the Add More Photos button or the "+ Add Photos" thumbnail displayed at the end of the album.

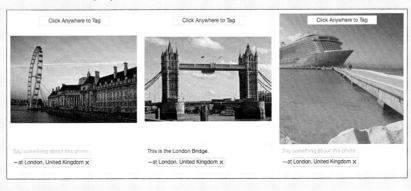

If you want to change the order in which your photos are displayed in the album, press and hold the mouse button on one thumbnail, and then drag it to a new location. Alternatively, click on the Order By Date Taken button to display the images based on the date/time each was taken.

At any time, you can access, edit, or delete any of your albums. This includes having the ability to add more photos to an album, delete individual images from an album, or alter metadata information associated with the album or photos within an album. This can all be done from the menu options when viewing your own albums online. Click on the gear-shaped icon to access this menu.

For more in-depth directions on how to share photos on Facebook, the service offers online help available by visiting https://www.facebook.com/help/174641285926169.

Getting Started with Twitter

Twitter is considered a "micro-blogging" service, because the posts you create with it (called *tweets*) can be only a maximum of 140 characters long. In a tweet, you can include text but also attach a photo, plus include location information, a website address, and/or hashtags (searchable keywords).

Although a Twitter account can be managed from any computer connected to the Internet, most people enjoy using it from their smartphone or tablet, when they're out and about, to share details about their whereabouts and experiences with their online friends (who are referred to as followers).

Compose a Tweet Featuring Your Photo

Because Twitter integration is built in to the OS X operating system for Macs and the iOS operating system for the iPhone/iPad, for example, you can compose and send a tweet that contains a photo directly from the Photos app. To do this, select the image, tap/click on the Share icon, select the Twitter option, fill in each field, and then click on the Post option.

Composing and publishing a tweet and managing your Twitter account can also be done from the official Twitter app, or from a third-party app, like Twitterific, that's designed for this purpose.

To compose a tweet and include a photo using the official Twitter app, sign in to your Twitter account and follow these steps (which are demonstrated here using an iPhone):

1. From the main Twitter timeline screen, click on the Home icon.

2. Click on the Compose icon.

3 In the What's Happening? field, enter a text-based caption. This can include descriptive hash tags (#keyword), which help people find your tweet who are using a keyword search on Twitter. To alert specific people of the tweet, include their Twitter username (@username) into the body of the tweet message. This will result in that person being notified of your post.

4 Tap the Picture icon to load a photo stored in your mobile device, or snap a photo using the camera.

5 Select a photo, and then tap its thumbnail to attach it to the tweet you're composing. Tap on the "+" thumbnail to add an additional image (optional). (Not shown.)

6 Tap on the Who's in This Photo button (if applicable) to tag people who appear in each photo (optional).

7 If you want to include the location where the photo was taken, click on the Location icon.

8 To edit the selected photo using the photo enhancement tools built in to the Twitter application, tap on the image thumbnail.

9 From the Edit Photo screen, tap on any of the special effect filters displayed along the bottom of the screen, or tap on one of the other two Edit command icons, which include Enhance (left) and Crop (right).

10 Tap Done when you are finished making edits. (Or Cancel if you want to discard edits you've made.)

11 After you've composed the text-based portion of your tweet and have edited the attached image(s), tap on the Tweet button to publish your tweet online.

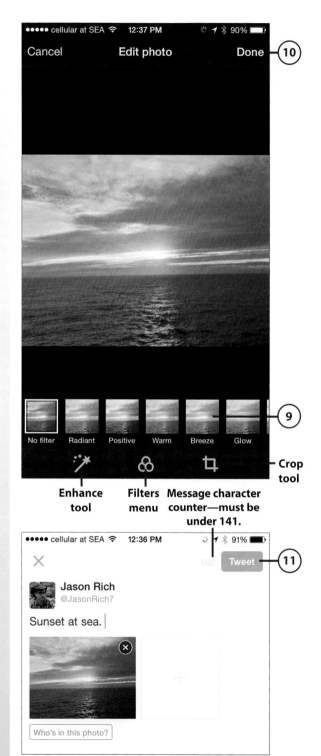

Crop tool

Enhance tool

Filters menu

Message character counter—must be under 141.

USING TWITTER'S ENHANCE AND CROP TOOLS

The Enhance icon turns on or off the one-tap image enhancement tool. When turned on, the Twitter app automatically enhances the contrast, color, brightness, saturation, and other elements in the photo to make it look better.

Tap on the Crop tool to adjust the crop frame and then reposition your image within the frame, or rotate the image by tapping on the rotation icon. To change the shape of the image, tap on the Original, Wide, or Square icon.

When you're finished, tap on the Apply option, followed by the Done option, to save your changes and return to Twitter's Compose screen.

CHECKING TWEETS

Tweets you compose and publish appear on your timeline and are visible to anyone. At any time, you can view your own tweets and then edit or delete them from your timeline.

To view your own tweets, click on the Me icon displayed at the bottom of the screen, and then tap on the Tweets tab displayed under your account profile information.

Getting Started with Instagram

Instagram is somewhat like Twitter, except instead of the focus of the service being on publishing 140-character text-based messages (with images attached), Instagram is all about sharing one photo at a time, with the photo being the main focus. Each photo you publish on your timeline can have a text-based caption and other information associated with it.

It's also possible to include the location where the photo was taken and tag the people who appear in the photo. Built in to the official Instagram app for mobile devices is the capability to simultaneously publish your post on Instagram, Twitter, Facebook, Tumblr, and Flickr.

What most people love about Instagram is that when using the official Instagram app on your smartphone or tablet, you can snap photos from within the Instagram app (instead of using the Camera app), or you can choose an image already stored on your mobile device to publish online.

The Instagram App Offers Powerful Image Enhancement Tools

After you select a photo, the Instagram app has powerful but easy-to-use special effect filters and image editing tools you can quickly add to your image to enhance it before publishing it online.

Using the official Instagram app on your mobile device, create a free Instagram account the first time you launch the app, and then manage your account and publish photos to your account from your Internet-enabled smartphone or tablet.

Instagram enables you to publish one photo at a time online. Each image becomes part of your account and is displayed as part of your timeline. All images are public and available to your followers, as well as to people who use Instagram's Search feature to find photos using keywords (hash tags).

Instagram Is All About the Square

Instead of displaying images in rectangular form, like most online photo sharing and social media services, Instagram crops and displays all images in a square shape.

Publishing Photos on Instagram

After creating a free Instagram account, to publish a photo online, launch the Instagram app and follow these steps (shown here on an iPhone):

(1) Tap on the Image Selection icon to select a photo.

Snap a Photo

If you want to capture a new photo to share, just frame it on the screen and tap the Shutter button.

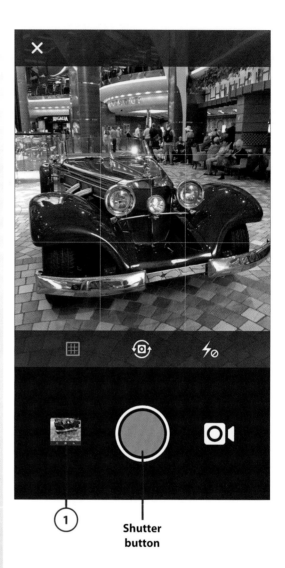

(1)

Shutter button

(**2**) Select the image you want to edit and publish.

(**3**) Use a reverse-pinch or pinch figure gesture to zoom in or out, and then reposition the image by placing your finger on the image, holding it down and dragging it around.

(**4**) Tap on the Next option when the image is framed how you want it.

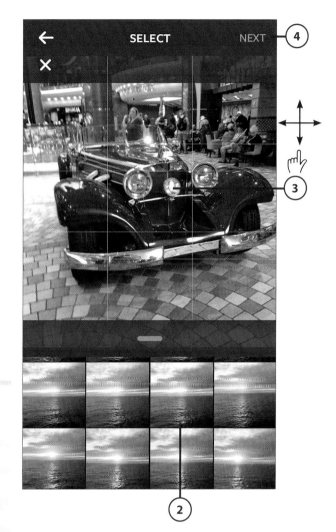

(5) Make any edit you want to your
photo, and tap Next to Continue.

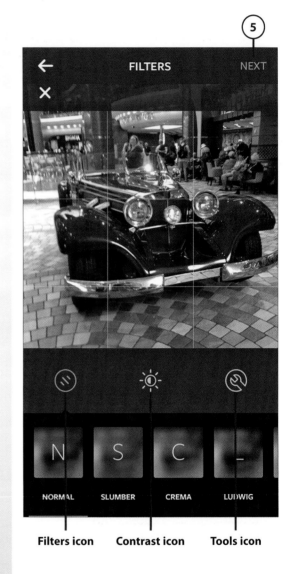

Filters icon Contrast icon Tools icon

6 In the Write a Caption field, enter a text-based caption for your image. This can include searchable and descriptive hashtags (#keyword).

7 Tap on the Tag People option to add the names of the people who appear in the photo. Adding this metadata links the people's names to the digital image, and their names become searchable.

8 To include the location where the photo was taken, tap on the Name This Location option, and then select the location from the menu that displays. Your mobile device's GPS feature is used to determine your whereabouts.

9 To simultaneously publish your photo on Facebook, Twitter, Tumblr, and/or Flickr, for example, if you're active on any or all these services, tap on each service's respective listing to select it.

10 Tap on the Share button to publish your photo. Once your photo is published online, it is public and viewable by your followers or people who stumble upon it using Instagram's Search feature.

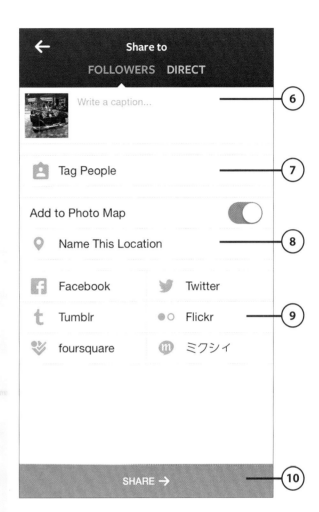

Edit or Delete Your Instagram Posts

After publishing content on Instagram, as you're viewing your own timeline, you can select an image and then edit or delete it anytime in the future. To do this, tap on the Profile icon at the bottom of the screen, tap on the photo you want to edit or delete, and when you're viewing it, tap on the More icon. From the More menu, select the Delete or Edit option.

>>>Go Further
MORE INSTAGRAM CUSTOMIZATION

The editing tools available in Instagram enable you to apply filters to your photos, adjust their contrast, apply highlights or shadows, crop, sharpen, and more.

To learn more about Instagram, including how to manage your overall account, from the official app, tap on the Profile icon (in the bottom-right corner of the screen) and then tap on the gear-shaped Settings menu icon (in the top-right corner of the screen). Scroll down to the Help Center option and tap on it.

Everyone has a story to tell. You can
use a digital diary to tell yours.

In this chapter, you'll learn about specialized software and mobile apps that allow you to create and maintain a digital diary that makes it easier to tell your story using your photos. Topics include

→ Understanding what makes a digital diary different from a traditional one

→ Using digital diary software to chronicle your life's events and memorable moments

→ Sharing your life's story with others using the Internet

Creating a Digital Diary That Tells a Story

A single digital photo can help you chronicle, remember, and share an important, meaningful, or exciting moment in your life by capturing what you see or experience using a camera. However, when you group together individual photos over time, it's possible to easily piece together a digital diary that chronicles your life as it unfolds and allows you to tell a meaningful visual history.

Using specialized software or a mobile app, the images that help tell your story can be combined with text that you compose, as well as other elements, and then organized using dated entries in a way that takes little time to put together.

Keep It Private, or Make It Public

Based on how you set up the digital diary software or mobile app, it's possible to password protect what you create, store it safely on your computer, and keep all your content private. However, it's just as easy to publish this information on the Internet and share your story with friends, family, and/or the general public by publishing your digital diary online.

Understanding the Difference Between a Written and Digital Diary

Unlike a traditional diary that involves purchasing a bound book filled with blank pages and then filling those pages by handwriting whatever is on your mind, creating a digital diary allows you to showcase and include your own digital photos, combined with short, text-based captions, to tell your story in a more visual way that's less time-consuming to create and maintain.

As you incorporate digital photos into your diary, metadata from your images and features built in to the specialized diary software you use automatically keeps track of the date, time, and location information. Plus, by tagging people in your photos, it becomes almost an automated process to keep track of whom you were with when various pictures were taken.

>>>Go Further

WHERE TO FIND DIGITAL DIARY SOFTWARE OR A MOBILE APP

From the Mac App Store or Windows Store, enter the phrase "diary" in the Search field to find and purchase special digital diary software, such as Day One Journal ($9.99, http://dayoneapp.com) and iScrapbook 5 ($49.99, www.chronosnet.com), both of which are available for the Mac. Journal, discussed later in this chapter, is a digital diary and scrapbooking option available for PCs.

You can also find similar software available for smartphones and tablets that enables you to compose digital diary entries while virtually anywhere and easily incorporate photos you've taken using your smartphone or tablet's built-in camera.

Getting Acquainted with Digital Diary Software

Many different digital diary software packages are available for PCs and/or Macs, as well as for various mobile devices. Day One, for example, is available for Macs, iPhones, and iPads and offers a variety of features that enable anyone to quickly create and maintain a digital diary related to a trip or vacation, a special event, or on an ongoing daily or weekly basis. If you know how to use a basic word processor, you have the skills to use almost any digital diary software.

Similar software from other companies is available for the PC. The next section offers a sampling of what Day One can do using the Mac edition of the software. Keep in mind that whichever digital diary software you use, it will only prove useful if you get into the habit of regularly creating entries, adding your photos to your entries, and then taking advantage of the app's features and functions to help you format, organize, access later, and potentially share your diary entries.

>>>Go Further

SOFTWARE THAT SYNCS

If you use multiple devices, look for software that's available for all of them and can synchronize its data among each installation. This makes it easy to update your diary with new entries from whichever computer or mobile device you happen to be using.

To turn on the autosync feature in Day One, for example, click on the gear-shaped Settings menu icon, and then choose the Preferences option. From the Preferences menu, click on the Sync tab, and then adjust the onscreen settings shown here.

Create an Entry in Day One

If you have purchased and installed the Day One software on a Mac you can follow these steps to create and maintain a digital diary:

(1) Open the software and, to get started, click on the New Entry ("+") icon.

First-Time Use
The first time you run Day One some introductory information screens display that you can read to learn more about the software.

(2) Start typing your entry. Day One automatically inserts the time and date as soon as you start typing.

(3) To change the date, click on the Calendar icon and then select an alternative date from the calendar that displays.

iOS Differences
Virtually all the same features and functions shown here on the Mac version of Day One are available in the iPhone/iPad edition, although the location of the menus and icons is different.

(4) Tap on the location icon if you want to add a location (useful for travel).

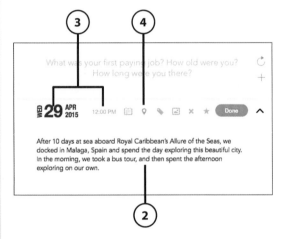

5 Click on the Use Current Location option, or manually enter an alternative location by clicking on the Search field, and then entering the desired location. The map displays the selected location.

6 Click on the Tag icon if you want to add optional tags for the entry.

7 Type keywords that relate to your entry. For example, for this entry, the tags "Royal Caribbean," "Cruise," "Spain," "Malaga," and "Tour" are already created, and the tag "Barcelona" is being added.

Using Your Tags

After you create a tag, Day One remembers it, so you can simply click on any precreated tag(s) as you create future entries. Later, anytime you want to access and read previously created diary entries, one way to search through them is by entering related tags into the Search field.

8 To add one or more photos to your diary entry, click on the Add Photo icon.

9 From the pop-up menu that's displayed, choose Take Picture (using the camera that's built in to your computer or mobile device) or Choose from Finder (to choose a photo stored on your computer).

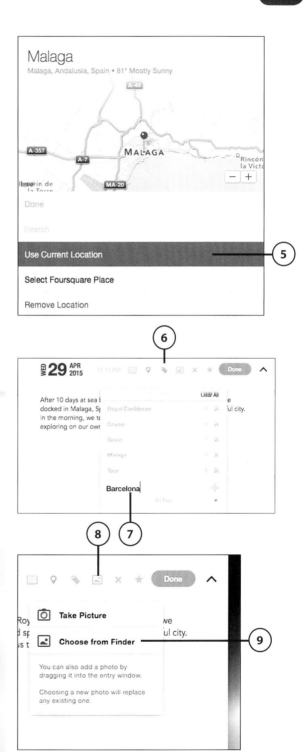

10 Using the Finder when prompted, locate and open the folder where your desired image is located and click on the thumbnail for the image you want to include in your entry. To select multiple images at the same time, hold down the Command key while clicking on each thumbnail.

11 Click on the Open button.

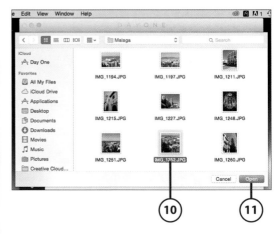

Add Multiple Photos to Each Entry

Repeat steps 8 through 11 to add additional photos to a single journal entry. To view an image that's been added to an entry, click on the View Photo option, or to delete a selected photo from an entry, click on the Move Photo to Trash option.

12 Each time you select a photo, the software reads its metadata. To use the metadata associated with your photo for the journal entry, click on Use Photo Information.

13 When you're finished typing your individual entry, as well as adding photos and location information, click on the Done button to save your entry.

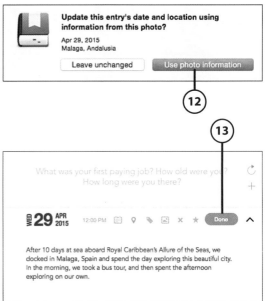

14 A summary of each diary entry, shown in chronological order, is displayed. Click on an entry to open and view it. Notice the date, location, and weather when the entry was created is gathered and displayed automatically. At any time, click on the New Entry ("+") icon to create an additional entry.

Work with Day One Entries

Once you have created an entry in Day One, you have a few things you can do to view and work with them:

(1) To view a complete entry, click on the desired entry from the Summary listing.

(2) Use the arrow icons in the top-right corner of the app window to scroll forward or backward through your entries, one at a time.

(3) Click the View Entry Summaries button to return to the main diary.

After 10 days at sea aboard Royal Caribbean's Allure of the Seas, we docked in Malaga, Spain and spend the day exploring this beautiful city. In the morning, we took a bus tour, and then spent the afternoon exploring on our own.

(4) Along the left margin of the Day One app window are additional command icons, which from top to bottom, include Add Entry, View Entry Summaries, Calendar, Location, and Alarm. Click on any option to use that functionality. Shown here, the Entry Summary icon is selected.

Pull-Down Menus Are Also Available

In addition to the command icons displayed in the Day One app window, along the top of the screen is a series of pull-down menus that offer an alternative way to access and use virtually all these features and functions. Some of these pull-down menu options also have keyboard shortcuts.

(5) Click the Calendar button.

(6) To view an existing entry click on that date. (Entries with dates are highlighted in blue. The current date is in red.)

(7) To create a new entry related to a specific date, click on that date's "+" icon that appears when the mouse is placed over the date.

(8) Click the Map icon to find and view entries based on the location in which each was created.

(9) The blue and white icons with numbers on them depict where entries were created, and how many entries were created at that location.

(10) Use the zoom tools to zoom in or out on the map.

(11) Click the Alarm icon to set up a reminder for when you want to create new entries.

(12) Drag the Off/On switch to the On position.

(13) Select how often and what time you want to receive the reminder.

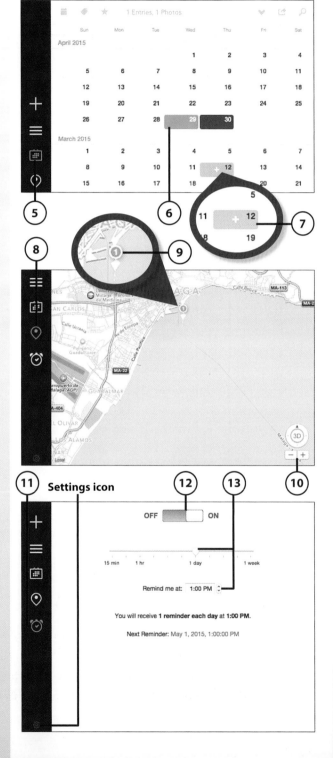

Adjusting Preferences

If you click the gear-shaped Settings menu icon and select Preference you see a menu that lets you personalize various features and functions related to the app. For example, click on the Appearance tab to choose a font and font size that your digital diary uses to display the text in your entries. Click on the Security tab to turn on Password Protection for your diary and set a custom password.

(14) As you're viewing any entry summary or full entry using Day One, click on the Share icon to create a PDF file based on that entry, print an entry, or share an entry with others via email.

(15) When viewing or composing any entry, to delete just that entry from your digital diary, click on the Delete ("X") icon, and confirm your decision by clicking on the Delete Entry option.

Using Journal for Windows

If you're a PC user and want to create a digital diary, a free app called Journal is available from the Windows Store. On the screen, it simulates a leather-bound diary, within which you can create a private virtual scrapbook and fill it with text, drawings, doodles, and photo-based entries.

What's nice about this virtual diary is that it never runs out of pages, and its onscreen appearance is customizable. Another useful feature of this app is that your diary can be divided into sections. Thus, it's possible to separate your diary entries into topic-related sections, such as travel experiences, dining experiences, information about special events in your life, or have sections related to anything that's important to you.

To add a digital image to your diary, simply click on the Add Image/Video/Music icon, select an image stored on your computer, and then place it on the diary page. It's then possible to resize, rotate, and position the image on the virtual page, and even create a collage of your favorite images within a minute or two. Each image can be given its own border.

When it comes to adding text, simply insert a customizable text box anywhere you want on each page. Each text box can display any amount of text. You select the font, font size, font color, typestyle, and positioning of the text box.

To do this, click on the Add Text icon, customize the appearance of the text, position the size and location of the text box on the page, and then start typing. When a page is full, click on the Next icon to create a new page.

After creating each entry, be sure to click on the Save icon to save your diary. Click on the My Profile option to set up a password for your diary, plus choose a theme for it.

The Journal app is easier to use than a word processor and enables you to create a highly personal, private, and visually interesting virtual diary or scrapbook that can be very photo-intensive.

Setting Up an Online Digital Diary

Digital diary software or mobile apps enable you to create and manage a digital diary or virtual scrapbook that can be securely stored and password protected on your computer and/or mobile device. If you want to create a digital diary and share with others, a variety of free, online blogging tools are available.

What's a Blog?

A blog is basically an online-based digital diary that has its own website address (URL) but that requires no programming knowledge or graphic design skills to create and maintain. What is required, however, is an Internet connection.

All the software needed to create a online-based digital diary (blog) is online-based, so there is nothing to install on your computer. Based on the blogging service you use, a specialized mobile app is most likely available to help you create and maintain your blog from your mobile device.

Popular online blogging services include

- **Blogger.com**—www.blogger.com
- **Tumblr**—www.tumblr.com
- **WordPress.com**—www.wordpress.com

Although Blogger and WordPress are free to use, they require the blog creator to customize the layout and design of their blog, as well as each blog entry. Thus, there is a learning curve associated with using these services, one that goes beyond the scope of this book. That said, online help and tutorials are available if you want to explore these options.

Tumblr, however, is a free, very easy-to-use blogging service that requires no programming or graphic design skills to use.

>>>Go Further
EASY SHARING WITH TUMBLR

One of the fastest and easiest ways to publish photos online and share them with the public is to create a free Tumblr account, either from your computer (visit www.tumblr.com) or mobile device (using the official Tumblr app). Tumblr is a social media service that lets you create a simple blog (an online diary that's public) and then publish text, photos, or any other content to your Tumblr page (blog) anytime you want.

What's great about publishing content on Tumblr is that absolutely no formatting or programming is required. You simply type text you want to publish, select photos you want to add, and then click or press the publish button.

Tumblr offers a way to publish multiple images in the form of an online gallery and include photo captions/descriptions and other details about your photos. You can update your Tumblr page as often as you want from your computer, smartphone, or tablet, plus edit or delete posts you've already published.

People enjoy using Tumblr because it's so quick and easy, and it allows you to publish photos with an unlimited amount of text, or other content, without first having to lay out or format each post, which is something most traditional blogging services require. If you plan to use Tumblr from a PC or Mac, specialized Tumblr software is also available, so you can manage your account from this software or directly from the Tumblr website using your web browser.

You can order prints directly
from a photo lab, using your
mobile device or computer.

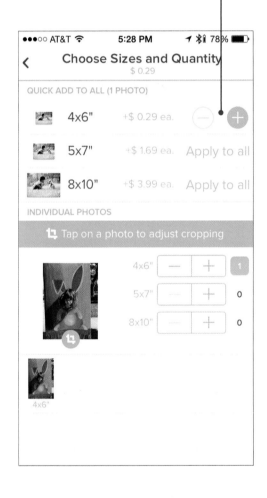

In this chapter, you'll discover your options for ordering prints to be made from the digital images stored on your mobile device or computer. Topics include

→ Using one-hour versus online-based photo labs
→ Ordering prints directly from your mobile device
→ Ordering prints from your computer
→ Understanding what's possible beyond traditional prints

Ordering Prints from Your Digital Images

When it comes to showing off your pictures, you have the ability to create paper-based prints in a wide range of sizes and then place those prints in an album, frame, or wallet; collect them in a shoebox; or distribute them to friends and family.

As you learn in Chapter 13, "Printing Digital Photos from Your Own Printer," it's possible to create your own professional-quality, full-color prints using a home photo printer. However, many people find it easier to use a local one-hour photo lab or an online-based photo lab to order the prints they want.

Virtually all one-hour photo labs located within pharmacies, such as CVS, Rite-Aid, and Walgreen's, as well as mass-market retail stores, such as Costco, Target, and Walmart, allow you to use an app on your mobile device or the store's website to upload your photos via the Internet to their respective one-hour photo labs. The labs then have your prints waiting for you to pick up by the time you drive to the store.

These one-hour labs let you order any number of prints from each of your digital image files and then choose the print size(es) you want. From these one-hour labs, 4×6-inch, 5×7-inch, and 8×10-inch prints are the most readily available, and the cost starts at around $0.10 for each 4×6-inch print.

It's Not All Good

Drawbacks of a One-Hour Photo Lab

When it comes to one-hour and online-based photo labs, the services offered, as well as quality and prices charged, vary dramatically. Consider trying out a few different services yourself, shopping around for the best deals and seeing firsthand which photo lab offers the best results at the most competitive prices. Then stick with that service or lab.

Although using a one-hour photo lab is quick and convenient, the quality of the prints you wind up with is sometimes inferior to what can be ordered online from an independent, professional photo lab. This is because the one-hour photo labs sometimes use inferior print processing equipment, photo paper, and inks, and rely on an automated print creation process that requires very little human interaction.

To create the highest-quality prints possible, using the best photo paper and the best inks, consider using a professional-level, online-based photo lab. The price per image often is higher, but that old saying, "You get what you pay for," typically applies.

If you prefer to use an online-based photo lab, in some cases, your prints will turn out better than printing yourself because higher-end processing equipment, as well as better quality inks and photo paper are used. The processing equipment also is typically operated by trained professionals who oversee the processing of your images into prints and can tweak the equipment, as needed, to generate better results.

BENEFITS OF A PROFESSIONAL LAB

If you opt to use an independent, professional-level photo lab, either in person, or one based online, the prices are higher but the quality of the prints and the service you receive often are significantly better. You also have more options in terms of photo paper quality, available print sizes, and print finishes when using a professional-level lab.

The following are examples of online-based, professional-level photo labs often used by professional photographers:

- **Artsy Couture Prints and Printing Services**—www.artsycouture.com
- **Bay Photo**—www.bayphoto.com
- **Miller's Professional Imaging**—www.millerslab.com
- **Mpix.com**—www.mpix.com
- **ProDPI**—www.prodpi.com

For really important prints that will go into a wedding album or will be hung on the wall in your home or office, consider using a higher-end, independent photo lab to achieve the best possible results, even if the prices are higher. This applies whether you're ordering prints from high-resolution digital images stored on your mobile device or a computer.

Keep in mind that when you pay more at a professional-quality photo lab, the print might look the same as using a less expensive option but your prints might be created on acid-free paper, with special inks that make it "archival quality." This means the inks and paper will last much longer and will not fade, yellow, or crumble over time.

Finding an App

You already know that once photos are taken using the camera built in to your mobile device, it's possible to share those images in a variety of ways using the Internet. However, you can just as easily order paper-based prints from the images stored on your mobile device.

To do this, you need to download and install a free, proprietary app offered by the one-hour or online-based photo lab you want to use. If you opt to use the one-hour photo lab located in your local pharmacy or mass-market retail store, for example, each has its own app that can be used for ordering prints, or that has print ordering functionality as a module within the store or retail chain's more general purpose mobile app.

All the online-based photo labs, such as Flickr.com, Freeprints.com, Shutterfly.com, and Snapfish.com, have their own proprietary apps for managing your online photo sharing account and ordering prints.

>>>Go Further
WHERE TO FIND THE RIGHT APP

The app you need to order prints from your desired one-hour or online-based photo lab is available from the app store associated with your mobile device. For the iPhone or iPad, access the App Store using the App Store app that comes preinstalled on your mobile device.

For Android-based smartphones or tablets, access the Goggle Play app store using the pre-installed Play Store app. Your Windows Mobile-device enables you to acquire apps from the Windows Store, which also has an app that comes preinstalled on your mobile device.

From the appropriate app store, using the Search field, enter the name of the lab you want to use, such as "Walgreen's Photo," or use a more generic search term, like "Order Prints," to see all your available options. Of course, if you know the name of the app you want to use, enter that name into the Search field.

Locate, download, and install the print ordering app just as you would any other app. Then, when you're ready to order prints, launch the app. Most of the apps ask you to set up a free account and provide your name, billing and shipping address, phone number, and credit card details, which ultimately are saved in the app for future use. This lets you speed up the print ordering process in the future, because you do not need to re-enter this information.

Ordering Prints from Your Mobile Device

Once the appropriate app is installed on your smartphone or tablet, the app gains access to all the images stored in your mobile device (with your permission). You might also need to log in to the app using your account username and password.

At this point, ordering prints, regardless of which app you use, generally involves the following steps:

- Choose a local one-hour photo lab location.

Each Lab Is Slightly Different

The order in which you need to complete these steps will vary, based on which print ordering app and which one-hour or online-based lab you opt to use.

- Select the images you want to print and the specifications you want used to print them, including size, treatment (glossy, matte, and so on), and number of copies.

Image Quality

If your digital images have been taken or stored using a low-resolution and smaller file size, when it comes to having prints created, your options often are limited. Although you can typically create 4×6-inch or 5×7-inch prints from low-resolution digital image files, if you want to create large size prints (8×10-inch or larger), the images will become pixelated and blurry. Keep in mind that if you've used the Crop feature of your photo editing software to focus in on a specific area of your image and have reframed the shot, this too results in a lower-resolution image.

>>>Go Further

CONSIDER YOUR PRINT'S FINISH

Anytime you have prints made from your digital images, one of the choices you'll often need to make is the photo paper's finish. Depending on the photo lab (or if you're using a home photo printer), options can include glossy, semi-glossy, matte, or lustre, although not all options will always be available.

As the name suggests, a print with a glossy finish will have a very shiny or glossy finish. You will see glares if light bounces off the print. This type of finish works great in a photo album or when you're keeping the prints loose. A semi-glossy finish offers less shine.

Prints created with a matte finish have no gloss or glare. This type of finish is ideal if the print will be placed in a frame and covered with glass or clear plastic. Higher-end photo labs offer a lustre finish. This is like a matte finish but fancier. There's a silky quality to this finish, which is why many photographers use it for wedding album prints, for example.

- If the images will be mailed to you, you are prompted to select a shipping address. This allows you to send images to other people or choose where you want your prints shipped. The default option is the home or work address you initially provided when you set up the app for the first time.

As mentioned earlier, if you use a one-hour lab, you can download an app specific to that lab, be it for CVS, Walgreen's, or some other lab. However, instead of using a company-specific app for a local one-hour photo lab, another option is the free Kicksend app for iOS and Android-based mobile devices. What's great about this app is that it uses the GPS capabilities built in to your mobile device, automatically locates the closest one-hour photo labs to your location, and then enables you to upload your images and order prints from the location you select.

The Kicksend app works with most CVS, Duane Reade, Target, and Walgreen's stores in the United States. So, you can use it to order your prints, and by the time you get to the selected store to pick them up, they'll be ready for you. Plus, Kicksend has its own photo lab, which allows you to order prints and have them shipped to you almost anywhere in the world.

Order Prints with Kicksend

To use the Kicksend app to order prints from your local one-hour photo lab (demonstrated here using an iPhone), download and install the app and follow these steps:

(1) Launch the app on your mobile device.

(2) Tap on the Print button if you want to locate a local one-hour photo lab, and then upload images to that lab so you can pick them up (within an hour).

Mailing Photos

Alternatively, if you want to order prints to be mailed to you (or other recipients), tap on the Mail Prints To Loved Ones button.

(3) Tap on the Prints For Myself button. (Not shown.)

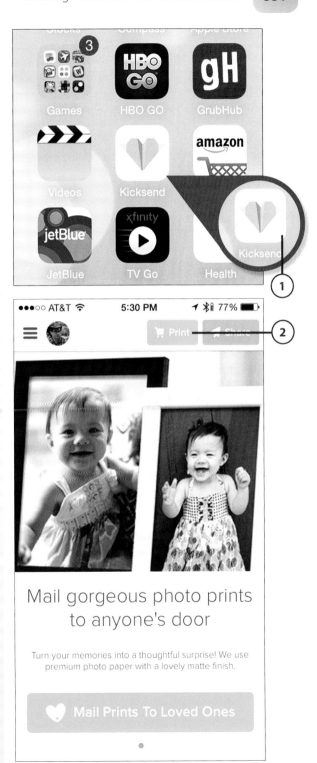

4 Select the compatible one-hour photo lab closest to your location, or that you want to use.

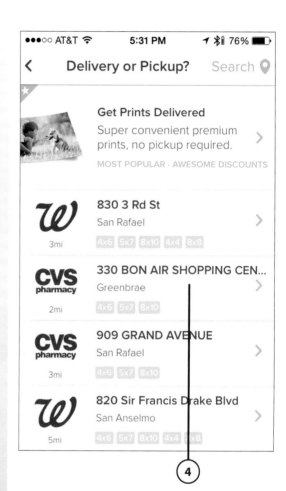

5 Select the images you want to create prints from by tapping on their thumbnails. All the images currently stored in your mobile device are displayed (as thumbnails) in chronological order, with the newest images displayed first.

6 Tap the Next button when you have selected all the images you want to print.

(**7**) From the Review Order screen, customize your order. Tap on the Sizes, Cropping and Quantity option first.

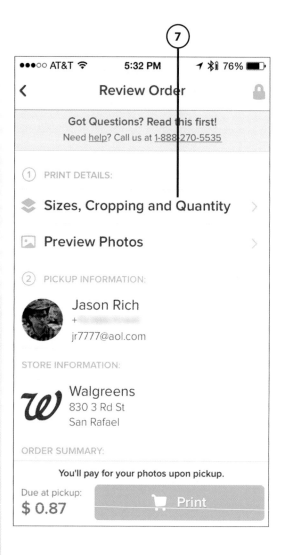

8 For the selected image, choose what size print(s) you want to create. Depending on the one-hour lab selected, options can include 4×6-inch, 5×7-inch, 8×10-inch, 4×4-inch, or 8×8-inch. The price for each size print is displayed near the top of the screen.

Choose One Print Size for All Images

If you want the same size and quantity for all the prints, select the size from the list at the top of the screen shown for step 8. Otherwise, make sure all the options displayed near the top of the screen say Apply To All, and then scroll down and adjust each selected image's settings separately. Thus, for one image you can order two 8×10-inch prints, and for another, you can choose five 4×6-inch prints, for example.

9 Tap on the Crop icon associated with the image if you want to adjust the print's scale and dimensions.

(10) Use the reverse-pinch finger gesture to zoom in, or the pinch figure gesture to zoom out. The white frame indicates the dimensions of the print, so whatever is seen within the frame is what will be displayed when the print is created.

Repositioning

From the Crop screen you can also reposition the image within the white box. Place your finger on the image and drag it around.

(11) Tap on the Save option when you're ready to move forward with your selections. Repeat steps 9 through 11 for each image, as needed.

12 Tap on the < arrow icon to the left of the Choose Sizes and Quantity heading (at the top of the screen) to return to the Review Order screen.

13 Tap on the Preview Photos option to see thumbnails of exactly what each print will look like.

Making Changes

If you don't like what you see in the preview, go back to the Choose Sizes and Quantity screen and readjust the cropping or positioning of an image within the frame.

14 Tap the < icon displayed in the top-left corner of the screen to return to the Review Order screen. (Not shown.)

15 Confirm your pickup information and selected store information, and then tap on the large green-and-white Print icon. You receive a confirmation in the app that your order has been placed. Depending on the lab you selected, you might also receive an email or text message from the lab. Within an hour, your prints will be ready for you to pick up and pay for at the selected one-hour photo lab.

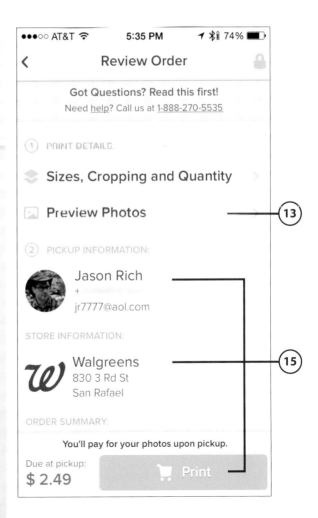

>>>*Go Further*

CREATE PRINTS FROM AN IN-STORE KODAK KIOSK

Many pharmacies, one-hour photo labs, specialty photo stores, and popular tourist attractions have Kodak Print Kiosks available. These bright yellow kiosks look like bank ATM machines but enable you to upload your digital files from your mobile device to the kiosk while you're standing in front of it and then create prints while you wait. This is typically a more expensive option than using a one-hour photo lab, for example, but it's a while-you-wait option for creating any size prints quickly.

To use a Kodak Print Kiosk, you need to download and install the free Kodak Kiosk Connect app (available for iOS, Android, and Windows Mobile-based devices). Then when you're at a kiosk location, activate the kiosk by touching its screen, select the wireless mobile device connection option, turn on your device's Wi-Fi feature, and enter the Wi-Fi password provided by the kiosk into your mobile device. Then launch the Kodak Kiosk Connect app, which walks you through the image selection and print creation process.

Ordering from an Online-Only Photo Lab

The big difference between ordering prints from a one-hour photo lab and an online-only lab is that when you use a one-hour lab, in addition to having mailing options, the lab can also make your prints ready for in-person pickup, typically within one hour. If you use an online-based lab, the prints you order are mailed to you (without a local pickup option) and typically arrive to the address you provide within three to five business days (unless you pay for expedited shipping).

Depending on the photo lab you choose, you also tend to have more options. For example, you can select the print paper quality and/or the photo finish (glossy, semi-glossy, or matte). Plus, when you work with a higher-end online-only lab, the quality of the prints will be better, because higher-quality photo paper and inks are used to create your prints.

The good news is that if you receive your prints and don't like them, you can typically contact the lab and have them redo the order, or refund your money, typically with very little hassle. Shutterfly.com, for example, has a strong reputation for superior customer service.

It's Not All Good

Cellular Data Usage

Many of the print ordering apps enable you to upload photos from your mobile device using a cellular (3G/4G/LTE) data connection or a Wi-Fi connection. However, if your cellular data plan has a monthly cap, such as 2GB, this will be used up quickly once you begin uploading large size digital image files. Thus, you're better off using a Wi-Fi connection whenever possible.

To order prints from an online-only photo lab directly from your mobile device, you need to download and install that lab's free app. Each lab has its own proprietary app. As you'll discover, many consumer-based photo labs make ordering prints from images stored on your mobile device easy. The majority of these labs are associated with popular online-based photo sharing services, such as Flickr.com, Shutterfly.com, Smugmug.com, or Snapfish.com. You'll learn more about Shutterfly.com shortly.

SHUTTERFLY: MORE THAN JUST PRINTS

Shutterfly.com, as well as the Shutterfly app, enable you to upload and share your digital images with others (see Chapter 10, "Sharing Photos Online"), as well as order prints from your digital images in many different size and finish options.

In addition, Shutterfly enables you to create a vast selection of high-quality, photo-based products and gifts that feature your digital images. These products include custom imprinted photo greeting cards, professionally printed photo books, posters, canvas print enlargements, coffee mugs, T-shirts, mouse pads, iPhone/iPad cases, puzzles, coasters, and Christmas tree ornaments. Literally hundreds of customizable products are available.

Each product can be designed in just minutes to create a one-of-a-kind keepsake. These products can be created right from the Shutterfly website or using the Shutterfly app on your mobile device and shipped directly to you or the intended gift recipient.

Beyond the dozens of full-service photo sharing and photo lab services, there are also online labs that do nothing but process print orders. One such company is FreePrintsNow.com, which offers the free FreePrints app for iOS, Android, and Windows Mobile-based smartphones and tablets. As the name suggests, this company enables you to order up to 1,000 4×6-inch prints per year for free. FreePrints charges a small fee for each larger size (non-4×6-inch) print—prices are competitive for 5×7-inch or 8×10-inch prints, for example—but otherwise you only pay a shipping and handling charge for each order (between $1.99 and $9.99, depending on the quantity and size of prints ordered).

FreePrints Can Save You Money

To save the most money using the FreePrints app to order prints, order a large number of non-duplicate, 4×6-inch prints with each order. Otherwise, with the flat shipping and handling fee, the price of a small order will be higher than using a one-hour photo lab or other online-based labs.

The FreePrints service is being showcased in this book because it offers a quick and easy way to order prints directly from your mobile device—for a fee—using a well-designed app. Lower prices for prints may be available elsewhere, so don't be fooled by the implications of the company's name that implies your print order will be 100 percent free.

Order Prints with the FreePrints App

To use the FreePrints app to order prints directly from your mobile device, download and install the app, and then follow these steps (shown here on an iPhone):

(1) From the Home screen, launch the Free Prints app. (Not shown.)

First-Time User

The first time you run the app, you are asked whether you want the app to be able to send you notifications related to your orders. To approve this, tap on the OK button. Otherwise, tap on the Don't Allow button. It also asks whether you want to give it access to your photos. For this step you must tap OK. Finally, you need to swipe past some one-time introductory screens that teach you about the app.

(2) From the app's main menu, which you see every time you launch the app, tap on the Begin or Tap To Get Started option.

(3) The Select Photos screen displays all the albums currently stored in your mobile device. To find images you want to create prints from, first open an album by tapping on its listing. (Not shown.)

(4) Select the desired images from the album you opened. As you select images, a check mark icon appears on the thumbnail for them. (You can also tap Select All to select all of your album's images.)

Access Online Photos As Well

Displayed at the top of the Select Photos screen are icons for Facebook, Instagram, DropBox, Google Drive, Google Picasa, and Flickr. If you have images stored on any of these image sharing or social media services, tap on that service's icon to access those images from the FreePrints app and order prints from those images.

(5) Tap on the Next option when you're finished selecting images.

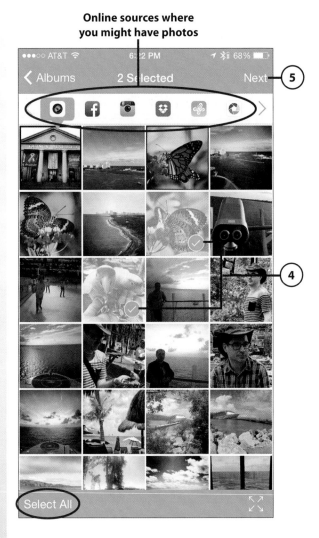

Online sources where you might have photos

6. Tap on the desired print size for each image you selected. (You can swipe left or right on this bar to see more print sizes.)

7. Select the number of prints you want in that size. The price per print is selected next to each quantity option.

Print Prices Are Displayed

Remember, prices vary, based on the print size you select. The first 1,000 4×6-inch images are free. However, if you order two or more 4×6-inch prints of the same image, a small fee applies. You're also charged a fee for larger size prints, plus the shipping and handling fee.

8. Tap on the Done option to continue. (Repeat steps 6–8 if you want to order prints of the same image but in different sizes.)

9. It might be necessary to crop each image so that it's displayed properly in the print. To do this, tap on the Crop icon displayed in the bottom-right corner of the images as you preview them.

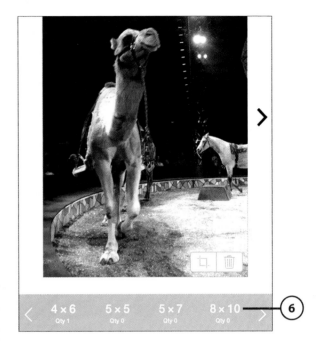

10 Reposition the image within the frame by placing your finger on it and dragging it around, or zoom in (or out) using the reverse pinch or pinch finger gesture.

More Customizations

In the lower-left corner of the Crop screen are three command icons: Rotate, Flip, and Filter. Tap on the Rotate icon to rotate the image, the Flip icon to flip the image (horizontally), or the Filter icon to transform the full-color image into black and white (shown).

11 Tap on the Save option when you're finished working with the photo. Tap on the Back option to continue. The newly cropped and edited image appears.

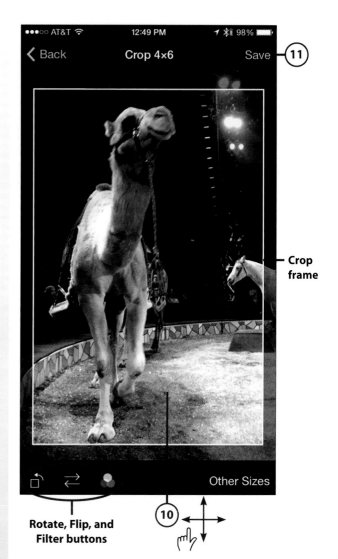

Crop frame

Rotate, Flip, and Filter buttons

12 If you selected multiple images to create prints from, tap on the > icon to proceed to the next image. Then repeat steps 4–12 for each image.

13 Tap Checkout after you are finished selecting options for each image in your order.

Creating an Account

The first time you use the app, you are prompted to create an account by entering your first and last name, email address, and an account password, as well as your mailing address, billing address, and credit/debit card information. Subsequently, these steps won't be necessary. You just sign in.

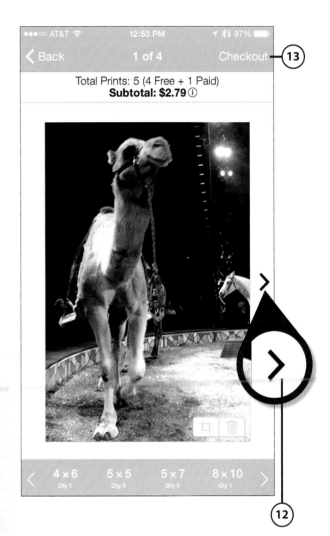

(14) The Shopping Cart screen, which summarizes your order is displayed. From here, you can edit the Shipping To address, so the prints can be shipped to an alternative address.

(15) Tap on the first virtual on/off switch and turn it on to request expedited shipping (for an additional fee, which is displayed).

(16) Turn on the second virtual switch if you want all the prints in your order to have a matte finish instead of a glossy finish.

Choosing a Finish

If you plan to frame the prints in a frame that covers the print with glass, a matte finish reduces glare.

(17) Tap on the Continue button.

(18) Enter your credit card information for the order. If you leave the Remember This Payment Method option turned on, this too only needs to be done the first time you use the app because the FreePrints app stores your payment details.

Other Payment Options

Instead of using a credit or debit card, it's possible to pay for the order using Apple Pay or PayPal by tapping on the appropriate button.

(19) Tap on the Submit Order option to finalize the transaction. Your images are uploaded to the FreePrints service, and within a few business days, the prints you ordered will arrive at the address you provided.

Creating Prints from Your Computer

Just as you can easily order prints from digital images that are stored in your smartphone or tablet, this can also be done from a Windows PC or Mac computer, as you'll discover from this section.

If you're a Mac user and use the Photos (formally known as iPhoto) app that now comes preinstalled with the OS X Yosemite operating system, from directly within the Photos app, it's possible to order prints, photo books, and other photo-related products, and then pay for your orders using your existing Apple ID and password (or Apple Pay).

Apple's Photo Lab and iCloud

Because the Photos app running on your Mac fully integrates with iCloud Photo Library, you can use Apple's photo lab to order prints from images stored on your computer, or from images stored online in your iCloud Photo Library. This also works for images other people share with you via iCloud.

Ordering from a One-Hour Photo Lab

There are two options for creating prints from images currently stored on your computer. First, you can copy those images onto a flash drive, CD, or DVD, and then bring that media to the one-hour photo lab in person. You then must wait for your prints or return to pick them up in about an hour.

Alternatively, you can visit the one-hour lab's website from your computer, upload the images from your computer to that service, choose your print sizes and quantities, and then place your order online. Your images will be ready for pickup in about an hour.

Making It Simpler

Most sites enable you to create a personal account (if you haven't done so already). By setting up a free account, details about you and your store location preference for pickup are saved, which makes subsequent orders much faster to initiate.

The one-hour photo labs in most pharmacies (CVS, Rite-Aid, and Walgreen's, for example), mass-market retailers (such as Costco, Target, or Walmart), as well as photo specialty stores, all offer the option to upload your photos from home to order prints.

From the Costco website (www.costco.com), for example, click on the Photo option displayed near the top of the screen (or visit www.costcophotocenter.com) and then click on the Upload Photos button.

Costco.com website

The website walks you through the process of uploading your photos, selecting print sizes and quantities, choosing your print finish, editing/cropping the image, and then placing your order. The options you find here are similar to what you see when using apps, as described earlier in this chapter.

The following are the website addresses for popular one-hour photo labs in the United States:

- **Costco**—www.costcophotocenter.com
- **CVS**—www.cvsphoto.com
- **Rite-Aid**—http://mywayphotos.riteaid.com
- **Ritz Camera & Imaging**—www.ritzpix.com/photo-processing/film-developing
- **Target**—www.targetphoto.com
- **Walmart**—http://photos.walmart.com/walmart/welcome
- **Walgreen's**—http://photo.walgreens.com/walgreens/welcome

Ordering from an Online-Only Photo Lab

Using an online-only photo lab to create prints works pretty much the same way as uploading images to a one-hour photo lab, except your prints are mailed to you and arrive within a few business days.

One benefit to using an online-only photo lab, such as Flickr.com, Shutterfly.com, or Snapfish.com, is that in addition to traditional size prints, these services (and others like them) also offer a vast selection of photo gifts and products you can order from the website. In many cases, the quality of the prints will also be higher from an online-only photo lab that uses higher end printing equipment, better quality photo paper, and higher-quality inks. Once again, the process for ordering through your computer's web browser is not much different from using an app, as explained earlier in the chapter.

Tip for Saving Money

When choosing an online-based photo lab to order prints, look for one that's competitively priced but that also offers free shipping. Some of these labs require you to enter a promotional code at checkout to obtain free shipping. You can acquire this code either from the company directly or by using any Internet search engine (such as Yahoo! or Google). Search for the name of the service, followed by the words "online coupon code."

The following are the website addresses for popular consumer-oriented, online-based photo labs:

- **AdoramaPix**—www.adoramapix.com
- **Flickr.com**—www.flickr.com
- **Google Picasa**—http://picasa.google.com
- **Photobucket**—www.photobucket.com
- **Shutterfly.com**—www.shutterfly.com
- **Smugmug**—www.smugmug.com
- **Snapfish.com**—www.snapfish.com

Order from Apple

To order prints and other photo products from Apple's photo lab via the Photos app, make sure your Mac has Internet access, open the Photos app, and then follow these steps:

① Select the images you want to create prints from. The selected images display a thin blue border around them.

② Tap on the + icon displayed near the top-right corner of the screen.

③ Select the Prints option from the menu that appears.

4 From the Choose Format & Size screen, select the print size you want for the images. The prices associated with each print size are displayed on this screen.

5 The Photos app uploads your images to Apple's photo lab. You are prompted to provide additional details pertaining to your order, such as the Ship To address. Within a few business days, your prints will arrive. (Not shown.)

>>>Go Further
APPLE BENEFITS

There are several benefits to using Apple's photo lab to order prints directly from within the Photos app. First, you can pay for your order using your Apple ID or Apple Pay information. Thus, Apple already has your name, address, phone number, and payment details, so there's no need to manually enter this information when placing your order.

Second, the Photos app helps you format your image files so they work perfectly, regardless of which print size you select. Any necessary editing or enhancement can be done from within the Photos app.

Third, there's no need to export your photos elsewhere or manually access a photo lab's website to upload your images. This is all done for you. You'll also discover that Apple's photo lab is competitively priced, and the quality of the prints (or photo products) you order is always top-notch.

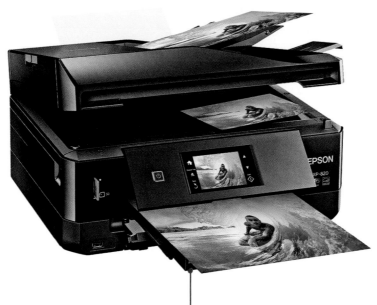

Using a home photo printer, it's possible to create professional-quality prints from your digital photos.

In this chapter, you'll learn how to use a home photo printer to create prints from the digital images stored on your computer or mobile device. Topics include

→ Choosing a home photo printer
→ Buying the right photo paper and printer ink
→ Creating prints from your computer
→ Creating prints from your iPhone or iPad

13

Printing Digital Photos from Your Own Printer

You already know that you can have prints made from your digital images using a one-hour photo lab or online-based photo lab. However, if you want to create your own prints, in whatever sizes you want, within minutes and without leaving your home, it's possible to use a home photo printer to accomplish this.

A home photo printer and a color inkjet printer are similar; however, a photo printer uses special inks and photo paper to create professional-quality prints from the digital images stored on your computer or mobile device.

In recent years the prices for home photo printers have dropped considerably. However, the price of the ink cartridges and photo paper needed to create professional-quality prints from your computer or

mobile device winds up costing a bit more than using a one-hour or online-based photo lab.

The benefit is that with a home photo printer, you can create prints at home in minutes and often in various sizes.

Shopping for a Photo Printer

Many printer manufacturers sell inexpensive photo printers that work with PCs and/or Macs, either by connecting the computer to the printer using a USB cable or by connecting the computer and printer to a Wi-Fi wireless home network.

AirPrint

To wirelessly create prints on a home photo printer from your iPhone or iPad, you must invest in an AirPrint-compatible wireless printer.

Some specialty home photo printers are small, and even battery powered, but can create prints in only a single print size (typically 4×6-inch or 5×7-inch). These cost around $200.

However, most full-size home photo printers can create prints that are 8.5×11-inch or smaller. Thus, you can choose between common print sizes, such as 4×6-inch, 5×7-inch, 8×10-inch, or wallet-size prints, based on what size photo paper you feed into the printer.

These printers start as low as $100 and go up in price to $500 (or more), depending on the features and functions offered.

For a bit more money, a wide-carriage home photo printer can accept larger size photo paper and thus create larger prints, up to poster size, for example.

It's Not All Good

Don't Be Fooled By Low Printer Prices

Many home photo printer manufacturers sell the printers themselves at very low prices, knowing that to create prints, you need to purchase costly name-brand ink cartridges and photo paper on an ongoing basis.

As you're shopping around for a home photo printer, look beyond the price of the printer itself and calculate the average price per print, based on the cost of the replacement printer ink cartridges (and how many prints each set of cartridges can create on average) and the cost of the photo paper.

On the packaging for most printer ink cartridges, the average life of the cartridges, which is measured in the number of 4×6-inch prints that can be generated, is typically displayed. Keep in mind that if you create larger size prints, the number of prints you can create with a set of ink cartridges decreases.

Photo printers and related supplies can be purchased from stores that sell consumer electronics (such as Best Buy, BJ's Wholesale Club, or Costco), office supply superstores (Office Depot or Staples, for example), computer specialty stores, photography specialty stores, and a wide range of online merchants.

Three popular home photo printer manufacturers, each of which offers many different printer models, include

- **Canon**—www.cannon.com/MAXIFYPrinters
- **Epson**—www.epson.com
- **HP**—www.hp.com

At least once or twice per year, these printer manufacturers release new home photo printer models and discontinue older models. After several years, it often becomes difficult to find and purchase replacement ink cartridges for older and discontinued printer models.

Understanding Printer Ink and Photo Paper

Regardless of which home photo printer make and model you ultimately purchase, it will require multiple proprietary black and color ink cartridges to create prints. In some cases, each color ink cartridge is sold separately, while other printers use a black and single multicolor ink cartridge.

Either way, you need to purchase only the ink cartridges made for your specific printer make and model, which can cost anywhere from $20 to $60 per set. How many prints can you create from each cartridge set typically varies between 50 and 200 4×6-inch prints.

>>>Go Further

CONSIDER GENERIC INK CARTRIDGES

Although companies like Canon, Epson, and HP recommend using only their own name-brand ink cartridges with their respective printers, independent and online-based companies often sell compatible ink cartridges for much less money. In many cases, these cartridges are as good as or better than the name-brand cartridges, but not always.

If you go with this money-saving route, you might need to try several different companies that sell generic ink cartridges that are compatible with your home photo printer make and model before finding a high-quality but money-saving option.

To find online merchants that sell ink cartridges compatible with your printer, go to Amazon.com, eBay.com, or a price comparison website, such as Nextag.com, and in the Search field of the service you choose, enter the exact make and model of your printer, followed by the phrase "replacement ink cartridges." Pay attention to the customer review ratings for each search result, and stay away from products with a high percentage of poor reviews.

In addition to the printer manufacturers selling their own photo paper that's compatible with their printers, many companies sell their own or generic photo paper that's just as good but priced considerably less than name-brand photo paper from the printer manufacturers.

The following are the most important things to understand about photo paper:

- Any brand of photo paper can be used with any home photo printer, as long as the size of the photo paper fits in your printer.

- Photo paper typically comes in packs of 10, 25, 50, or 100 sheets and in specific sizes, including 4×6-inch, 5×7-inch, or 8.5×11-inch (which can be trimmed to create 8×10-inch prints).

- All photo paper is rated between one and five stars, which determines its quality. If you want create professional-quality prints that will last for years without fading, choose three star or higher-rated photo paper.

- Photo paper is available in different finishes, including matte, semi-glossy, glossy, and luster. Semi-glossy and glossy are the most common and readily available from office supply superstores and other retailers, for example. Higher grade, professional-quality, five-star photo paper with a matte or luster finish is typically available from retail or online-based photo specialty stores.

Photo Paper Quality Is Also Worth Considering

Higher-quality photo papers tend to be acid-free and/or archival-grade. This means that the paper will not fade or crumple over time, and the prints will last much longer. If prints are exposed to direct sunlight, this does cause fading.

Focus on Quality

To create the best-quality prints at home, consider investing in five-star photo paper, precut in the size you want, with a semi-glossy or luster finish.

Creating Prints from Your Computer or Mobile Device

After connecting your home photo printer to your computer via a USB printer cable, or connecting both the printer and computer (or mobile device) to the same wireless home network, install the ink and photo paper into the printer, and turn on the printer so that it's set up to create prints.

Getting Connected

The process of connecting a printer with your home network or computer varies by the model. If you're having a hard time, check the manufacturer's instructions or, if necessary, call its tech support line.

Each popular home photo printer comes with proprietary software for PCs and Macs that enables you to create prints from digital images stored on your computer. Home photo printers with wireless capabilities also typically offer a free mobile app that can be used with Android and/or iOS mobile devices.

An easier option for creating prints, however, is to use the Photos app that comes preinstalled on OS X Yosemite (Mac), as well as on Android and iOS-based mobile devices. To print files from a PC, access the Desktop, launch File Explorer, and print images directly from the File Explorer window.

Based on which equipment you're using, follow the steps provided in one of the next sections.

Instead of Printing from Your Mobile Device

If you are unable to print directly from your mobile device, instead transfer the images from your smartphone or tablet to your computer, and then create your prints. Refer to Chapter 4, "Transferring Photos to Your Computer," for information on how to do this.

It's Not All Good

Check Your Formatting

Based on what size print you want to create from your digital images, it might be necessary to adjust the aspect ratio of each image using the Photo app's Crop, Repositioning, Zoom in/out, and/or Aspect Ratio tools, so that the image fits properly within the frame for the print size you select. If the aspect ratio, for example, is incorrect, the entire digital image might not fit within the paper-based print. These adjustments can also be made using the proprietary printing software or mobile app offered by your printer manufacturer.

Create Prints on Windows PCs

To create prints using a home photo printer connected to your Windows PC, make sure your printer is on and connected, and follow these steps:

1. From your PC's Desktop, launch File Explorer.

2. From the File Explorer window, open the Pictures Library (or whichever folder contains the image you want to print) by clicking on its icon in the navigation pane (or double-click it in the main This PC view).

3. Double-click on the folder that contains the image you want to print.

(4) When looking at the image thumbnails, click on the desired thumbnail to select and highlight it.

(5) Click on the Share option.

(6) Click on the Print option.

(7) From the Print Pictures window, select your home photo printer from the Printer pull-down menu.

(8) Choose the appropriate print size option, based on the photo size and paper you're using, from the pull-down menu.

(9) Click on the Quality pull-down menu, and if applicable choose the highest quality option listed. This varies by printer. Otherwise, leave the default Auto option selected.

(10) Click on the Paper Type pull-down menu to select the type of photo paper you'll be using. This relates to the paper's finish. The options vary based on your printer make and model.

Always Use Photo Paper

Although photo printers can print full-color images on plain paper, for the best results that closely resemble pro-fessionally created prints from a photo lab, use high-quality photo paper when printing your images.

(11) From the options displayed as thumbnails along the right margin of the Print Pictures window, choose a printing format.

Page Formats

Typically, you use the Full Page Photo option to print one image on one sheet of photo paper. However, other multi-image per page options are available, including wallet-size photos.

(12) Click on the Copies of Each Picture option to determine how many prints per image you want to create.

(13) Click on the Print button to create your prints.

Print Options

For additional formatting and print quality options, which vary by photo printer, click on the Options button shown here.

Create Prints on Macs

To create prints using a home photo printer connected to your Mac, launch the Photos app and follow these steps:

(1) Click on the Photos, Shared, or Albums tab to locate the image(s) you want to print.

(2) Select the desired image.

3 From the File pull-down menu, select the Print option, or use the Command (⌘)+P keyboard shortcut.

4 Click on the Printer pull-down menu from the Print screen's sidebar, and select your home photo printer.

5 Select the Paper Size option from the pull-down menu.

6 Select the type of photo paper you are using. The options vary based on your printer make and model and should match the type of paper you inserted into your printer. Typically, you'll use Glossy Photo Paper.

7 Click on one of the page formatting options, which are displayed as thumbnails. For example, choose whether you want a thin border to appear around your image by selecting the Fit or Fill option, respectively.

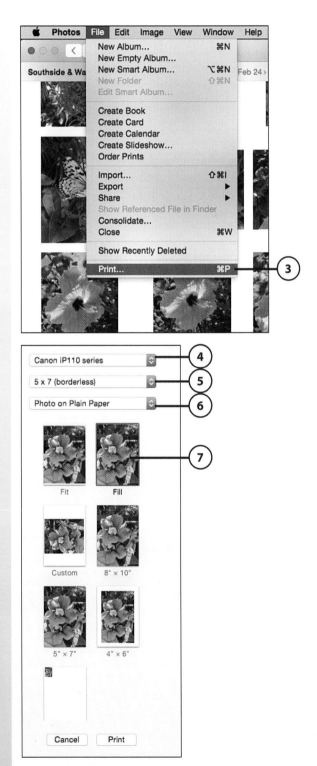

Zoom slider

8 Based on the print-related options you select, a preview of your print is displayed on the left side of the screen. This shows exactly what will appear within your print. Click on this image preview to access the Zoom slider to zoom in, and then hold down the mouse button with the cursor on the preview image to drag it around to reframe the shot.

9 Click on the Print button to create your print.

>>>Go Further
PRINTING FROM ANDROID DEVICES

To wirelessly create prints using a home photo printer connected to your Android-based smart-phone or tablet, launch the Photos app from the Apps screen.

Next, locate the image you want to print, and then open and view it. As you're viewing the image, tap once on the screen to reveal the menu icons. Tap on the More icon (which looks like three vertical dots). Tap on the Print option.

From the Printer Settings screen, select the Number of Copies you want to make, the Paper Size (print size), Orientation, and Paper Type. Tap the Save option to continue. Tap on the Print button to create your prints.

Create Prints Using AirPrint

To wirelessly create prints using an AirPrint-compatible home photo printer connected to your iPhone or iPad, launch the Photos app and follow these steps:

1. Open the album that contains the image(s) you want to print.

2 Tap on the image thumbnail to open and view the desired image.

3 Tap on the Share icon.

4 Tap on the Print icon displayed as part of the Share menu.

(5) Tap on the Printer option and select your wireless (AirPrint-compatible) home photo printer.

(6) Tap on the number of copies you want to create.

(7) Tap on the Print button to make your prints.

Other Options

When using an Android or iOS mobile device, based on your printer make and model, additional print-related options might be available. However, you have more control over your image printing if you download and install the mobile app available specifically for your printer make and model. This app walks you through the print creation process and can be acquired from the App Store.

Create photo albums, scrapbooks, or photo books
that allow you to tell a compelling visual story.

In this chapter, you'll discover strategies for creating a compelling photo album or scrapbook using your photos, plus learn how to create and publish a professionally bound photo book that showcases your favorite images. Topics include

14

- → Understanding the difference between photo albums, scrapbooks, and photo books
- → Strategies for creating a visually compelling photo album or scrapbook using prints of your digital images
- → How to create and publish a professionally bound photo book that showcases your images

Creating Compelling Photo Albums, Scrapbooks, and Photo Books

There's an age-old saying that states, "A picture is worth a thousand words." Well, imagine the story you could tell when you gather together a handful of your favorite images, arrange them in some type of meaningful (or chronological) order, and display them in a well-organized and visually interesting way? The result will be a compelling album or book that allows you to tell your story using visuals, text, and other graphic elements.

Using your own digital images, you can tell your story with images in several ways that do not involve showcasing your photos online. These options include

- **Creating a photo album**—A photo album involves having prints made of your favorite images, purchasing some type of photo album binder, and then adhering your images to pages within the binder (photo album) using a glue stick, tape, or adhesive photo corners. Some photo albums offer plastic pages with presized photo inserts that you simply need to slide your prints into.

- **Creating a scrapbook**—A scrapbook enables its creator to express his or her creativity, since in addition to attaching prints to each page, scrapbookers often include clip art, memorabilia, cutouts, and other decorations to each page. Creating a scrapbook is time consuming, but the result can be a one-of-a-kind keepsake that showcases your memories and allows you to share them in an artistic way. A lot of cutting, pasting, gluing, and other arts-and-crafts-related activities is required.

- **Designing and publishing a photo book**—Using specialized (free) software on your computer, it's possible to use professionally created templates to lay out each page in a photo book, showcase your photos in a customized way that tells your story, and then have your photo book professionally printed and bound in hardcover or softcover form. The finished product looks just like a book you purchase from a bookstore, but it showcases your photos. From the photo book service you use, you can order just one copy of your book, or have multiple copies printed to give as gifts to friends and family.

Whether you create a photo album, scrapbook, or photo book, each option has pros and cons. For example, over time, prints taped or glued into a photo album can come loose and get lost, or the images can fade. Pages can also be accidentally ripped. The same is true for a scrapbook, plus creating a scrapbook involves a rather significant time commitment.

Keep in mind that prints created by a professional photo lab (as opposed to a one-hour photo lab, which often uses inferior inks and photo paper) will last a long time, especially if they're displayed in a frame with treated glass that protects the print from sunlight.

A photo book, on the other hand, gets professionally printed and bound and is designed to last for years. The finished product is something that looks professional and that you can proudly display on your coffee table or give as a gift, plus if something happens to your photo book, you can simply return to your computer and reorder additional copies of it at any time in the future.

Furthermore, the price to have a professional-quality photo book printed has dropped significantly in recent years, yet the publishing options and quality of the finished books have dramatically improved.

Setting a Strategy for Your Photo Album, Scrapbook, or Photo Book

The purpose of a photo album, scrapbook, or photo book is to group together a collection of images, place them in a particular order, potentially add captions to them, and then display them on pages that tell some type of story.

The following 10 tips help you gather together images that enhance the photo album, scrapbook, or photo book you're creating:

- Select a collection of images that tell a story. Your story, like any other, should have a beginning, middle, and end. If you're showcasing vacation photos, for example, select photos taken at key moments throughout your vacation, starting at the arrival to your destination, and arrange them in chronological order.

- Select wide-angle shots that set the scene and visually showcase where you were, what you did, or the experiences you had. Then select other shots, including close-ups that depict the people you were with, as well as specific activities, and/or emotions that you experienced. Shown on the next page is a collage of photos being used as a single page in a photo book (being created using Blurb's BookSmart software) that shows the beginning of a family's vacation.

This group of images shows the beginning of a trip.

- When choosing images to include, remember you can crop, reposition, and/ or enhance images to improve their appearance or change their focal point, so that it better fits your storytelling objective.

- During the picture-taking process, especially when traveling, snap photos of signs that showcase places you visit. Of course, you can include yourself or people you're with in front of these signs. These images can be used as title images and replace the need for captions. In a photo book, use a sign photo like a new chapter heading to show a transition of locations. In the page of the photo book shown here, the Muir Woods sign image is used as a transition to images showcasing a visit to this popular tourist destination in San Francisco.

A sign can depict a location change in your photo book.

- Select photos that do not require a lot of verbal explanation or long text-based captions. The viewer should be able to answer basic questions for themselves, like who, what, where, when, why, and how, simply by looking at your images in an appropriate order.

- On a single page, keep related images together. Showcase a larger "scene set-ting" image prominently on the page, and then surround it with close-ups and other shots taken around the same time that show slightly different but related things.

- Keep in mind that you can showcase just one image on a page (in the form of an enlargement, for example) or include multiple images of different sizes on a single page, and in many cases, decide how you want to lay out the images on the page. Shown here on the left page is a template that displays six images, while on the right, one image template with a black border was used.

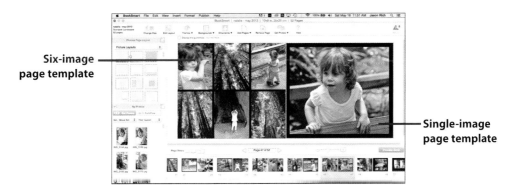

Six-image page template

Single-image page template

- If you choose to include only one image per page, select between 12 and 30 of your best images to showcase. However, if you're willing to create col-lages or showcase multiple images per page, it's possible to include 100 or more images in your album, scrapbook, or photo book but still keep the page count down.

- When deciding how to lay out your album, scrapbook, or photo book pages, avoid clutter. The focal point of each page should always be your images, and not other artwork or an abundance of text-based captions.

- If you're creating an album, scrapbook, or photo book just for yourself, choose images that elicit the best memories for you personally. However, if you plan to share your creation with others, also include images that help convey your story.

Choose a Theme

Whether you are using a scrapbooking kit, have purchased a specialized photo album, or are creating a photo book using specialized software, choose a theme, overall design, and/or appropriate color scheme that works best for your project. Chances are you have many customizable theme options to choose from.

Finding the Best Supplies

Photo labs, photo specialty stores, craft stores, and online retailers are most likely to offer the best selections of traditional photo albums (binders), as well as page inserts. To give yourself the most flexibility, choose an album option that enables you to add or remove pages and make sure you purchase enough extra pages that match the album and fit within it to meet your needs.

When choosing photo album pages, there are two main considerations—preservation and display options. Choose pages that keep your images enclosed or sealed within paper and/or airtight plastic to help preserve your images in the years to come. Also, choose page options that give you flexibility in terms of display options.

Some album pages have presized plastic sleeves that allow you to slide your prints into them. Depending on the size of the sleeve, it might hold just one 8×10-inch print or multiple 4×6-inch or 5×7-inch prints, but you probably won't be able to choose where on the page those images will go.

>>>Go Further
STOCK UP ON SCRAPBOOKING SUPPLIES

When it comes to scrapbooking, arts-and-crafts stores and specialty online retailers offer the best selection of supplies you need to create a truly one-of-a-kind scrapbook that showcases your photos and other memorabilia, which might include ticket stubs, menus, a printed invitation to an event, newspaper or magazine clippings, themed clip art, or other graphic elements beyond just your photos.

Brainstorm ideas for your scrapbook in advance, and then stock up on all the supplies you need to transform your idea into the scrapbook you envision. But be prepared to invest at least a few hours (or longer) to pursue and complete your scrapbooking endeavor.

Many tourist attractions, cruise ships, and arts-and-crafts supply stores offer themed scrapbooking kits that include predesigned album pages, decorative supplies, and other content that can be used with your own photos and within an album you select. These kits can save you time, both when it comes to collecting everything you need to create a scrapbook and when it comes to brainstorming and implementing page design and layout ideas.

The following is a list of some of the online-based merchants that offer photo album supplies:

- **Century Photo**—www.centuryphoto.com
- **Exposures Online**—www.exposuresonline.com
- **Gaylord**—www.gaylord.com
- **Get Smart Products**—www.pfile.com
- **Joann Fabric and Craft Stores**—www.joann.com (click on the Scrapbook menu tab)
- **My Publisher**—www.mypublisher.com

The following is a list of online merchants that offer scrapbooking supplies:

- **Michael's Stores**—www.michaels.com/shop-now/papercraft/809188524
- **Oriental Trading**—www.orientaltrading.com
- **Scrapbooking for Less**—www.scrapbooking-for-less.com
- **Scrapbooking Warehouse**—www.scrapbooking-warehouse.com

Find More Online Suppliers

Using any Internet search engine, such as Google or Yahoo!, in the Search field, enter the phrase "photo album supplies," "scrapbooking supplies," or "scrapbooking kits" to find additional online resources and suppliers.

Creating a Photo Book Using Your Computer

There are many ways to create a photo book from your digital images. This is something you can do at many one-hour photo labs or by using a specialized online service. If you use an online service, you need to set up a free account with that service and then download and install their proprietary photo book design software. (If you're a Mac user, it's possible to create a photo book from within the Photos app, and then use Apple's own photo book publishing service to print and bind the book. This can be done by clicking on the Projects tab and then the "+" icon to start creating a new project.)

This software makes designing your customized photo book easy. All you need to do is select a theme, choose from an assortment of professionally designed page templates, and then drag-and-drop your digital images into those page templates.

You decide on the overall look of your photo book, the number of pages it will contain, its trim size (dimensions), as well as whether it will be bound as a paperback or hard cover. In some cases, you're given additional options, including the quality of the paper used.

Although a photo book created online is template-based, you can typically customize each template, if you choose, to create your own page designs. To save time, however, it's perfectly acceptable to use the page templates exactly as they're made available.

You'll discover that each of the hundreds of photo book publishing companies out there offers different design, layout, and publishing options; varying paper quality; different publishing times; and vastly different prices. What they all have in common is that the finished photo book you have printed will most likely last for many years.

Among the hundreds of photo book publishing companies, some of your online-based options include

- **Adorama**—www.adoramapix.com
- **Artisan State**—www.artisanstate.com
- **Blurb**—www.blurb.com

- **Montage**—www.montagebook.com
- **My Publisher Photo Books**—www.mypublisher.com
- **Photo Books Pro**—www.photobooks.pro
- **Shutterfly**—www.shutterfly.com
- **Snapfish**—www.snapfish.com

Regardless of which photo book printing service you use, your end product is a one-of-a-kind, truly personalized, and professionally printed and bound book.

Getting Acquainted with Blurb

Featured in this chapter is a photo book service called Blurb (www.blurb.com). It was selected because it is a good example of the services that offer everything you could want from a photo book publishing service, including free and easy-to-use software, called BookSmart, for PCs and Macs.

The BookSmart software, which you must download, is used to lay out and design your photo book on your computer using a variety of book trim sizes, cover options, paper qualities, and themes. When you finish this part of the process, the software enables you to preview the book exactly how it will appear in print. After you approve it, the digital file for your book is uploaded via the BookSmart software to Blurb's automated book publishing service.

Blurb then prints and binds it within a few business days, and ships the book(s) directly to you or the address(es) you supply. At the same time you order your printed photo book, for a small additional fee, it's possible to purchase an iPad-compatible eBook version of your photo book that can be loaded and viewed in the iPad's iBooks app.

In addition to offering high-quality products, Blurb is also competitively priced, so you can create impressive hardcover or softcover books, starting at less than $15 each.

Download the Blurb Photo Book Software

Once you decide to use the Blurb service to design, lay out, and publish your photo books, follow these steps to initially download the free Blurb software and set up your Blurb account:

(1) Launch your computer's web browser and visit www.blurb.com.

(2) Click on the Create option, and then click on the Creation & Layout Tools option from Blurb's home page.

(3) Click on the Free Book-Making Tools option.

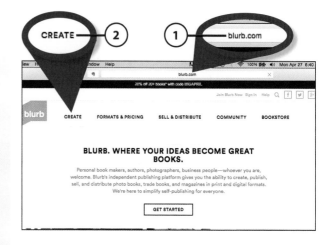

4. Click on the Download BookSmart option. Download and install this free software onto your PC or Mac. (Specifics depend on your computer type and web browser.)

5. While still on the Blurb.com website, click on the Join Blurb Now option displayed at the top of the screen to set up a free online account.

BOOKSMART

Still using Blurb BookSmart to make photo books? Download the latest version with simplified layouts, photo autoflow, and all the features you love.

Learn more

DOWNLOAD BOOKSMART

4

5

blurb

CREATE FORMATS & PRICING SELL & DISTRIBUTE COMMUNITY BOOKSTORE

Creation & Layout Tools Templates Dream Team

START YOUR BOOK WITH ONE OF OUR FREE TOOLS

Blurb makes it easy for you to create any kind of book or magazine—in both print and digital formats—for yourself, to share, or to sell.

FREE BOOK-MAKING TOOLS

Blurb tools offer creative control and customization and come loaded with easy-to-use templates.

SEE OPTIONS

TOOLS FOR ADOBE USERS

For those who use Adobe® InDesign® or Lightroom®, Blurb is built right in.

SEE OPTIONS

UPLOAD AN EXISTING BOOK

Already have a book in PDF format or Microsoft® Word®? Learn more about how to upload directly.

SEE OPTIONS

(6) Enter your email address, create a password, and confirm that password, as prompted.

(7) Click on the Register button to continue. When you see the Congratulations message, your account has been created.

Payment Information

Later, when you place your first order, you are prompted to provide your mailing address, credit/debit card details, and billing address. This information is stored in your account, so it needs to be entered only once.

New to Blurb? Please register to get started

Join Blurb to... Design and self-publish books with our free book-making tools

Make print books, magazines, and fixed-layout ebooks

Print your books on demand in any quantity (or in volume with offset printing)

Sell on Amazon.com or directly to your fans and friends

Get exclusive offers and promotio

Please use a valid email address. We will not sell or share it with anyone.

Your Email Address

Choose a Username

Choose a Password

Email me special offers and news?
☑ Heck, yeah!

By registering you agree to the Terms & Conditions.

Register

Use the Blurb BookSmart Software

To use the BookSmart software to lay out and design your photo book and have it printed using Blurb's service, launch the software and follow these steps (shown here on a Mac):

(1) From the initial pop-up window, click on the Start a New Book button to begin creating a new photo book.

(2) Enter a title for your book. (This title becomes the filename for the project.)

(3) Fill in the Author Name field with your name.

(4) Select the desired trim size for the photo book you want to create. Your options are listed on the left side of the window.

Pricing Information

When you click on an option, details about that option are displayed on the right side of the window, including pricing. You can adjust this option later, as you're designing or ordering your book.

(5) Click on the Continue button to proceed.

6 Select the type of book you want to create. This determines the types of templates offered to you.

Choosing a Book

For a generic photo book, choose the Photo Book option. However, if your book will have a specialized theme, such as Wedding Book or Portfolio, choose that option.

7 Click Continue.

(8) Select the folder or location where your images currently reside, and then follow the onscreen prompts to gather those photos within the BookSmart software.

(9) Click Continue.

(10) Select one of the available Theme options. You can customize this theme as you go.

(11) Click Continue.

(12) Click on the Get Photos button to add more photos to your collection. Any photos you have selected are displayed as thumbnails in the lower-left corner of the BookSmart software's Layout and Design screen.

(13) For the selected page, choose a template from those available. The selected template is displayed in the center of the screen.

MORE ABOUT LAYOUT TEMPLATES

When you have the cover thumbnails selected at the bottom of the screen, by clicking on the Choose Page Layouts menu and selecting the Cover Layouts option, you see thumbnails for the available cover templates.

When you begin laying out the inside pages of your book, when you click on the Choose Page Layouts menu, two of the menu options for template selection include Picture Layouts and Photo Spread Layouts. These are primarily what you use to design your photo book.

Some of the Picture Layouts showcase one image per page, while others enable you to drag-and-drop and then showcase multiple images per page or create collages with your photos. The Photo Spread layouts enable you to spread a single image across two printed book pages. This is particularly useful for showcasing panoramic photos.

Other types of page layouts, for different styles of books, are also listed in the Choose Page Layouts menu. Choose any of them, as needed, based on how you want your photo book to ultimately look.

Once you select a category, such as Picture Layouts, all your different page template options are displayed as thumbnails. For the selected page of your photo book, click on the thumbnail for the template you want to use on that page.

Some of the Picture Layouts have text boxes for adding text-based captions or even complete paragraphs of text. After choosing a template, if you click on the Edit Layout icon, it's possible to alter the size and location of these text boxes or picture frames on the page.

14 Select the image you want to feature on your book's cover, and then drag it to the center of the screen over the template. The software inserts that photo on the page.

15 To switch to the next page or a previous page, click on its thumbnail at the bottom of the screen. The highlighted thumbnail is the page you're currently editing. Repeat steps 13 through 15 for each page in your book.

It's Not All Good

Watch Out for Error Messages

When you place photos within page templates, if the resolution of an image is too low (if it's too low quality) for how it's used on the page, you will receive an error message. At this point, you can remove the image from the page and select a different one, or click on the Fix button to fix the problem.

Using the Fix tool resizes the image on the page. When this happens, consider using a different page template that can accommodate smaller pictures and maybe incorporating the lower-resolution image into a collage layout.

If you ignore the error and proceed with printing your book, the image(s) that caused the error appear blurry or pixelated on the printed page.

Error message window

Error message icons

Border button

16

16 Click on a placed image to edit it, zoom in or zoom out, and/or reposition it within the template frame. What you see on the screen within the page template is exactly how the page of your photo book will appear in print.

Using Borders

The image on this page has a border, which was selected by clicking on the Border button.

(17) Use the editing tool icons to Rotate Counter-Clockwise, Rotate Clockwise, Flip Horizontally, Flip Vertically, Zoom In/Out, Zoom By Percentage, Reposition Image in Frame (four options), and Border selection.

How Presentation Matters

To demonstrate some of these tools, shown above is a two-page spread is the same photo that has been resized, repositioned, and displayed in three different ways using these image editing tools.

(18) If you click within a text box on a page template, a selection of text editing tools is displayed across the top of the screen. Like a word processor, these options allow you to choose a font, font size, type style, and font color, plus customize line spacing and other related text formatting options.

CUSTOMIZING YOUR BOOK

Based on the cover option you selected at the start of the photo book creation process, the BookSmart software includes a preset number of pages, which is the minimum number of pages for that book format. You can modify your book in multiple ways using the row of icons across the top of your screen:

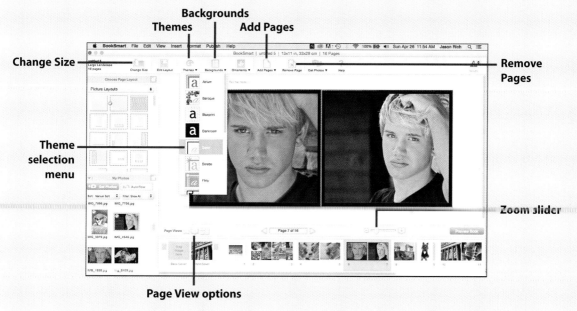

Backgrounds

Themes Add Pages

Change Size

Theme
selection
menu

Remove
Pages

Zoom slider

Page View options

- **Add Pages**—Adds pages to your book (for an additional fee per page). Next to it is a Remove Pages button (you cannot go beneath the book's minimum number of pages).

- **Change Size**—Change the trim size of your book.

- **Cover**—Change the type of cover you use with the book. To change this, click on the cover thumbnail along the bottom of the screen, and then use the Cover pull-down menu that appears.

- **Themes**—Use this option to add decorative artwork in the margins of each page. The design you select automatically is added to all pages in your book.

- **Backgrounds**—Alter the default background color of each page, which appears in the borders and around your images, based on which theme or template you select.

- **Page View**—By default, in the center of the screen, only one page of the photo book is displayed at a time. Use this option to change the display, so you can see two facing pages, for example.

- **Zoom**—To zoom in or out as you're looking at the page preview in the center of the screen, use the zoom slider displayed near the bottom-right corner of the screen.

(19) Click Preview Book when you've placed all your photos in the book and you're ready to preview it on the screen.

20 From the Preview screen, either click on the left- or right-pointing arrows that surround the page numbers to move forward or backward, or click on individual page thumbnails displayed along the bottom of the screen.

Best Preview

When previewing your book, it's best to set the Page Views icon to the middle, two-page spread option, so you can see how facing pages will look.

21 Use the zoom slider on the Preview screen to increase or decrease the size of the previewed pages. This does not impact the actual layout or design of your book.

22 If you need to edit or fix something in your photo book, click on the Edit Book button to return to the Page Layout and Design screen.

23 When you're ready to upload your book to the Blurb service to be printed, click on the Order Book button. The Final Checklist appears to remind you to proofread your book carefully and look for spelling or grammatical mistakes, plus make sure that every image on every page is positioned correctly.

(24) Click on the Check Now button to use the software's built-in spelling checker.

(25) Click on the Continue button to proceed.

(26) From the Sign In screen, enter your Blurb username and password.

(27) Click on the Sign In button. From this point forward, your computer needs Internet access.

28

(28) The digital files for your photo book design, as well as the images included within your photo book, are uploaded to the Blurb service. This could take a while, so be patient.

(29) When the upload process is complete, place an order for one or more copies of your photo book, and choose from a variety of printing options, such as the cover type and paper quality. Based on the options you choose, the price of your book will fluctuate. (Not shown.)

(30) When prompted, enter your payment details and address. The order for your book is processed. At this point, you can typically cancel your order within about 30 minutes. Otherwise, once the order begins the production process, it can't be changed or cancelled. Your order is delivered, typically within 7 to 10 business days, or less if you opt to pay for expedited shipping. (Not shown.)

Order Additional Books Anytime

Once your photo book has been uploaded to the Blurb service, it is stored online permanently, and you can reorder copies of your book at any time from Blurb's website. If you want to edit the photo book before reordering, this can be done using the BookSmart software.

Taking the Next Step

As you'll discover, using Blurb or any photo book service, you can create stunning travel books, family albums, wedding albums, baby books, tribute books, as well as any other type of themed book that nicely showcases your photos. What's possible is truly limitless when you tap your own creativity and use the layout and design tools provided, which go above and beyond just dragging and dropping photos into templates (which is the fastest option for creating these books).

Index

Symbols

(hash tags), 298

A

accessing Microsoft OneDrive
 from Android, 121
 with Windows 7, 118
accounts, creating
 for Flickr, 284
 for FreePrints, 345
action shots, 89
 mistakes, 98
 motion effects, 89
Add Text icon, Journal, 321
adding
 color to tags, 216
 photos to email, 267-269
 photos to your Favorites on iPhone/
 iPad, 232

Adjust icon, Photos app (Mac), 192-193
adjusting
 contrast/brightness, 47
 Zoom feature, 46
adjusting preferences, Day One, 319
advantages of professional photo labs,
 327
AirDrop, 134
 sending photos, 270-272
 transferring photos from iOS to your
 Mac, 135
AirPrint, creating prints, 366-368
Alarm icon, Day One, 318
albums
 creating, 372
 on Android devices, 236-239
 in Facebook, 294-296
 on iPhone/iPad, 224-225
 with Photos app (Mac), 209
 deleting
 on Android devices, 242-243
 on iPhone/iPad, 226-228

deleting photos from albums (Android devices), 243-244

hiding on Android devices, 240

moving on iPhone/iPad, 226-228

opening on iPhone/iPad, 220-221

renaming on Android devices, 242

supplies for, 376-377

tips for creating, 373-375

altering

image metadata, 213-214

from Macs, 215-216

from PCs, 214

images, appearance, 18

Android Beam, 273

Android devices

Attachment icon, 260

Camera app, 51-52

picture-taking, 52-54

Settings menu options, 55-58

shooting modes, 59-63

creating prints, 366

deleting photos, 140-141

Gallery app, 233

Google Drive, 128

internal storage, managing, 107-110

launching Camera app, 27-28

Microsoft OneDrive, accessing, 121

memory cards, 90

moving single photos, 240

organizing photos, 233

accessing photos with Gallery app, 234-236

creating new albums, 236-239

deleting albums, 242-243

deleting images from albums, 243-244

hiding albums, 240

renaming albums, 242

sorting photos, 244-249

photos, rotating, 168

Photos app, editing photos, 163-168

removing apps, 110

sending emails with photos, using Gallery app, 264-266

sharing photos with Bluetooth, 273-274

tagging photos, 249

Android Market app store, 8

animated slide shows, WEB: 4

App Store app, Photo & Video category, 8

Apple

iCloud, 279

iCloud Photo Library, 280-283, WEB: 28

photo labs, ordering from, 351-352

Apple ID accounts, creating, 123

apps

Camera app. *See* Camera app

camera apps, 5

Contacts app, 257

FreePrints app, 339-340

Gallery app. *See* Gallery app

Instagram app, 303

Journal, 319-321

Kicksend app, 330

Mail app, sharing photos through email, 256-260

Messages, sending photos, 274-275

Microsoft OneDrive app, 121

downloading, 115

People app, 257

for photo labs, finding, 327-328

Photos app, 112

Android, editing, 163-168

iOS, editing, 156-162

iPhone. See *Photos app*
 Mac. See *Photos app (Mac)*
 PC. See *Photos app (PC)*
 sharing photos through email, 261-264
 removing from Android devices, 110
Apps screen, launching Camera app, 28
Aspect Ratio, 191
Attachment icon, Android devices, 260
Auto Fix, Photos app (PC), 177
auto focus sensors, 31-32, 47, 85
automatically backing up
 Macs, WEB: 24-26
 PCs, WEB: 20-23
autosync features, Day One, 313
AWB (Auto White Balance), Settings menu options, 57

B

Back button, 164
backing up
 iPhones/iPads, iTunes Sync, WEB: 26
 Macs, automatically, WEB: 24-26
 PCs, automatically, WEB: 20-23
 photos to external hard drives, WEB: 18-19
 smartphones/tablets, WEB: 26-27
backups, WEB: 17
 cloud-based storage, 278
 finding online backup solutions, WEB: 27-30
 reviewing periodically, WEB: 31
Basic Fixes, Photos app (PC), 177
batteries, 16
 dead batteries, 97

Beauty Face, shooting modes (Android devices), 61
black-and-white filters, 87
Blogger.com, 322
blogs, 322
Bluetooth, 103
 enabling, 137
 sending photos
 Android devices, 273-274
 Windows Mobile, 274
 transferring photos from Android devices to your computer, 135-137
 turning on, 135
Blur Background tool, 154
Blurb
 borders, 389
 creating photo books, 379
 BookSmart software, 382-395
 downloading software, 380-382
 layout templates, 387
blurry pictures, 97
BookSmart software, 379
 Blurb, 382-395
 customizing books, 391-392
 pricing, 383
borders, photo books (Blurb), 389
brightness, adjusting, 47
Brightness tool, 151
browsing collections of photos on iPhone/iPad, 222
Burst mode, 35-37
B&W Menu, 162

C

Camera app, 6
 Android devices, 51-52
 picture-taking, 52-54
 Settings menu options, 55-58
 shooting modes, 59-63
 autofocus sensors, 31
 flash, 38
 iPad, 49
 iPhone/iPad
 Grid feature, 49-50
 image filters, 43
 launching, 24
 on Android, 27-28
 on iOS, 25-26
 picture-taking with iPhone/iPad, 45-48
 Shutter button, 30
 zoom feature, 33-35
Camera app icon, 6
camera apps, 5
Camera Backup, 119
camera lenses, dirt, 97
cameras
 digital SLR cameras, 69
 front-facing camera with customizable border, 62
 iPhone 6
 point-and-shoot cameras, 21
 point-and-shoot digital cameras, 68
 Samsung Galaxy Note 4, 5
Cancel icon, Photos app (PC), 177
candid shots, 71
 strategies for, 85-86

cellular data usage, uploading photos from mobile devices, 339
Center Focus tool, 154-155
challenges to picture-taking, 96-98
changes to edited photos, saving (Android), 165
checking tweets, 301
close-ups, 76
cloud-based photo storage options, 129
cloud-based services
 backups, WEB: 28-30
 syncing photos, 112-114
cloud storage services, 278-279
collections of photos, browsing (iPhone/iPad), 222
color, adding to tags, 216
Color Menu icon, 161
color-related tools, 180
Color tool, Photos app (PC), 180
coloring, 97
common mistakes when picture-taking, 96-98
composing tweets with photos, 296-301
computers
 creating prints, 359-360
 ordering from Apple's photo labs, 351-352
 ordering from one-hour photo labs, 348-349
 ordering from online-only photo labs, 349-350
 syncing photo libraries, 111-112
Contacts app, 257
content, transferring from mobile devices
 to Macs, 133-134
 to Windows PCs, 131-132
content storage, memory cards, 13

Continuous mode, 37

Continuous shots, 57

Contrast tool, 152

contrast/brightness, adjusting, 47

copying
 images into PC folders, 203-204
 versus moving, 237
 photos between albums on iPhone/iPad, 229-230
 photos to Mac folders, 210-211

cost
 of BookSmart, 383
 of cloud-based storage, 279
 of extra features, Photos app, WEB: 8
 of ordering prints, FreePrints, 343
 of photo printers, 357

Costco.com website, 348-349

creating
 accounts, FreePrints, 345
 albums in Facebook, 294-296
 Apple ID accounts, 123
 entries in Day One software, 314-316
 Flickr accounts, 284
 folders, Photos app (PC), 202
 new albums
 on Android devices, 236-239
 on iPhone/iPad, 224-225
 photo books with Blurb, 379, 382-395
 prints. *See* prints
 slide shows
 with mobile devices, WEB: 13
 with Photos app (Mac), WEB: 8-12
 tips for, WEB: 4-5
 from Windows PCs, WEB: 5-6
 storage space, 13
 subfolders, 202

creative decisions, 67

Crop Frame, 167

Crop icon
 Kicksend, 335
 Photos app (PC), 175

Crop tool, 148-149
 Image Straightening feature, 147
 Photos app (Mac), 190-191
 Twitter, 301

cropping
 photos, photo editing tools, 148-149
 resolution, 149

custom named folders
 on Macs, 207-213
 on PCs, 200-207
 Pictures folder, 198-200

customizing
 Instagram posts, 308
 photo books, BookSmart software, 391-392

D

Day One, 312
 Alarm icon, 318
 autosync feature, 313
 creating entries, 314-316
 Map icon, 318
 preferences, adjusting, 319
 pull-down menus, 317
 tagging, 315
 working with entries, 317-319

dead batteries, 97

Delete icon, Photos app (PC), 174

deleting
 albums
 on Android devices, 242-243
 on iPhone/iPad, 226-228
 photos, 138
 from Android devices, 140-141
 from iPhone/iPad, 138-139
 photos from albums
 on Android devices, 243-244
 on iPhone/iPad, 231-232
 posts
 in Facebook, 293
 on Instagram, 308
deleting images immediately, 98
devices, unlocking, 24
diaries. See digital diaries
digital diaries, 311
 online, 321-322
 Tumblr, 322-323
 privacy, 312
 versus traditional diaries, 312
digital diary software, 313
 Day One
 creating entries, 314-316
 working with entries, 317-319
 Journal (Windows), 319-321
 syncing, 313
digital photography, 8-9
 basics of, 10
 metadata, 10-13
 resolution, 13-14
 editing photos, 17
 managing photos, 16
 picture-taking, 15, 20
 printing photos, 19

 sharing photos, 18
 transferring photos, 19
digital SLR cameras, 69
dirty lenses, 97
disadvantages
 of external hard drives, WEB: 19
 of one-hour photo labs, 326
 of sharing photos through email, 255
downloading
 Blurb photo book software, 380-382
 defined, 19
 Microsoft OneDrive app, 115
 shooting modes, 63
Dropbox, 279, WEB: 29
 syncing photos, 129
Dropbox Pro account, 129
Dual Camera mode, Android devices, 62-63
Duplicate command, 189
Duration, slide shows (Photos app [Mac]),
 WEB: 11

E

Edit icon, Photos app (PC), 175
Edit tools, Photos app (Mac), 186
edited photos, saving changes (Android),
 165
editing
 versus enhancing, 144
 images, 98-99
 photos, 17
 Android Photos app, 163-168
 iOS Photos app, 156-162
 with Photos app (Mac), 185-188

posts
 in Facebook, 293
 on Instagram, 308
editing tools
 Photos app (Mac), 189
 Adjust icon, 192-193
 Crop tool, 190-191
 Enhance tool, 190
 Filters icon, 192
 Flip tool, 192
 Retouch tool, 194-195
 Rotate tool, 190
 Photos app (PC), 175-177
 Auto Fix filters, 177
 Basic Fixes, 177
 Color, 180
 Effects icon, 180-181
 Light icon, 179
 Retouch tool, 178-179
 Selective Focus tool, 182-183
 selective editing tools, 169
Effects icon, Photos app (PC), 180-181
email
 adding photos to, 267-269
 free accounts, 254
 resizing photos for, 269
 sending from your computer, 267
 adding photos to email, 267-269
 sending images between devices, 269-270
 with AirDrop, 270-272
 with Bluetooth (Android devices),
 273-274
 with Bluetooth (Windows Mobile), 274
 sending images in messages, 274-275
 sharing large image files, 270

sharing photos
 from Android devices, 264-266
 from iPhones/iPads, 261-264
 from smartphones/tablets, 256-260
 with Windows Mobile devices, 266
 using to share photos, 254-255
enabling Bluetooth, 137
Enhance icon, Twitter, 301
Enhance tool, Photos app (Mac), 190
Enhancement tool, 144-145
 turning off, 158
enhancing versus editing, 144
error messages, resolution (photo books),
 388
exporting slide shows, WEB: 12
Exposure Value, 57
external hard drives, 115
 backing up photos to, WEB: 18-19
 disadvantages of, WEB: 19
extra features, Photos app, WEB: 8
eyes, 87

F

Face Detection, 57
face detection technology, 31
Facebook, 291
 creating albums, 294-296
 image resolution, 292
 posts, editing/deleting, 293
 privacy, 291
 publishing photos on your Wall, 292-293
 tagging people in photos, 293
Favorites, adding photos to (iPhone/iPad),
 232

File Explorer windows, using two at the same time, 205

file extensions, 212

File History, WEB: 20

file sharing, cloud-based storage, 278

file syncing, cloud-based storage, 278

files, sharing large image files via email, 270

filters, 87
 image filters, 42-43, 145
 third-party filters, 160

Filters icon, Photos app (Mac), 192

Finder, 207

finding
 apps for photo labs, 327-328
 cloud-based photos storage options, 129
 digital diary software, 312
 online backup solutions, WEB: 27-30
 photos
 once transferred, 137
 Photos app (Mac), 186
 slide show tools, online, WEB: 13-14
 supplies for photo albums/scrapbooks, 376-377

finger shots, 97

finish for prints, 330

flash, 37-38
 Android devices, 56
 iPhone 6, 4
 Samsung Galaxy Note 4, 5

Flickr, 282-289
 accounts, creating, 284
 mobile devices, 289
 tags, 286

Flickr Uploader, 285

Flickr.com, 280

Flip tool, Photos app (Mac), 192

focal points, 77

focus, mistakes, 98

folders
 custom folders
 on Macs, 207-213
 on PCs, 200-202
 subfolders, creating, 202

followers, Twitter, 296

formatting, printing photos, 360

framing shots, Rule of Thirds, 78-79

free email accounts, 254

freeing up storage space, 102, 107

FreePrints app, 339-340
 accounts, creating, 345
 ordering prints, 341-347
 payment options, 347

FreePrintsNow.com, 340

front-facing cameras, 4-5
 with customizable border, 62

G

Gallery app, 233
 accessing photos, 234-236
 deleting albums, 242-243
 deleting photos from albums, 243-244
 GPS feature, Android devices, 249
 renaming albums, 242
 sharing photos through email, Android devices, 264-266
 sorting photos, 244-249

generic ink cartridges, 358

geo-tagging, 11

glass, shooting through, 93-96

glossy finish, 330

goals of photographers, 68

Google Drive, 112, 279, WEB: 29
 Android devices, 128

Google Play App Store, slide show production apps, 8, WEB: 13

GPS feature, Gallery app (Android devices), 249

grid, enabling, 78

Grid feature, Camera app (iPhone/iPad), 49-50

grid lines, Android devices, 58

H

hard drives, external hard drives, WEB: 18-19

hash tags (#), 298
 keywords, 303

HDR (High Dynamic Range), 38-39
 Android devices, 58

hiding albums on Android devices, 240

Highlights and Shadows tool, 153

Hightail, 270

home photo printers, 355

I

iCloud, 112-114, 279
 edited photos, syncing, 163
 Photos app (Mac), 184
 setting up on iPhone/iPad, 125-128, WEB: 27

iCloud Drive, 280

iCloud for Windows, 125

iCloud Photo Library, 280, 283, WEB: 28
 setting up
 on a Mac, 123-125
 on iCloud/iPhone, 125-128
 syncing photos, 122

icons
 Add Text icon, Journal, 321
 Alarm icon, Day One, 318
 Attachment icon, Android devices, 260
 Camera app, 6
 Crop icon, Kicksend, 335
 Map icon, Day One, 318
 Share, 264

image editing tools, 146

image filters, 42-43, 145

image metadata, altering, 213-214
 from Macs, 215-216
 from PCs, 214

image quality, ordering prints, 329

image resolution, Facebook, 292

Image Straightening tool, Photos app (iPhone/iPad), 17

images
 altering appearance, 18
 tinkering with, 98-99

improving images by tinkering, 98-99

inanimate objects, photographing, 74-76

ink, for printing photos, 358

inspiration, seeking, 92

Instagram, 302-303
 customizing, 308
 editing/deleting posts, 308
 publishing photos on, 304-307

in-store Kodak Kiosks, creating prints, 338

internal storage, 103
 managing
 on Android devices, 107-110
 on iOS mobile devices, 104-106
Internet, syncing photo libraries between mobile devices and computers, 111-112
Internet access, WEB: 30
internet connections, WEB: 30
iOS
 launching Camera app, 25-26
 Photos app, editing photos, 156-162
 Settings menu options, Android devices, 57
iOS Control Center, 26
iOS devices, managing (OneDrive), 118-121
iOS mobile devices
 internal storage, managing, 104-106
 Macs and, 130
iPad
 backing up with iTunes Sync, WEB: 26
 Camera app, 49-50
 deleting photos, 138-139
 memory, 90
 organizing photos, 220
 adding photos to your favorites, 232
 browsing collections, 222
 copying photos between albums, 229-230
 creating new albums, 224-225
 deleting albums, 226-228
 deleting photos from albums, 231-232
 moving albums, 226-228
 opening albums, 220-221
 picture-taking, 45-48

 sending emails with photos using Photos app, 261-264
 setting up iCloud, 125-128
iPhone 6, 4
iPhones
 backing up with iTunes Sync, WEB: 26
 Camera app, 49-50
 Camera app icon, 6
 deleting photos, 138-139
 memory, 90
 Noir filter, 43
 organizing photos, 220
 adding photos to your Favorites, 232
 browsing collections, 222
 copying photos between albums, 229-230
 creating new albums, 224-225
 deleting albums, 226-228
 deleting photos from albums, 231-232
 moving albums, 226-228
 opening albums, 220-221
 Photos app, 7
 picture-taking, 45-48
 sending emails with photos, Photos app, 261-264
 setting up, iCloud, 125-128
iPhoto, 122-124
 upgrading to Photos app (Mac), 184
iScrapbook 5, 312
iTunes Sync, WEB: 26

J

Journal, 319-321
 Add Text icon, 321
journal entries, Day One (Macs), 314-319

K

keywords, hash tags, 303

Kicksend app, 330

 Crop icon, 335

 ordering prints, 331-338

Kodak Print Kiosks, 338

L

Landscape mode, 39-40, 88

large images files, sharing via email, 270

launching Camera app, 24

 on Android, 27-28

 on iOS, 25-26

layout templates, Blurb, 387

lenses, dirt, 97

Library, 199

Light icon, Photos app (PC), 179

lighting, 79-82

 uneven light, 80

Location Tags, Android devices, 58

locations, photos (Android devices), 249

Lock screen, Camera app (launching), 24

logging in to OneDrive, 116

lustre finish, 330

M

Macs

 adding image file metadata, 215-216

 backing up automatically, WEB: 24-26

 creating prints, 363-365

 custom folders, 207-209

 copying/moving photos to, 210-211

 renaming photo files, 212-213

 Day One software

 creating entries, 314-316

 working with entries, 317-319

 finding online backup solutions, WEB: 27-30

 iOS mobile devices, 130

 Photos app. *See* Photos app (Mac)

 setting up iCloud Photo Library, 123-125

 transferring content from mobile devices, 133-134

 transferring photos via USB cables, 130

Mail app, sharing photos through email, 256-260

mailing photos, 331

managing

 internal storage

 on Android devices, 107-110

 on iOS mobile devices, 104-106

 Microsoft OneDrive

 via iOS devices, 118-121

 from Windows computer, 116-118

 photos, 16

managing photos, custom-named folders, 198-200

 on Macs, 207-213

 on PCs, 200-207

Map icon

 Android devices, 249

 Day One, 318

mapping photos, 223

matte finish, 330

megapixels, 13

memory, 97
 freeing up storage space, 102
 internal storage. *See* internal storage
 iPhone/iPad, 90
memory cards, 13
 Android devices, 90
menus, pull-down menus (Day One), 317
Messages app, sending photos, 274-275
metadata, 10-13
 geo-tagging, 11
 images, altering, 213-214
 from Macs, 215-216
 from PCs, 214
 tagging, 11
Metering modes, Android devices, 57
micro-blogging services, Twitter, 296
Microsoft OneDrive, 279, WEB: 29
 accessing
 from Android, 121
 with Windows 7, 118
 downloading, 115
 logging in to, 116
 managing
 via iOS devices, 118-121
 from Windows computers, 116-118
 storage resolution, 118
 syncing photos, 114-116
mistakes when picture-taking, 96-98
mixing and matching different types of
 shots, 92
mobile devices
 creating prints, 359-360
 Flickr, 289
 ordering prints, 329-330
 slide shows, creating, WEB: 13

syncing photo libraries, 111-112
transferring content
 to computers, 102
 to Macs, 133-134
 to Windows PCs, 131-132
motion effects, 89
moving
 albums on iPhone/iPad, 226-228
 versus copying, 237
 images into PC folders, 203-204
 photos to Mac folders, 210-211
 single photos on Android devices, 240
multiple copies of same shot, 98
multiple shots, posed shots, 89

N

natural surroundings, using when picture-
 taking, 84-85
Noir filter, 43

O

objectives of picture-taking, 70-72
one-hour photo labs, 326
 disadvantages, 326
 ordering prints from, 348-349
OneDrive, WEB: 29
 accessing from Android devices, 121
 logging in to, 116
 managing
 via iOS devices, 118-121
 from Windows computers, 116-118
 storage resolution, 118
 syncing photos, 114-116

OneDrive app, 121

online-based slide show services, WEB: 13

online blogging services, 322

online digital diaries, 321-322

 Tumblr, 322-323

online-only photo labs

 ordering prints from, 338-350

 Apple photo lab, 351-352

 FreePrints app, 341-347

online photo labs, 326

online photo-sharing services, 279-281

 Flickr, 282-289

 iCloud Photo Library, 283

 photo labs, 282

Open With icon, Photos app (PC), 174

opening albums, iPhone/iPad, 220-221

Optimize iPhoto Storage option, 127

ordering

 extra copies of photo books, 395

 from one-hour photo labs, 348-349

 from online-only photo labs, 349-350

 Apple photo lab, 351-352

 prints

 finishes, 330

 with Kicksend, 331-338

 from mobile devices, 329-330

 from online-only photo labs, 338-341

organizing

 photos on Android devices, 233

 accessing albums with Gallery app, 234-236

 creating new albums, 236-239

 deleting albums, 242-243

 deleting images from albums, 243-244

 hiding albums, 240

 renaming albums, 242

 sorting photos, 244-249

 photos on iPhone/iPad, 220

 adding photos to your Favorites, 232

 browsing collections, 222

 copying photos between albums, 229-230

 creating new albums, 224-225

 deleting albums, 226-228

 deleting photos from albums, 231-232

 moving albums, 226-228

 opening albums, 220-221

 photos on PCs, 200-202

OS X Yosemite, 347

P

Pano shooting mode viewfinder screen, 41

Panorama, shooting modes (Android devices), 61

Panoramic mode, 41-42

paper

 for printing photos, 358-359

 photo paper, 362

payment options

 Blurb, 382

 FreePrints, 347

PCs

 adding image file metadata, 214

 backing up automatically, WEB: 20-23

 creating prints, 361-363

 custom folders, 200-202

 copying/moving images into, 203-204

 renaming images, 206-207

 finding online backup solutions, WEB: 27-30

Journal, 319-321

Photos app. *See* Photos app (PC)

people, tagging in photos (Facebook), 293

People app, 257

perspective, 82-84

photo albums. *See* albums

photo book publishing companies, 378

photo books, 373

 Blurb,

 borders, 389

 creating, 379, 382-395

 layout templates, 387

 creating, 372

 on your computer, 378-379

 customizing with BookSmart software, 391-392

 error messages, resolution, 388

 ordering extra copies, 395

 previewing, 393

 tips for creating, 373-375

photo editing tools, 146, 149-150

 Blur Background tool, 154

 Brightness tool, 151

 Center Focus tool, 154

 Contrast tool, 152

 cropping images, 148-149

 Highlights and Shadows tool, 153

 rotating images, 147-148

 Saturation tool, 152

 Sharpness tool, 153

 straightening shots, 146-147

 Vignette tool, 154

photo labs

 finding apps, 327-328

 one-hour labs, 326

 online, 326

online-only photo labs, 338-341

online photo-sharing services, 282

professionals, benefits of, 327

photo libraries, syncing between mobile devices and computers via the Internet, 111-112

photo management, custom-named folders, 198-200

 on Macs, 207-209

 copying or moving photos to folders, 210-211

 renaming photo files, 212-213

 on PCs, 200-202

 copying/moving images into folders, 203-204

 renaming images, 206-207

photo management software, 197-198

photo organizing software, 197

photo paper, 358-362

photo printers, 355

 cost of, 357

 shopping for, 356-357

photo-sharing services, 279-281

Photo shooting mode, 46

Photo & Video category, App Store app, 8

photographer goals, 68

photos

 adding to email, 267-269

 albums, creating in Facebook, 294-296

 backing up to external hard drives, WEB: 18-19

 composing tweets with, 296-301

 copying into PC folders, 203-204

 cropping, 148-149

deleting, 138
 from Android devices, 140-141
 from iPhone/iPad, 138-139
edited photos, syncing, 163
editing, 17
 with Android Photos app, 163-168
 with iOS Photos app, 156-162
 with Photos app (Mac), 185-188
finding
 after transferring, 137
 with Photos app (Mac), 186
mailing, 331
managing, 16
mapping, 223
moving single photos on Android devices, 240
ordering prints, quality, 329
organizing on Android devices, 233
 accessing albums with Gallery app, 234-236
 creating new albums, 236-239
 deleting albums, 242-243
 deleting images from albums, 243-244
 hiding albums, 240
 renaming albums, 242
 sorting photos, 244-249
organizing on iPhone/iPad, 220-230
organizing on PCs, 200-202
printing, 19
publishing
 on Facebook Wall, 292-293
 on Instagram, 304-307
renaming
 on Macs, 212-213
 on PCs, 206-207
resizing for email, 269

rotating, 147-148
 in Android, 168
saving changes, Android, 165
saving with Photos app (Mac), 188
sending between devices, 269-270
 with AirDrop, 270-272
 with Bluetooth, 273-274
sending in messages, 274-275
sharing, 18
 privacy settings, 21
sharing online, 279-281
 social media services, 290
sharing through email, 254-255
 Android devices, 264-266
 iPhones/iPads, 261-264
 smartphones/tablets, 256-260
 Windows Mobile devices, 266
sorting on Android devices, 244-249
syncing
 with cloud-based services, 112-114
 with Dropbox, 129
 with iCloud Photo Library, 122
 with Microsoft OneDrive, 114-116
tagging
 on Android devices, 249
 people in Facebook, 293
transferring, 19
 from Android devices to your computer with Bluetooth, 135-137
 from iOS to your Mac with AirDrop, 135
 from mobile devices to Windows PC or Mac via USB cables, 102, 130
viewing, 16
Photos app, 112, 233
 Android, editing, 163-168
 creating prints, 360

extra features, WEB: 8

iOS, editing, 156-162

iPhone, 7

iPhone/iPad, Image Straightening tool, 17

sharing photos through email, 261-264

Slide Show feature, WEB: 6

slide shows, starting, WEB: 6-7

Photos app (Mac), 183-184

altering image metadata, 213-216

Edit tools, 186

editing photos, 185-188

editing tools. *See* editing tools

finding photos, 186

iCloud, 184

saving photos, 188

slide shows, WEB: 7-8

creating, WEB: 8-12

undoing edits, 189

Photos app (PC), 172

altering image metadata, 214

creating new folders, 202

editing tools. *See* editing tools

getting started, 173-174

tools, 174-175

Picture Stabilization, 57

picture-taking, 15, 20

action shots, 89

Android devices, Camera app, 52-54

breaking habits, 69-70

candid shots, strategies for, 85-86

close-ups, 76

common mistakes, 96-98

finding interesting subjects, 73

inanimate objects, 74-76

finger shots, 97

focal points, 77

with iPhone/iPad, 45-48

knowing your objectives, 70-72

lighting, 79-82

posed shots, strategies for, 86-88

Rule of Thirds, 76-77

framing shots, 78-79

shadows, 97

shooting angles/perspective, 82-84

Shutter button, 30-31

surroundings, 84-85

travel photography, 90-91

mix and match different types of shots, 92

shooting through glass, 93-96

signs, 91

Pictures folder, 197-198

Pinterest, 290

pixels, 13

point-and-shoot cameras, 21

point-and-shoot digital cameras, 68

popular feature, Panoramic mode, 41-42

popular features

autofocus sensors, 31-32

Burst mode, 35-37

flash, 37-38

HDR (High Dynamic Range), 38-39

image filters, 42-43

landscape mode, 39-40

Portrait mode, 39

Shutter button, 30-31

Time Lapse feature, 40

Timer, 40

zoom feature, 33-35

Portrait mode, 39, 88

posed shots, 71
 strategies for, 86-88
postcards as inspiration, 92
posts
 Facebook posts, 293
 Instagram posts, 308
preferences, adjusting in Day One, 319
previewing photo books, 393
pricing BookSmart software, 383
printer ink for printing photos, 358
printers, photo printers, 355
 shopping for, 356-357
printing photos, 19
prints
 creating on Android devices, 366
 creating with AirPrint, 366-368
 ordering from photo labs, 349-352
 creating from in-store Kodak Kiosks, 338
 creating from your computer, 347
 creating on Macs, 363-365
 creating on Windows PCs, 361-363
 ordering
 finishes, 330
 with Kicksend, 331-338
 from mobile devices, 329-330
 from online-only photo labs, 338-341
privacy
 digital diaries, 312
 Facebook, 291
privacy settings, photo sharing, 21
professional photo labs, benefits of, 327
props, 87
publishing photos
 on Facebook Wall, 292-293
 on Instagram, 304-307
pull-down menus, Day One, 317

Q

quality
 of photo paper, 359
 of photos, ordering, 329

R

rear-cam selfies, 60
rear-facing cameras, 4-5
Record Settings, Android devices, 58
removing apps from Android devices, 110
renaming
 albums on Android devices, 242
 images on PCs, 206-207
 photo files on Macs, 212-213
Reset Adjustments button, 193
resizing images for email, 269
resolution, 13-14, 57
 cropping, 149
 error messages, photo books, 388
 photos uploaded to Facebook, 292
 storing photos on OneDrive, 118
Retouch tool
 Photos app (Mac), 194-195
 Photos app (PC), 178-179
Review Pics/Video, Android devices, 58
reviewing backups periodically, WEB: 31
Rotate icon, Photos app (PC), 175
Rotate tool, Photos app (Mac), 190
rotating photos
 Android, 168
 photo editing tools, 147-148

Rotation tool, 147-148

Rule of Thirds, 76-77

 framing shots, 78-79

S

Samsung Galaxy Note 4, 5-6

Saturation tool, 152

Save a Copy option, Photo apps (PC), 177

saving

 changes to edited photos (Android), 165

 photos, Photos app (Mac), 188

scrapbooks

 creating, 372

 supplies for, 376-377

 tips for creating, 373-375

selective editing tools, 169

Selective Focus, 155

 Android devices, shooting modes, 60

Selective Focus tool, 181

 Photos app (PC), 182-183

selfies, 14

 rear-cam selfie, 60

semi-glossy finish, 330

sending emails with photos

 from Android devices, 264-266

 between devices, 269-274

 from iPhones/iPads, 261-264

 in messages, 274-275

 from smartphones/tablets, 255-260

 from your computer, 267-269

Set As icon, Photos app (PC), 175

Settings menu options, Android devices (Camera app), 55-58

shadows, 80, 97, 180

shaky hands, steadying, 31

Share icon, 264

sharing photos, 18

 between devices, 269-270

 with AirDrop, 270-272

 with Bluetooth (Android devices), 273-274

 with Bluetooth (Windows Mobile), 274

 through email, 254-255

 from Android devices, 264-266

 from iPhones/iPads, 261-264

 from smartphones/tablets, 255-260

 with Windows Mobile devices, 266

 in messages, 274-275

 online photo-sharing services, 279-281

 privacy settings, 21

 slide shows. *See* slide shows

 social media services. *See* social media services

Sharpness tool, 153

shipping costs for prints, 350

shooting angles, 82-84

Shooting Mode menu, 59

shooting modes

 Android devices

 Camera app, 59-63

 downloading, 63

 Selective focus, 155

shopping for photo printers, 356-357

Shot & More, shooting modes (Android devices), 62

Shutter button, 30-31

 action shots, 98

 Burst mode, 35-37

 multiple copies of same shot, 98

 options, 54

Shutter Sound, Android devices, 58

Shutterfly, 338-339

 online albums, 281

signs, picture-taking, 91

size of external hard drives, WEB: 19

Slide Show feature, Photos app, WEB: 6

Slide Show icon, Photos app (PC), 175

slide show production apps, Google Play App Store, WEB: 13

slide show production software, WEB: 4

slide show services, online, WEB: 13

slide show tools, finding online, WEB: 13-14

slide shows

 animated slide shows, WEB: 4

 creating

 with mobile devices, WEB: 13

 with Windows PCs, WEB: 5-6

 exporting, WEB: 12

 Photos app (Mac), WEB: 7-8

 creating, WEB: 8-12

 starting with Photos app, WEB: 6-7

 tips for creating, WEB: 4-5

smartphones

 backing up, WEB: 26-27

 sending emails with photos, 255-260

SmileBox, WEB: 14

Snapchat, 290

social media services, 290

 Facebook, 291-296

 Instagram, 302-308

 Twitter, 296-301

software for digital diaries, finding, 312

sorting photos on Android devices, 244-249

space, storage space, 13

Square shooting mode, 46

squares, Instagram, 303

starting slide shows with Photos app, WEB: 6-7

steadying breaths, 31

storage

 cloud storage services, 278-279

 memory cards, 13

storage space, 97

 creating, 13

 external hard drives, 115

 freeing up, 102, 107

Store Location, Android devices, 58

storytelling through pictures, 371-373

 tips for, 373-375

straightening shots, photo editing tools, 146-147

Straightening tool, 147

strategies

 for candid shots, 85-86

 for posed shots, 86-88

subfolders, creating, 202

subjects for picture-taking, 73

 inanimate objects, 74-76

supplies

 for photo albums/scrapbooks, 376-377

 for printing photos, 357

 ink, 358

 photo paper, 358-359

surroundings, using when picture-taking, 84-85

syncing

 digital diaries, 313

 edited photos, 163

 new albums, Android devices, 239

 photo libraries, between mobile devices and computers via the Internet, 111-112

photos
 with cloud-based services, 112-114
 with Dropbox, 129
 with iCloud Photo Library, 122
 with Microsoft OneDrive, 114-116
System Image Backup option, WEB: 23

T

tablets
 backing up, WEB: 26-27
 sending emails with photos, 255-260
tagging, 11
 Day One, 315
 people in Facebook photos, 293
 photos on Android devices, 246-249
tags
 color, adding, 216
 Flickr, 286
taking pictures. See picture-taking
Tap To Take Picture, Android devices, 58
templates, Blurb, 387
themes, 376
third-party filters, 160
thumbnail size, 212
Time Lapse feature, 40
Time Machine, WEB: 24-26
Timeline view, sorting photos on Android
 devices, 244
Timer feature, 40
 Android devices, Camera app, 56
tips for storytelling through pictures,
 373-375

tools
 Adjust icon, Photos app (Mac), 192-193
 Blur Background tool, 154
 Brightness tool, 151
 Center Focus, 155
 Center Focus tool, 154
 color related tools, Photos app (PC), 180
 Color tool, Photos app (PC), 180
 Contrast tool, 152
 Crop tool, 148-149
 Image Straightening feature, 147
 Photos app (Mac), 190-191
 editing tools. See editing tools
 Enhance tool, Photos app (Mac), 190
 Enhancement tool, 144-145
 turning off, 158
 Filters, Photos app (Mac), 192
 Flip tool, Photos app (Mac), 192
 Highlights and Shadows tool, 153
 image editing tools, 146
 photo editing tools. See photo editing
 tools
 Retouch tool
 Photos app (Mac), 194-195
 Photos app (PC), 178-179
 Rotate tool, Photos app (Mac), 190
 Rotation tool, 147-148
 Saturation tool, 152
 selective editing tools, 169
 Selective Focus tool, 181-183
 Sharpness tool, 153
 Vignette, 181
 Vignette tool, 154-155
traditional diaries versus digital diaries, 312

transferring
 content from mobile devices
 to Macs, 133-134
 to Windows PCs, 131-132
 photos, 19
 from Android devices to your computer with Bluetooth, 135-137
 from iOS to your Mac with AirDrop, 135
 from mobile devices to computers, 102
 from mobile devices to Windows PC or Mac via USB cables, 130
travel photography, 90-91
 mix and match different types of shots, 92
 shooting through glass, 93-96
 signs, 91
Tumblr, 322-323
turning off Enhancement tool, 158
turning on Bluetooth, 135
tweets, 296
 checking, 301
 with photos, 296-301
Twitter, 296
 checking tweets, 301
 composing tweets with photos, 296-301
 Crop tool, 301
 Enhance icon, 301

U

Undo icon, Photos app (PC), 177
undoing edits, Photos app (Mac), 189
uneven light, 80
unlocking devices, 24
Update Original icon, Photos app (PC), 177

upgrading iPhoto to Photos app (Mac), 184
uploading
 defined, 19
 to Flickr, 285
USB cables, transferring photos from mobile devices to PC or Mac, 130

V

View Original icon, Photos app (PC), 177
viewfinder, 29
viewing photos, 16
Vignette tool, 154-155, 181
Virtual Tour mode, Android devices, 63
Voice Control, Android devices, 58
Volume Key, Android devices, 58

W

washed out images, 81
white vignette effect, 181
Wi-Fi, 103
Windows,
 File History, WEB: 20
 Library, 199
Windows 7, accessing OneDrive, 118
Windows 10, 172
Windows computers, managing Microsoft OneDrive, 116-118
Windows Mobile, sharing photos with Bluetooth, 274
Windows Mobile devices, emailing photos, 266

Windows PCs
 creating prints, 361-363
 iCloud Photo Library access, 283
 Microsoft OneDrive, 279
 slide shows, creating, WEB: 5-6
 transferring content from mobile devices,
 131-132
 transferring photos via USB cables, 130
Windows Store, 8

wireless networks, 103
WordPress.com, 322
written diaries versus digital diaries, 312

X-Y-Z

zoom feature, 33, 35
Zoom feature, adjusting, 46

More Best-Selling **My** Books!

Learning to use your smartphone, tablet, camera, game, or software has never been easier with the full-color My Series. You'll find simple, step-by-step instructions from our team of experienced authors. The organized, task-based format allows you to quickly and easily find exactly what you want to achieve.

Visit quepublishing.com/mybooks to learn more.

REGISTER THIS PRODUCT
SAVE 35%*
ON YOUR NEXT PURCHASE!

How to Register Your Product

- Go to quepublishing.com/register
- Sign in or create an account
- Enter ISBN: 10- or 13-digit ISBN that appears on the back cover of your product

Benefits of Registering

- Ability to download product updates
- Access to bonus chapters and workshop files
- A 35% coupon to be used on your next purchase – valid for 30 days
 - To obtain your coupon, click on "Manage Codes" in the right column of your Account page
- Receive special offers on new editions and related Que products

Please note that the benefits for registering may vary by product. Benefits will be listed on your Account page under Registered Products.

We value and respect your privacy. Your email address will not be sold to any third party company.

** 35% discount code presented after product registration is valid on most print books, eBooks, and full-course videos sold on QuePublishing.com. Discount may not be combined with any other offer and is not redeemable for cash. Discount code expires after 30 days from the time of product registration. Offer subject to change.*

quepublishing.com